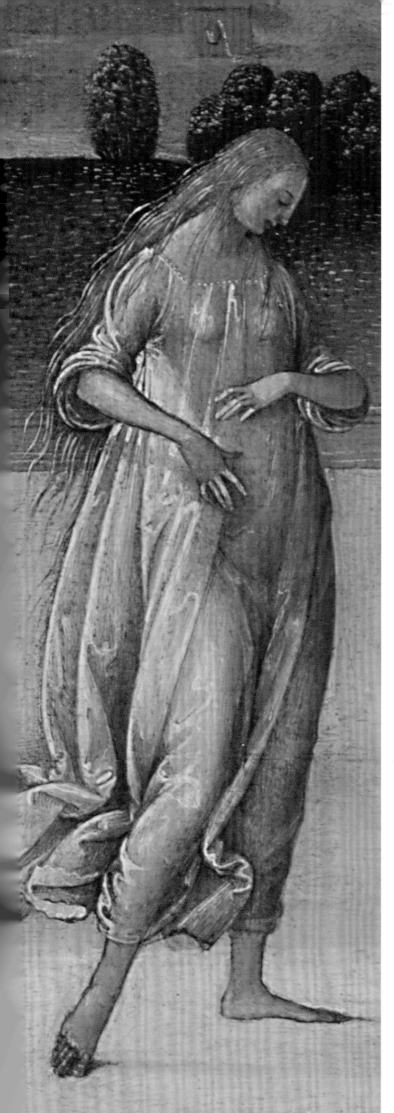

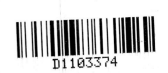
NATIONAL GALLERY TECHNICAL BULLETIN

RENAISSANCE SIENA AND PERUGIA 1490–1510

VOLUME 27

National Gallery Company
London

Distributed by
Yale University Press

This volume of the *Technical Bulletin* has been funded by the American Friends of the National Gallery, London with a generous donation from Mrs Charles Wrightsman.

'The Master of the Story of Griselda and Paintings for Sienese Palaces' is published with the additional generous support of The Samuel H. Kress Foundation.

Series editor Ashok Roy

First published in Great Britain in 2006 by
National Gallery Company Limited
St Vincent House, 30 Orange Street
London WC2H 7HH

www.nationalgallery.co.uk

British Library Cataloguing in Publication Data
A catalogue record for this journal is available from the British Library

ISBN: 1 85709 357 7
ISBN 13: 978-1-85709-357-5
ISSN 0140 7430
525047

Publisher Kate Bell
Project manager Claire Young
Editor Diana Davies
Designer Tim Harvey
Picture research Joanne Anderson
Production Jane Hyne and Penny Le Tissier
Repro by Alta Image, London
Printed in Italy by Conti Tipocolor

FRONT COVER

The Master of the Story of Griselda,
The Story of Patient Griselda, Part III: Reunion, NG 914,
detail of PLATE 3, PAGE 6.

TITLE PAGE

The Master of the Story of Griselda,
The Story of Patient Griselda, Part II: Exile, NG 913,
detail of PLATE 2, PAGE 5.

Contents

The Master of the Story of Griselda
and Paintings for Sienese Palaces

JILL DUNKERTON, CAROL CHRISTENSEN AND LUKE SYSON

THE STILL ANONYMOUS 'Master of the Story of Griselda' derives his designation from three gloriously entertaining panels in the National Gallery,[1] retelling Boccaccio's tale from the *Decameron* (1348–51) of the marriage of the Marchese Gualtieri di Saluzzo to the peasant girl Griselda (PLATES 1–3).[2] The personality of their painter was established by Bernard Berenson in 1931,[3] building upon the research of Giacomo De Nicola in 1917.[4] Nonetheless, the master's precise artistic and geographical origins, the identity of his patrons, the dates of his paintings, their relative chronology and his methods of collaboration with other masters (quite apart from his name) all remain matters of dispute.[5] While a consensus has been reached that he was active in the period *c.*1490–1500, the question of whether his career was cut short prematurely by death or whether his pictures represent the juvenile (or possibly mature) phase of one or another better understood – preferably a named – painter is not resolved. A small group of panels is now unanimously assigned to him: the National Gallery pictures, the ex-Zoubaleff collection bacchic tondo last recorded on the Paris art market,[6] and four of the series of Virtuous Men and Women that will be discussed below.[7]

The Griselda panels

The starting point for any investigation of this master remains the three London panels that give him his 'name'. In the first of the three (the first, that is, of the narrative sequence but not necessarily, as we shall see, the earliest painted), here entitled *Marriage*, the Marchese Gualtieri, out hunting, encounters the beautiful peasant girl Griselda (PLATES 1 AND 4) and announces that he will wed her on condition of her absolute obedience. Having obtained her father's consent (right background), he publicly humiliates her, stripping her bare to dress her again in her wedding finery (right). The wedding takes place at the centre of the picture, framed by a triumphal arch. In the second picture *Exile* (PLATE 2), which reads left to right, the now married Gualtieri tests his wife further by removing her newborn daughter and son and

pretending he has had them killed (left background). Underneath the loggia at the centre he then stages a bogus annulment of their marriage. Griselda returns her wedding ring and is once again forced to strip, though this time she is permitted to keep her *camicia*, in which she returns disconsolately to her father's house (right). In the final painting of the cycle *Reunion* (PLATE 3), the Marchese seeks out Griselda, who now believes her children murdered and herself divorced, and orders her to prepare his home for the arrival of a new bride (right background). Griselda – inevitably – obeys (left background) and meanwhile, in the far background, the wedding procession of this new bride arrives in Saluzzo; the Marchese's supposed wife-to-be is in fact Griselda's long-lost, grown-up daughter, accompanied by her younger brother. Griselda is reunited with her children (right) and the Marchese reveals that her long ordeals have all been tests of her obedience, and that she has indeed proved herself a perfect wife. At the end of this troubling little tale, they embrace, an ideal couple at long last (left).

The pictures, of the type now generally classified as *spalliere*,[8] may have been installed in a row, since they are all lit from the left. It is more certain that they were intended to furnish a principal *camera* of a patrician *palazzo*, perhaps placed above three *cassoni* – or, given that the perspective angle of the architectural settings suggests that the viewpoint was intended to be low, they were installed higher up, conceivably as overdoors. A bedchamber location may be deduced not only by their size and shape, but also by their subject matter, which makes them particularly (and typically) appropriate for a nuptial chamber. The painter's style and technique will be seen to have evolved during the painting of these three works, but some aspects are consistent and distinctive and his works are characterised above all by a delicacy and lightness of touch. The pictures are populated by notably elongated men with long, well-formed legs and barrel-like thoraxes and women with tiny waists and flowing hair. The protagonists flounce and bounce on their toes, swaying and gesticulating with consummate elegance while high-stepping horses with frothy

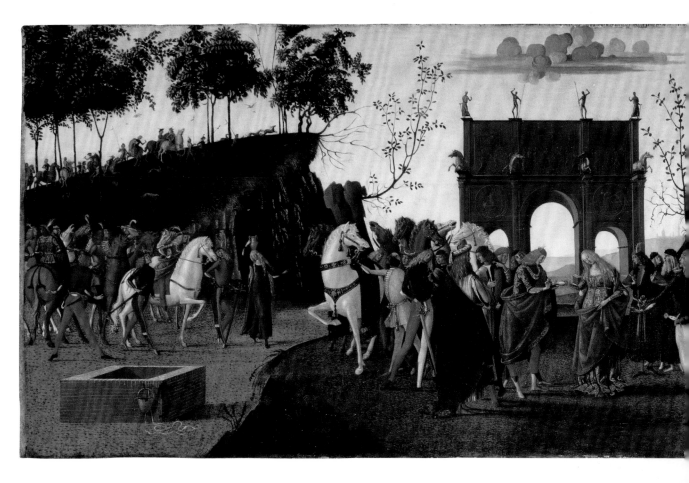

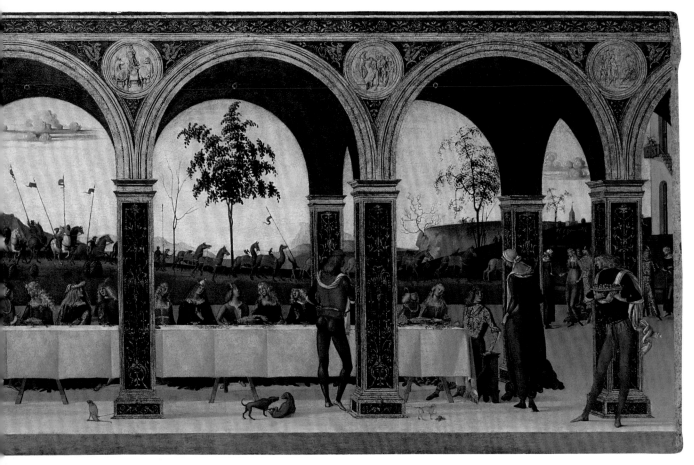

914), 1493–4. Poplar, 61.9 × 157.5 cm.

manes adopt almost balletic poses. Gesture is all-important. He could also be immensely witty, and he is highly sophisticated in his approach to episodic narrative. Throughout, moments in the story are linked by a chattering commentary of bystanders, a feature of Boccaccio's tale, and the animals in the foregrounds mirror or satirise the behaviour, even the extravagant costume, of the human protagonists.

Date and patron

The provenance of the three London paintings is known only from the mid-nineteenth century. They are first recorded in the collection of Alexander Barker, in which they were examined by Gustav Waagen in 1854; Barker had attributed them to Pintoricchio.[9] They were sold to the National Gallery in the Barker sale at Christie's in 1874 (lots 85–7), and were later catalogued as Umbrian School.[10] However, their original patron has been a matter of speculation. Vilmos Tátrai's suggestion that they were commissioned by members of the Spannocchi family, lacking proof, has not always been accepted.[11]

Tátrai linked the pictures with the wedding on 17–19 January 1494 of the sons of the late Ambrogio Spannocchi, papal banker to Pius II Piccolomini,

Antonio (b. 27 May 1474) and Giulio (b. 1475?), respectively to the Sienese Alessandra Placidi, and to a Roman bride, Giovanna Mellini.[12] The wedding was celebrated with huge and extravagant ceremonies, by the performance of another of Boccaccio's *novelle* (IX.3) and, tellingly, given the inclusion of the arch in *Marriage*, by the erection of a temporary triumphal arch with on top four statues of famous men of arms.[13] Tátrai's theory has recently been confirmed by their connection – established by heraldry and shared provenance – with two panels that can be seen at Longleat House, Wiltshire, accepted in lieu of tax in 2005 (but remaining *in situ*) by the Victoria and Albert Museum.[14] This further pair of so-called *spalliere*, respectively 76 × 229.5 and 73.5 × 170 cm, came just before the Griselda pictures in the Barker sale (lots 83 and 82 – only divided by Pintoricchio's *Penelope with the Suitors* [NG 911], also of course with a Sienese provenance). The first panel depicts episodes from the life of Alexander the Great, the story taken from Plutarch's *Parallel Lives* (xx, 5–xxi, 5). The second shows Alexander's Roman parallel, Julius Caesar crossing the Rubicon, as told by Suetonius (I: xxxi–xxxiii). They were sold to the Marquis of Bath as works attributed to Pintoricchio. It has now been established

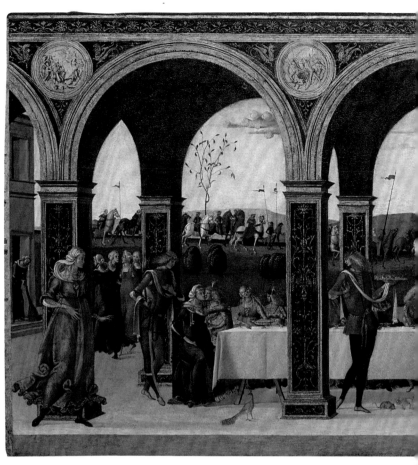

PLATE 3 Master of the Story of Griselda, *The Story of Patient Griselda, Part III: Reunion* (NC

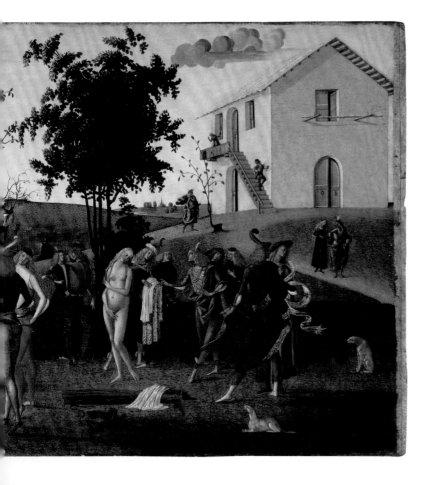

PLATE 1 Master of the Story of Griselda, *The Story of Patient Griselda, Part I: Marriage* (NG 912), *c*.1493–4. Poplar, 61.6 × 157.5 cm.

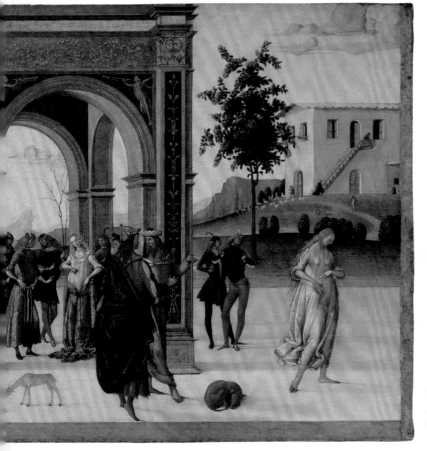

PLATE 2 Master of the Story of Griselda, *The Story of Patient Griselda, Part II: Exile* (NG 913), 1493–4. Poplar, 61.6 × 157.5 cm.

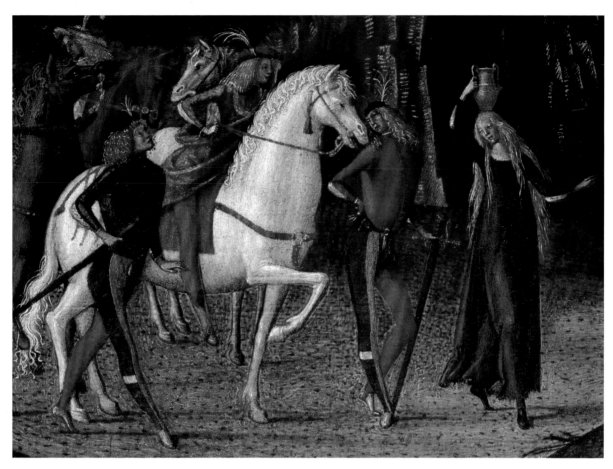

PLATE 4 *Marriage*. Detail of PLATE 1.

that a coat of arms painted on Alexander's tent is that of the Spannocchi family. The Piccolomini *stemma* is visible on the dexter (the family had been granted the right to incorporate Piccolomini arms with their own) and, severely abraded, the Spannocchi arms, with their three Spannocchi gold paired ears of corn (*pannocchi*), are seen on the red sinister side.

An attribution to the workshop of Domenico and Davide Ghirlandaio means that the pictures can now be linked with a regularly discounted passage in Vasari's 1568 life of Ghirlandaio: 'Domenico [Ghirlandaio] e Bastiano [Mainardi] insieme dipinsono in Siena, nel palazzo degli Spannocchi, in una camera, molte storie di figure piccole, a tempera.'[15] One hand (there appear to be three in all) is certainly identifiable as that of Bastiano Mainardi and it should be noted that, even if no part seems likely to have been painted by Domenico himself, his brother Davide was active in Siena between April 1493 and about March 1494 (or possibly a little later).[16] Davide (like his brother-in-law Mainardi) was still operating within Domenico's shop, and continued to run it even after Domenico's death on 11 January 1494. The dates of Davide's work for the Duomo *operai* give us a probable dating for the Longleat Spannocchi pictures

of *c.*1493–4, probably commissioned just before Domenico's death and perfectly coinciding with the marriage of the Spannocchi brothers. A firm link is established between the two sets of pictures by the fact that servants garbed in the same liveries appear in both the Longleat *Alexander* painting and, accompanying the Marchese Gualtieri, in the first and third Griselda panels (PLATE 4). They are clearly therefore to be identified with the bridegroom in both instances. This is evidently a Spannocchi livery and the colours of their hose tie in precisely with those of the coat of arms: white (standing for silver), blue and a flash of gold on one leg (the Piccolomini dexter), red for the Spannocchi on the other.[17] Since the Palazzo Spannocchi was an important focus for the wedding ceremonies, we can perhaps assume that the Griselda panels, like the Longleat pictures, were commissioned for the marriage and begun in 1493.

The problem remains as to what these pictures tell us of the master's artistic origins. Boskovits, most recently, has re-stated the canonical view that the Master of the Story of Griselda was a pupil, *creato* or assistant of Luca Signorelli.[18] A superimposition of Signorelli's style can indeed be detected, but, as Kanter has pointed out, the Griselda Master's citations can

almost all be explained by the presence of Signorelli's 1488 Bichi Altarpiece in the church of Sant'Agostino[19] in Siena. The system of insistent shadowing, especially in *Exile*, is indebted to Signorelli and a number of subsidiary bystanders and servants in both *Reunion* and *Exile* are based on figures in two small panels from the Bichi Altarpiece, now in Toledo, Ohio. Beyond these local citations, the master makes almost no use of motifs from other non-Sienese phases of Signorelli's career, as might be expected from someone with access to drawings in the workshop.[20] It should not be forgotten that Francesco di Giorgio had a key part to play in the decoration of the Bichi Chapel, responsible not only for the polychrome statue of *Saint Christopher*[21] on the altar but also for the grisaille frescoes on the walls, which are also likely to have had some impact upon the Griselda Master. In fact, there are aspects of the Griselda Master's refined style, and of his technique, especially at the outset, that are quite unlike Signorelli's. Indeed, it is arguable that his understanding of Signorelli's approach became ever more profound during the course of his brief career, and that his style was formed at the start primarily by contact with native Sienese painters of the previous generation, and with Umbrian painters, above all Perugino and Pintoricchio.[22]

Indeed, the seamless blending of these two styles has led to the Griselda Master's ambiguous classification as 'Umbro-Sienese'; there can be no way of knowing whether he was born in Siena or Umbria. An Umbrian birthplace remains plausible, and may explain the painter's resolutely anonymous status in Siena (in addition, because he specialised in secular painting, he is unlikely to be identified by linking a name in a contract with a surviving work). Moreover, even if he were native to Siena (likely given that all his known works seem to have been painted there), there can be little doubt that the young painter spent some time in close contact with Umbrian masters; Angelini has even proposed, somewhat dubiously, that the Griselda Master may have been a member of Pintoricchio's huge équipe in Rome.[23]

Pintoricchio certainly provided a model for the Griselda Master's decidedly decorative landscape style. The Griselda Master also seems to have had some contact with Perugino's *bottega*, perhaps in Florence.[24] One of the male servants in *Reunion* adopts, rather wonderfully, the attitude of the attenuated Annunciate Virgin in the *Ranieri Annunciation*, probably a Perugino workshop product.[25] The dashes of paint that give texture and distance to his landscapes also probably derive from Perugino.

However, other elements in his paintings he could have learned only from Sienese masters. Zeri proposed a link between the *View of an Ideal City* in Baltimore, variously attributed, and the Griselda Master and, even if the Griselda Master is in fact very unlikely to have contributed to this panel, it is true that the architecture in *Exile* (which is markedly more sophisticated than in *Reunion*) is like an ideal city of the type surviving in Berlin and Urbino as well as in Baltimore, the first of these probably best attributed to Francesco di Giorgio or his shop.[26] Indeed, the reiteration of a dancing statue and landscape features from *Marriage* and *Reunion* respectively in the background painted behind a polychrome terracotta *Virgin and Child* relief of *c*.1490–3, attributed to Francesco di Giorgio and a collaborator (formerly at the Pieve di San Leonardo a Montefollonico, now in the collection of the Museo Diocesano at Pienza), has suggested to Bagnoli that this element of the relief may have been delegated to the Griselda Master.[27] It therefore becomes possible that, after a first training in Umbria or Siena, the Griselda Master occupied a junior role in Francesco di Giorgio's workshop, starting as a specialist in landscape and architectural backgrounds, and only subsequently began fully to absorb the lessons of Signorelli's Bichi Altarpiece. It will be seen that these observations, based at this stage on the master's style, are borne out by his technique.

The panels

The three panels are constructed from substantial boards of dense, good quality poplar, 2.8 cm thick, and with the grain running horizontally (PLATE 5, FIG. 1). The panels for *Marriage* and *Exile* consist of two planks, joined approximately across the centre, while that for *Reunion* is made up of three narrower boards. In the case of the third panel, a fault at the left end of the central board was filled on the front face with an X-ray opaque putty, probably the same as that which appears in a gap between joins on the reverse at the opposite end. Other small knots and flaws, inevitable in planks of these dimensions, have also been filled with this putty, even on the reverse faces. In general, the panels are notable for their straight grain and for their stability. Woodworm damage is slight, but water stains on the reverses of all three panels indicate that, at some time, they may have been in contact with a damp wall.

Cut into each panel are two vertical channels, slightly tapering at alternate ends and with a dovetail profile, designed to hold battens. They are assumed to be original since no woodworm channels have been exposed by the cutting, and lines scored into the

PLATE 5 *Marriage*. Back.

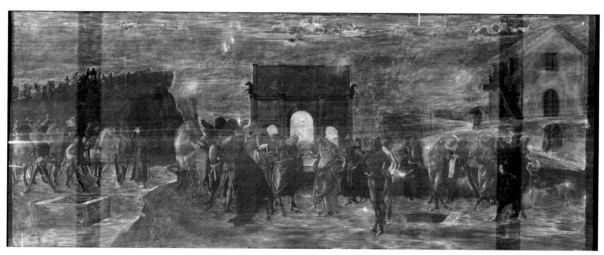

FIG. 1 *Marriage*. X-radiograph.

wood approximately along the centre of the upper and lower sides of each panel were presumably made by the carpenter in order to establish the depth to which the channels were to be cut. Similar batten channels occur on other Tuscan furnishing panels of comparable dimensions from this period,[28] but as none remain *in situ* it is not known whether the battens had a role in the installation of the panels or whether they were fitted simply to prevent the long panels from warping and twisting. The Griselda panels have at either ends borders of unpainted gesso, between one and two cm wide and demarcated by incisions; these must have been capped by vertical framing elements. The paint extends almost to the very edge along the upper and lower edges, however, and so it is possible that the ends of the battens projected above and below the panels, providing fixing points for their attachment to a frame or indeed a wall which could then be covered by horizontal mouldings or framing elements.

The underdrawing

It is reasonable to suppose that the panels were prepared with gesso at the same time. As is often the case with later fifteenth-century Italian panels, the surfaces are peppered with pits caused by air bubbles in the gesso. Many of the paint samples feature a translucent yellow-brown layer over the gesso; this was also visible in damaged areas before restoration and it may be an unpigmented priming layer, probably glue or a drying oil, applied to reduce the absorbency of the gesso.

The design of all three panels, and especially the distribution of the many episodes of Boccaccio's narrative, must have been worked out to a considerable extent in advance. Every detail that relates to the narrative was carefully underdrawn on the gessoed surface so that in the episode of the Marchese hunting in the left background of *Marriage*, the minute huntsmen, hounds and stag – figures that one would expect to have been painted on top of the completed land-

9

FIGS 2 AND 3 *Marriage*. Infrared reflectogram mosaic detail and X-ray detail of hound and stag.

FIG. 4 *Marriage*. Infrared reflectogram mosaic detail.

scape and sky – are in fact drawn and painted and the sky then brushed in around them (FIGS 2 AND 3). As will be demonstrated, however, the paintings were probably executed one at a time and out of narrative sequence. Sets of painted furnishings commissioned for marriages were not necessarily finished in time for the ceremonies themselves,[29] but, in the context of such a commission, it would have made sense in this instance for the painter to try to complete the third in the set first, the one that depicts the feast celebrating

the marriage (albeit a staged one) of the Marchese to his supposed new bride, and the happy ending brought about by female obedience.

In spite of the complex architecture of the structures that appear in this and in *Exile*, the painter made little use of incision, preferring to rule straight lines in ink (PLATE 6), perhaps using a quill pen, although elsewhere the underdrawing has clearly been executed with a brush.[30] Occasionally these lines extend into areas destined for figures (see FIG. 6). The only incision in the architecture occurs in the arcs of the arches in all three panels and in the vaulting and roundels in *Reunion*. Here the holes made by the point of the dividers used to inscribe the circles are clearly visible (PLATE 7). Inconsistencies in the incised curves of the vaulting of this panel suggest some uncertainty about the perspective of the construction. With the exception of the bridal procession and the episodes that take place at the back of the stage at the extreme left and right, the figures are symmetrically disposed in the shallow space established by the long table and the front of the loggia.

The positioning of the figures in *Exile*, on the other hand, is more complex and, while retaining an element of symmetry, is more subtly varied. For this more elaborate setting, the painter drew a perspective grid that allowed him to establish the correct spatial location for each figure (FIG. 5). Confirmation that this was the purpose of the grid is the fact that the lines can be seen in infrared to be running beneath the figures. In many areas of the foreground the perspective lines are clearly visible to the naked eye. The reason why infrared imaging enhances the legibility of the underdrawing only to a limited extent is that the drawing material used on all three panels consists principally of an iron-gall ink, perhaps with a small amount of carbon black.[31] Where a line of underdrawing appears in a cross-section, it can be seen

FIG. 5 *Exile*. Infrared reflectogram mosaic detail.

to be surprisingly thick and dark (see PLATE 12). In the badly damaged gilded capitals of the loggia in *Exile* the brown-black lines of underdrawing are often all that has survived of the architectural detail (PLATE 6).

In *Marriage*, the copper-based pigments used for the grassy landscape reduce penetration of infrared, but a horizontal line and a diagonal, which lead to the vanishing point at the base of the arch, are visible with the naked eye beneath the blue-grey legs of the young courtier with his back turned in the right foreground of the central group. They may represent traces of a system to guide the positioning of these figures. Landscape elements were sketched in with long fluid lines (FIG. 4), but here the underdrawing tends to be more approximate and it was not always followed in the painting. A different underdrawn profile of the rocks on the left appears behind the heads of the waiting horses and their grooms (now beautifully set against the sky). Few of the tree trunks visible in the first and second panels were painted in their drawn positions, and the tree sketched in front of Griselda's parents' house on the right of *Exile* is now easily visible with the naked eye. X-radiographs confirm that trunks, branches and foliage were painted over the skies in all the panels. Because the positioning of the trees does not affect the telling of the story, the painter could re-arrange them at a late stage, unlike the figures with their important narrative role.

More differences between the three panels become apparent in the drawing of the figures. In *Reunion*, here proposed as the first to be executed, the figures are exceptionally tall and slender, even by the Griselda Master's standards, and their heads and feet are proportionally very small – indeed a figure's feet can be smaller than their expressively gesturing hands. Although the standing figures are usually posed with their weight on one leg in a way that suggests knowledge of works by Perugino and Signorelli, their legs

PLATE 6 *Exile*. Detail, after cleaning, before restoration.

PLATE 7 *Reunion*. Detail of PLATE 3.

are often stiff and their backs remain straight.[32] In a figure such as the girl in pink who stands in front of the loggia on the left, the painter drew in the limbs beneath the fabric of her dress, which flutters out on

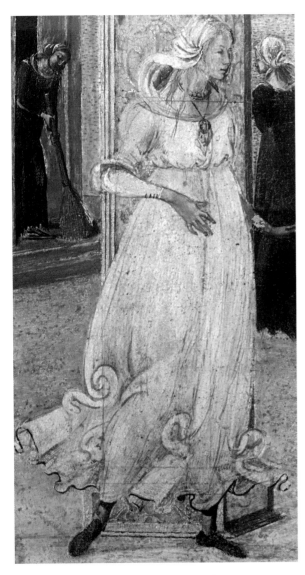

FIG. 6 *Reunion*. Infrared reflectogram mosaic.

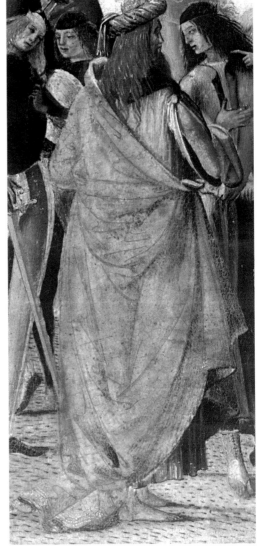

FIG. 7 *Marriage*. Infrared reflectogram mosaic detail.

both sides of the figure, the folds looping and coiling into distinctive shell-like spirals (FIG. 6).[33]

Marriage was probably the second panel to be painted, although some overlap is always possible in that work may have begun on the next one before the first was completed. Here bulkier and more heavily draped figures in the manner of Signorelli have been introduced, notably those of the Marchese and Griselda at the centre and the bystander with his back turned to the left of them (FIG. 7). Signorelli's system of shadowing has been better understood. The bystander's cloak was to be painted with azurite and ultramarine blue, unmodulated by white, and so, after the folds had been drawn, they were reinforced by incising them into the gesso, roughly following the liquid lines of the underdrawing – in the infrared image the crisp sharp lines are the incisions. Other dark blue draperies in the series have been similarly

incised. The practice is a traditional one, especially if black underpaintings were also to be employed, and is more usually associated with blue mantles worn by the Virgin. In the lower part of the same drapery small areas of fine parallel hatched shading can be seen in the bunched folds; similar areas of shading, always indicating areas of shadow rather than volume, occur in several places on all three panels.

By the time the painter drew the figures in *Exile*, their poses have become noticeably more varied and flexible. Although some still have the stiff-legged gait of the other panels, waists now bend and hips jut and sway to give the impression of dance that is so much a feature of this anonymous master. His way of representing fluttering draperies, on the other hand, has become a little less extreme, with the spirals replaced by slightly more credible zigzag folds. It can be seen in infrared that he eliminated a flutter of drapery which

he drew on the right side of the figure of Griselda in her shift (FIG. 8). This alteration better suggests the soft translucent nature of the fine fabric and enhances the sense of movement. However, it probably also marks the beginning of a tendency for the painter to curb some of his decorative flourishes and to reduce over-complex contours, and to pursue a more naturalistic, indeed more Signorellian, impulse.

Not surprisingly, given the careful planning, there are few pentimenti and all are minor. In *Exile*, for example, the drapery over the shoulder of the courtier in the foreground on the far left was originally drawn extending further down than it was painted and the head of an extra bystander to the right of Griselda in the central episode of the mock divorce was elimi-nated for obvious reasons. In *Reunion* the head of the horse of the new bride in the background procession was repainted in a lower position. Small changes to colours include the replacement of a purple cap on the young man to the left of the central pillar in this panel with one of scarlet. The only features of the panels which were not planned at the underdrawing stage are the birds and animals that supply the humor-ous commentary on events taking place behind them. They are all painted over the foreground layers; the more thinly painted ones are now transparent and worn by past cleaning.

The mordant gilding

The three paintings owe much of their decorative effect to the use of gold leaf. It is, however, always used illusionistically in the sense of being applied to surfaces that are represented as golden and with care-ful attention to lighting effects. The figure of the Marchese is identified throughout the story (no matter how small he appears) by his cloth-of-gold tunic and gold chain (PLATES 8 and 9). At her marriage, and until her divorce, Griselda wears a dress of a matching fabric. Over an unmodulated orange-brown base colour, consisting of an orange earth pigment with a little vermilion and lead white in oil, small pieces of gold leaf were affixed to a mordant painted onto the parts of the textile that catch the light. The shadowed areas were shaded with hatched strokes of black and then the red velvet part of the pattern added using a red lake glaze. The Griselda Master was not unusual in late fifteenth-century Siena in attempting to use real gold for cloth of gold with-out compromising the volume, structure and lighting of the draperies to be depicted.[34]

At their wedding, the Marchese and Griselda also wear sumptuous red mantles, the edges bordered with gilded patterns and the folds highlighted with tiny

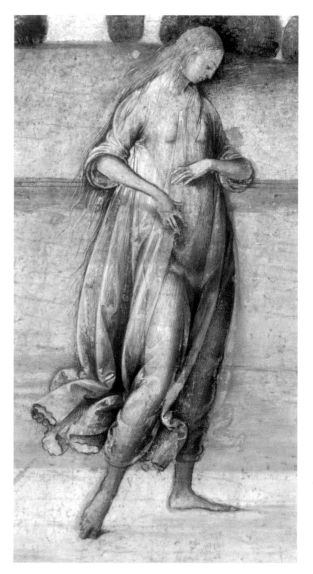

FIG. 8 *Exile*. Infrared reflectogram mosaic detail.

flecks of gold leaf. In *Exile*, the dark blue parts of the costumes of several figures are treated in the same way. The technique appears in paintings by Pintoricchio and Signorelli but also in works by Sienese masters such as Neroccio, although seldom used on a scale as small as the figures in these panels.[35] The rocks behind the figure of the peasant Griselda encountering the Marchese on the left of *Marriage* (PLATE 4) are lit with diagonal hatched lines of gold leaf.[36] Other gilded details that suggest the miniaturist tendencies of this painter are the wine cups and dessert dishes at the wedding feast in *Reunion* and, in *Marriage*, the sword hilts, horse bits and harness, and even the eyes of the dogs on the right who witness Griselda's first test of obedience.

The most extravagantly gilded panel is *Reunion* with its blue and gold loggia, but here too attention was given to the direction of the lighting: gold leaf

PLATE 8 *Marriage.* Detail of PLATE 3.

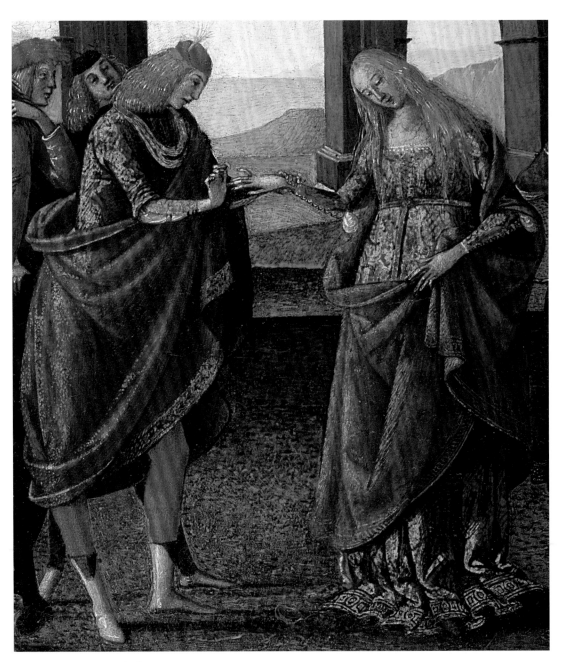

PLATE 9 *Marriage.* Detail of PLATE 1.

was applied only to the facets of the capitals and bases that catch the light and to the convex surfaces of the beaded moulding around the arches, each bead picked out individually with a highlight of gold (PLATE 7). The base for the mordant gilding is the same orange-brown paint layer that was used for the cloth-of-gold fabrics (PLATE 10). The mouldings and the reliefs of antique subjects in the roundels were painted over the gold with black and translucent brown pigments. More mordant-gilded patterns were applied over the azurite and ultramarine blue in the spandrels and on the pillars in this and in *Exile*. Here the gold appears less lustrous because of the rough surface of the underlying pigment.

In *Exile*, the panel that seems to have been painted after the other two, the orange-brown underlayer was omitted from the capitals and gilded bands on the cornices of the central loggia and the buildings to the left. Instead the mordant was applied directly onto the gesso (over the detailed underdrawing in the case of the capitals). The gold leaf is much abraded on this panel and so during the recent restoration the translucent yellow-brown mordant was visible (PLATE 6). The same mordant was used for the other areas of gilding on the three panels, and also features on *Alexander the Great*, one of the panels by the Griselda Master from the Virtuous Men and Women series (p. 44). Analysis has shown that the unpigmented mordant contains gum ammoniac, a gum resin exuded from the stems of a plant of the Apiaceae family *Dorema ammoniacum* D.Don, native to Iran and India. Gum ammoniac is partially soluble in water, alcohol, vinegar and dilute alkali, flows easily from a brush or pen and dries rapidly to a transparent glossy finish that can be gilded immediately or reactivated later with hot breath. The identification of gum ammoniac in the mordant here and on the panel by Giannicola di Paolo discussed in this *Bulletin* (p. 96) represents its first reported occurrence as a mordant for gilding on panel paintings.[37]

The paint layers: pigments and media

The panels were painted predominantly in oil, but egg tempera was used in some areas for specific reasons related to particular pigments or effects of colour and texture.[38] Opaque paints containing lead-based pigments such as the skies, painted with ultramarine and lead white, and the light warm grey platforms that form the foregrounds of the two panels with architectural settings are all bound with walnut oil. The paint has a stiff texture, retaining the marks and direction of the brushstrokes as the painter worked carefully around the contours of the figures and other important features. Often a ridge can be seen at the

PLATE 10 *Reunion*. Cross-section of a sample from the gilding on the arches. There is an orange-brown underpaint of yellow earth pigment, with some vermilion and lead white, lying on the gesso ground. Above is the translucent unpigmented yellow-brown mordant for the gold leaf. Photographed at a magnification of 500×. Actual magnification 440×.

junction between sky or foreground and the more thinly painted figures. Away from the figures, the paint application becomes broader and long sweeping brushstrokes can be seen in X-radiographs, including in the landscape foreground of *Marriage* (FIG. 1). Here most of the grassy slopes have been underpainted with mixtures of verdigris, lead-tin yellow, lead white and sometimes a little black. Curiously, the only costume in all the panels to be painted using lead-tin yellow is that of the black servant holding the white palfrey saddled ready to carry the bride. The slightly gritty, almost lumpy texture characteristic of lead-tin yellow paint films that have formed lead soaps is very apparent.[39] Other areas of yellow on the panels are painted with a bright ochre, with some vermilion and black in the shadows.

In most of the samples where the type of oil could be identified, it was found to be walnut oil, the most commonly used drying oil in Italy at this period. However, in the bright green hose of the young man who stands in front of the table towards the right in *Reunion* the mixture of verdigris and lead-tin yellow is bound with linseed oil; the paint has a particularly rich glossy surface which may be attributable to this choice of oil. The green glazes based on verdigris that occur over most of the landscapes have almost certainly discoloured to some extent. The short horizontal dashes of paint used to represent grass – a technique originating perhaps with Perugino but turned almost into a signature feature by this anonymous master – consist of verdigris in oil in *Marriage* and *Reunion* (PLATES 4, 9 and 14). They have probably darkened and so stand out against the lighter underpaint. In *Exile* the system is reversed with pale flecks containing mainly lead white scattered over the green and brown slopes (PLATE 18).

One area of landscape is painted with a completely different technique. The dark green grass

PLATE 11 *Marriage*. Cross-section of a sample from the dark green grass on the rocky outcrop in the left background, showing coarsely ground malachite in a matrix of discoloured binding medium. Photographed at a magnification of 500×. Actual magnification 440×.

PLATE 12 *Reunion*. Cross-section of a sample from the pinkish-red robe of the girl in the left foreground. The gesso ground is missing from the sample; the lowest brownish-black layer is the iron-gall ink underdrawing, which has cracked before the paint layers have been applied. An intense red kermes lake pigment can be seen in the paint layers. Photographed at a magnification of 500×. Actual magnification 440×.

of the rocky outcrop on which the Marchese is shown hunting in the left background of *Marriage* consists of a green-blue mixture of a coarsely ground malachite mineral pigment, bound not in oil but in egg tempera (PLATE 8). The common reaction between this copper-containing pigment and the egg medium has resulted in considerable discoloration – in paint samples the lighter green of the mineral is still apparent (PLATE 11). There is no obvious explanation as to why the grass in this area alone should have been painted with malachite in tempera (a rather old-fashioned technique by the late fifteenth century, but also found in the landscape of *Claudia Quinta* from the Virtuous Men and Women – see p. 37), but at least it demonstrates a consistent distinction between media, since any areas painted with the closely related blue pigment, azurite, are also bound in egg.[40]

Ultramarine was used with lead white for the skies and as a glaze to finish areas of dark blue such as the spandrels, the costumes and the striped hose of the servants wearing the Spannocchi livery, but the principal pigment for blue areas was azurite. It usually occurs in two layers, the first of finely ground pigment and the second of coarser and more intense colour. Often there is a considerable proportion of malachite present as well. The impurities present in the mineral azurite and malachite in the Griselda

panels have also been found in these pigments in other Sienese, Florentine and Umbrian paintings of this period, and it has been suggested that they were sourced from the copper and silver mines of Schwaz in the Tyrol.[41] No lead white was added to the upper layers and the pigment particles are exceptionally large; before the darkening of the egg medium the colour must have been rich and brilliant, especially in the large areas of blue on the vaults of the loggia in *Reunion*.

It might be thought that some of the other dark colours on the panels are the result of discoloration, but in fact several figures wear mantles and tunics painted with black pigment, often given a slight bluish cast by the addition of a little lead white; others are dressed in shades of maroon and purple, all based on mixtures of red lake, vermilion, ultramarine, black and lead white. A similar mixture, but with more white and a little yellow ochre, supplied the colour of Griselda's ragged peasant dress (PLATE 4). Together with the brown, white and steel grey of the horses, these more muted hues provide a foil for the brilliant reds that are distributed across the surfaces of all three panels.

Exile features only the warmer reds based on vermilion, mixed with a little red earth or red lead and often shaded with black pigment to give brownish shadows. The medium is probably oil. Bright vermilion reds appear on the other panels as well, but these panels also include draperies painted with a colder bluer red, for example the mantles worn by the Marchese and Griselda in *Marriage* (PLATE 9) and the pink dresses of the new bride (actually their daughter) and the girl in the left foreground of *Reunion* (PLATE 12). They are painted with a red lake prepared from kermes, the most expensive red dyestuff and in this instance probably extracted from clippings of silk textiles dyed with kermes.[42] The lake is of exceptional quality. The medium was found to be egg tempera, a surprising result since in Italian paintings of this period when both oil and tempera were often used on the same picture, oil is commonly found in areas of red lake even when the rest of the work was executed mainly in egg. The Griselda Master was perfectly capable of using oil, and the identification of powdered glass containing manganese in some of the other colours indicates that he knew about adding driers to assist the drying of the paint, especially important in the case of red lakes.[43] Therefore it seems that he chose to display the purity of the pigment by applying it in the less optically saturating medium of tempera.

Other instances of his selection of the egg medium for specific purposes include the fine white

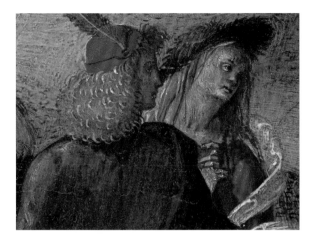

PLATE 13 *Marriage*. Detail of PLATE 1.

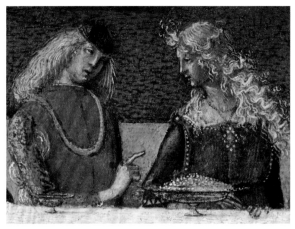

PLATE 14 *Reunion*. Detail of PLATE 3.

lines of the damask weave table-cloth in the wedding feast, even though the off-white base colour is in oil,[44] and the stone buildings in *Exile* where the surface is mottled with two tones of grey, the effect probably achieved by dabbing the paint on with a small sponge or something similar (PLATE 15). Magnification of the surface reveals minute craters formed by burst air bubbles in the paint. The tendency for egg-based paints to foam would be exacerbated by application with a sponge; craters can often be seen in the fictive coloured marbles that appear in many fifteenth-century Italian tempera paintings.[45]

The most unusual and perhaps significant use of the two media occurs in areas of flesh painting. In *Marriage* and *Reunion*, the heads and hands were first blocked in with the layer of green earth that is associated with traditional tempera painting (PLATES 13 and 14). Analysis has confirmed that it was applied in egg. Although it was becoming less common by the 1490s, green earth underpainting for flesh was still used by technically conservative painters in Siena, and also in certain Florentine and Umbrian workshops.[46] Over

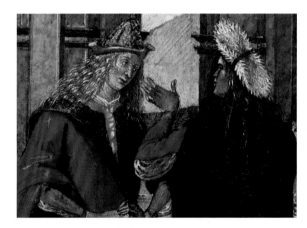

PLATE 15 *Exile*. Detail of PLATE 2.

this underlayer the Griselda Master began to model the hair and features, still in tempera, using thin and rather translucent strokes that allowed the green underlayer to remain visible. The flesh tones, for example on the cheek of the girl in profile who is a guest at the wedding feast, are a warm brownish pink, as are the lips (PLATE 17). On this figure, so close to the blond Sienese beauties painted by Neroccio de'

PLATE 16 *Exile*. Macrophotograph of the head of Griselda.

PLATE 17 *Reunion*. Macrophotograph of a wedding guest.

PLATE 18 *Exile*. Detail of PLATE 2.

of the formation of lead soaps in a drying oil, confirmed by analysis as walnut oil. On the girl in profile, only a few strokes of this paint are visible, for example under her eye and down the side of her nose, but most of the figures in *Reunion* and *Marriage* were extensively worked over with these flesh colours in oil. It is possible that the original intention was to paint all the heads and hands entirely in egg, but the fact that this dual use of egg and oil appears on both these panels, probably painted in sequence rather than simultaneously, suggests that it was a deliberate technique. Yet another indication that *Exile* was almost certainly the last to be painted is the presence of a thin wash of translucent yellow-brown as the underlayer instead of green earth (PLATES 15, 16 and 18). This is followed by a full modelling of the faces using the cool pink and white flesh tints with the greyish undertones to be seen in the final stages of the other panels. Under magnification the granular texture resulting from the formation of lead soaps is again apparent. It can also be seen how the modelling is more evenly blended, even on such small-scale figures, and how the mouths are picked out with touches of crimson.

In the course of painting these three panels, therefore, the anonymous master, who can be assumed to have been young and quick to learn, was still adapting and refining his technique as well as his figure style. As will be demonstrated, parallel changes, almost certainly interlinked with those in the panels from which he takes his name, occur in his contributions to the cycle of Virtuous Men and Woman.

The Virtuous Men and Women

The second sequence of secular panels (PLATES 19–26) associated with the Griselda Master, and similarly painted for a Sienese palace, has a more complex history.[47] It is generally agreed that, though divided since at least 1820,[48] the images of four men – *Alexander the Great*, *Joseph of Egypt* (also sometimes identified as *Eunostos of Tanagra*), *Scipio Africanus* and *Tiberius Gracchus* – and three or possibly four women – *Judith* (or *Tomyris, Queen of Scythia*), *Artemisia*, *Sulpitia* and *Claudia Quinta* – heroes and heroines of the ancient world, once formed a continuous sequence (the *Judith* panel discussed here, now in Bloomington, has not always been included in the series).[49] They depict classical (and it is generally thought two Old Testament) *exempla* posed on pedestals – some of which have since been cut off – as if they were polychrome statues (ones rather like Francesco di Giorgio's Bichi *Saint Christopher*) that had been brought to life. In the paintings that retain

Landi and Francesco di Giorgio, as well as on several of the other women in this panel, most of the white highlighting of their features and locks of rippling hair also has the appearance of tempera, the open brushwork a miniature version of the hatched technique to be seen on Francesco di Giorgio's *Scipio Africanus* (see PLATE 39).

Final touches, however, were added in paint of a different colour and have a distinct texture when seen under magnification. It is a cooler, almost grey pink, and is characterised by a gritty appearance, indicative

their fictive plinths, inscriptions supported by paired putti identify the subjects and give an account of the conjugal or, more broadly, familial virtues that lay behind their selection. Their landscape backgrounds contain episodes from the stories that had made them famous – amplifying the iconic figures by their exemplary narratives – and most of them, like saints, hold attributes essential to their stories. It is now almost unanimously agreed that four of these seven panels were executed in their entirety by the Griselda Master.[50] Two of them are clearly identified: *Alexander the Great*, now in Birmingham, and *Tiberius Gracchus*, now in Budapest. Alexander was selected for his magnanimous (and chaste) behaviour towards the women of the family of the defeated Darius. His type is close to the Alexander and Julius Caesar in the Ghirlandaio workshop paintings at Longleat (see pp. 6–7). However, his stance is most like that (reversed) of Publius Scipio in Perugino's Collegio del Cambio series of Famous Men painted in *c*.1498–9, although Perugino's painting almost certainly postdates the Griselda Master's panel, so it may be that Perugino had the chance to see this work by a lesser known painter or that the Griselda Master had the opportunity to study Perugino's preliminary drawings (or indeed that they had a common source, probably in Donatello's celebrated bronze *David*).[51] The proportions and draperies of the background figures suggest that the stylistic trajectory started by the three Griselda panels has been continued and that the *Alexander* panel should be dated at the same moment as, or slightly after, *Exile*.

The inclusion of *Tiberius Gracchus* was prompted by the story recounted by Plutarch and Valerius Maximus. Tiberius was said to have been particularly devoted to his wife, the virtuous Cornelia, daughter of Scipio Africanus. When a pair of snakes was found in their bedchamber, soothsayers advised that he should neither kill them both nor let them both escape, adding that if the male serpent were killed Tiberius would die, and if the female, Cornelia. Tiberius chose to dispose of the male snake, and let the female escape; and, just as predicted, he expired soon after, leaving behind his 'constant and noble-spirited' widow. In pose, he has much in common with Signorelli's Saint Catherine of Alexandria (reversed), once again from the Bichi Altarpiece.

The two other pictures by the Griselda Master are now lacking their fictive plinths and inscriptions. The third figure painted by him, in Washington, has been variously identified – first tentatively as Joseph of Egypt,[52] then more firmly as Eunostos of Tanagra,[53] and recently, as Joseph again.[54] It will be suggested

below that this latter identification should still be treated as uncertain, and that the former theory may have more merit than is now usually supposed; for the sake of convenience, however, this picture will here be called *Joseph*, the title by which it is best known today. Of the Griselda Master's works, this picture is the most indebted to Perugino. Although the stress on contour is alien to Perugino, Joseph's facial type, with his rounded, rosy cheeks, is close, for example, to the kneeling Saint John the Evangelist in Perugino's Uffizi *Pietà*.[55] His pose, moreover, reverses almost exactly that of Cato in the Collegio del Cambio, though here again the relative priority is difficult to determine. As will be demonstrated, *Joseph* seems to be the earliest of the paintings in the series for which the Griselda Master had full responsibility. The young man fleeing the embraces of the would-be seductress on the right repeats the turned-back pose employed by Francesco di Giorgio in his Uffizi drawing of Hippo.[56] The drapery arabesques, stiff-kneed figures and landscape are still close to those in *Exile* and even in *Marriage*.

The image of a virtuous woman painted by the Griselda Master – the painting now in Milan – can almost certainly be identified as Artemisia by the chalice she carries, containing the ashes of her dead husband Mausolus mixed with her tears, and by the unfinished mausoleum (incomplete at her death) under construction in the background. In the scene on the right Artemisia leans towards a woman dressed in pink and white, with another woman in attendance. On close examination (see PLATE 69) she can be seen to be weeping into the cup containing her dead husband's ashes; the ladies with her are perhaps maidservants, one in a pose which seems to denote suffering.[57] Whereas Perugino may have been the primary inspiration behind Joseph, here the Griselda Master in pursuit of greater naturalism, has once again turned first to Signorelli. As has often been remarked, Artemisia's pose and gestures are taken from Signorelli's Bichi Magdalen. So too is the strong shadow on her left wrist. That is not to say that the impact of Perugino has significantly diminished. Her face is far removed from those of Signorelli's heavy-jawed maidens and is much closer to Virgins by both Pintoricchio and Perugino; a good comparison can be found in Perugino's *Madonna del sacco* in the Uffizi of the mid-1490s.[58] The figures in the background of *Artemisia* have become weightier, the draperies entirely free of the frills and furbelows that have become so familiar. The landscape, without the Master's system of little dashes, is the part that has perhaps changed most, and the bushes with their

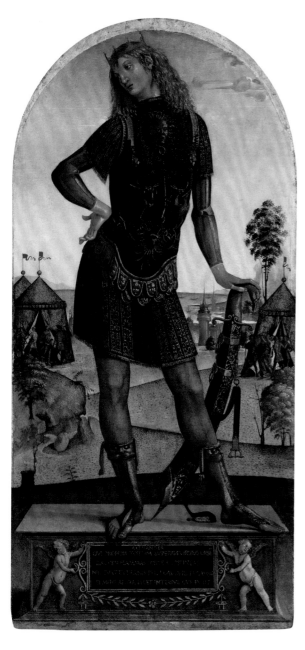

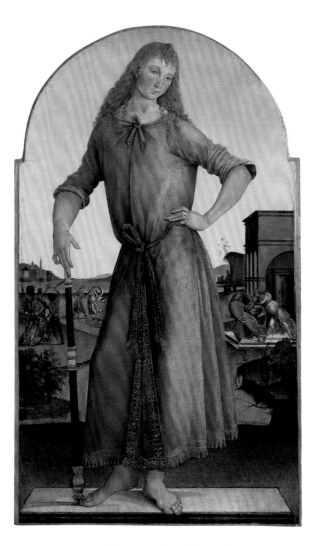

PLATE 20 Master of the Story of Griselda, *Joseph of Egypt* or
Eunostos of Tanagra, c. 1493–4. Canvas (transferred from panel),
85.5 × 52 cm. Washington, DC, National Gallery of Art.
Samuel H. Kress Collection, INV. 1952.5.2.

PLATE 19 Master of the Story of Griselda, *Alexander the
Great, c.* 1493–4. Poplar, 106 × 51.3 cm. Birmingham, The
Barber Institute of Fine Arts, The University of Birmingham,
INV. 51.4.

sparkling highlights and the bluer overall tonality
seem closer to those in the Perugino *Madonna*
mentioned above.

The other three panels (PLATES 21, 25, 26) that
retain their inscriptions have been attributed, though
by no means straightforwardly, to three other painters.
The *Scipio Africanus* (PLATE 21) has an especially knotty
attributional history. The background illustrates the
legendary tale of Scipio's magnanimity – when he
allows the Carthaginian maiden Lucretia, whom he
had been given as a prize of war, to marry her

betrothed, the prince Aluceius. Critics are agreed that
this panel derives from the workshop of Francesco di
Giorgio, from around the time he was employed in
the Bichi Chapel (his grisaille frescoes were certainly
finished by 1494). In recent years, however, it has been
argued that the figure of Scipio himself was executed
by an assistant, sometimes identified as the so-called
'Fiduciario di Francesco', rather than by Francesco di
Giorgio himself.[59] This theory has led Kanter to
suggest that this was the same assistant, to be identi-
fied as Lodovico Scotti, who (with Bernardino
Fungai) worked up Francesco's designs for the
Tancredi Altarpiece in San Domenico in Siena.[60]
Most scholars, however, have realised that, whether or
not the main figure can be considered autograph, the
plinth with its putti and the background with the tale

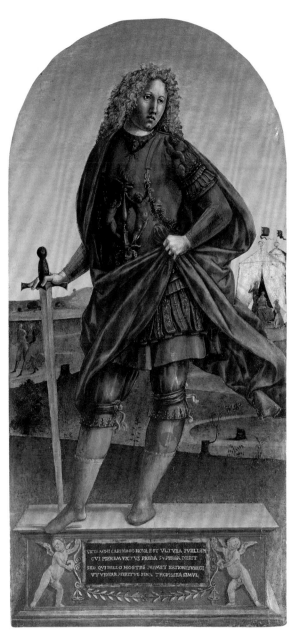

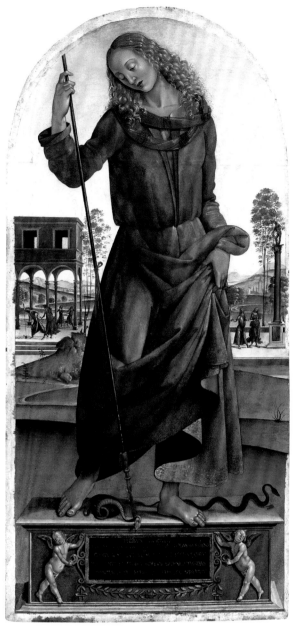

PLATE 21 Francesco di Giorgio and the Master of the Story of Griselda, *Scipio Africanus*, c. 1493–4. Poplar, 104.6 × 51 cm. Florence, Museo Nazionale del Bargello, INV. 2023 CARRAND.

PLATE 22 Master of the Story of Griselda, *Tiberius Gracchus*, c. 1493–4. Poplar, 107.2 × 51.2 cm. Budapest, Szépmüvészeti Múzeum, INV. 64.

of Scipio's magnanimity are by another hand, almost always agreed to be that of the Griselda Master.[61]

No such uncertainty is attached to the attribution of the Washington painting of Claudia Quinta (PLATE 26, p. 23), or her plinth, both painted by Neroccio de' Landi.[62] Coor reasonably suggests a date of 'in or about 1494', and Boskovits persuasively argues that the picture 'is from a stylistic point of view closer to the panel of Montepescini of 1492 (Pinacoteca Nazionale, Siena) than to the Montisi altarpiece of 1496'.[63] Claudia's figure is large in scale compared to

the other heroines, with Neroccio creating spatial uncertainty – further confusing the distinction between painted image and living heroine – by having her step forward beyond the front edge of the plinth, almost as if he had not anticipated including it. The sway of her figure is gentler than those by the Griselda Master, her grace relying on her flowing blond locks and elegantly elongated fingers. Her costume seems closer to contemporary fashions than those worn by the others in the series. Claudia Quinta proved her chastity, that (because of her generously

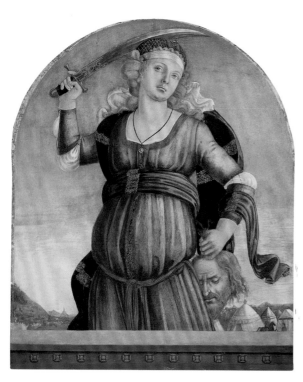

PLATE 23 Matteo di Giovanni, *Judith with the Head of Holofernes* or *Tomyris of Scythia*, *c.*1493–4. Poplar, 56 × 46.1 cm (height includes 7 cm false extension at lower edge). Bloomington, Indiana University Art Museum. Samuel H. Kress Study Collection, INV. 62.163.

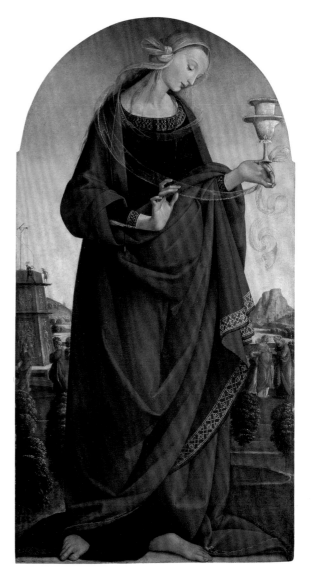

PLATE 24 Master of the Story of Griselda, *Artemisia*, *c.*1493–4. Poplar, 87.5 × 46 cm (not including added strip at lower edge). Milan, Museo Poldi Pezzoli, INV. 1126.

applied make-up and, tellingly, sumptuous dress) had been doubted, by pulling to shore a heavy ship with the statue of Cybele, 'the mother of the gods', after all the strapping male youth of Rome had failed, simply by tethering it to her sash (Ovid, *Fasti*, 315–48; Boccaccio, LXXVII). Neroccio had been Francesco di Giorgio's partner from *c.* 1468 to 1475 and their partnership had perhaps been temporarily revived for this project. Although there is critical unanimity as to the autograph status of the main figure, the authorship of the landscape and background figures is subject to dispute.[64] Despite its manifest dissimilarity to Neroccio's own landscapes (which feature only rarely in his works, but which are seen in the predella scenes with the story of Saint Benedict in the Uffizi perhaps from 1481, the female portrait in Washington from his mid-career, and – a tiny area – in the late *Virgin and Child with Saints John the Baptist and Andrew* in the Pinacoteca Nazionale, Siena[65]), Kanter believes that the whole painting was executed by Neroccio working alone, contradicting the long-held view that here too the Griselda Master was involved. This proposition will be tested below. Nevertheless, remembering the example of the Montefollonico *Virgin and Child* relief (see p. 8), it might provisionally be proposed that the Griselda Master's first involvement with the

Virtuous Men and Women series was as a background painter for Francesco (and also for his erstwhile partner), painting the landscapes and narratives in the pictures of *Scipio Africanus* and *Claudia Quinta*.[66]

The *Sulpitia* in Baltimore (PLATE 25) was for many years attributed to Giacomo Pacchiarotto, until Angelini's momentous discovery that many paintings, such as this one, traditionally considered to belong to Pacchiarotto's early career should properly be attributed to Pietro Orioli.[67] Sulpitia, the wife of Fulvius Flaccus, was an unusual subject, chosen for the series because she herself had been selected as the 'chastest of the enormous number of women abounding in Rome at that time' to dedicate (according to Valerius

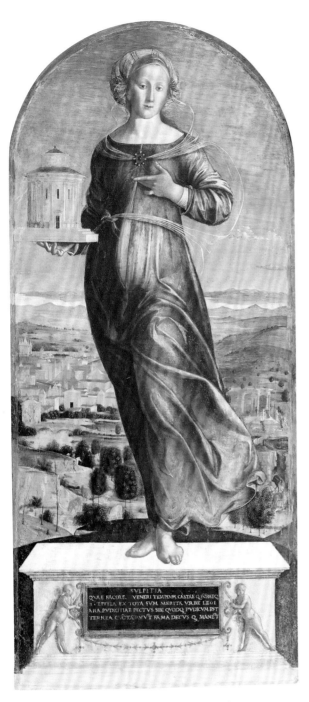

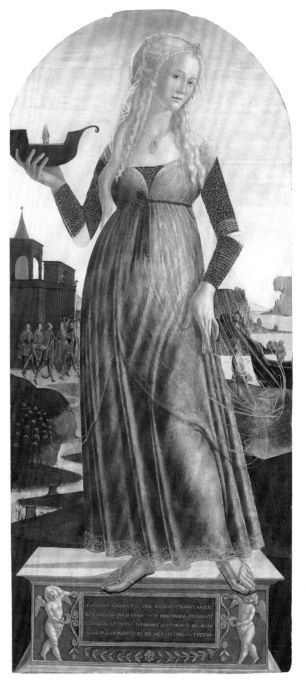

PLATE 25 Pietro Orioli, *Sulpitia*, *c.* 1493–4. Poplar, 105.8 × 47.7 cm (measurements are without added edge strips). Baltimore, The Walters Art Museum, INV. 37.616.

PLATE 26 Neroccio de' Landi and the Master of the Story of Griselda, *Claudia Quinta*, *c.* 1493–4. Poplar, 104 × 46 cm (trimmed slightly at left edge); panel 3.5 cm thick, width of painted area 45.2 cm. Washington, DC, National Gallery of Art. Andrew W. Mellon Collection, INV. 1937.1.12.

Maximus and Boccaccio, *Famous Women*, chapter LXVII) a statue and also (according to Ovid and Petrarch) a temple to Venus Verticordia.[68] Orioli was one of the most celebrated painters then working in Siena, whose premature death was an occasion of public mourning; his reputation there may be enough to explain his participation if one of the aims of the project was to demonstrate the individual talents of Sienese painters. However, it is worth pointing out that a connection with Francesco di Giorgio is established by Orioli's subsidiary role in painting the grisaille frescoes in the Bichi Chapel.[69]

The inclusion of a fourth image of a woman (therefore an eighth panel) by yet another artist,

Matteo di Giovanni, usually identified as the Old Testament heroine Judith, now in Bloomington, Indiana (PLATE 23), has sometimes been queried.[70] Although he included the panel, its cut-down state was misunderstood by Gilbert – he thought the now half-length image complete, made as an overdoor.[71] Doubts have also been also expressed as to what kind of message the redoubtable but not primarily conjugal Judith might bear within the series.[72] Nonetheless, her putative presence has been thought to support the identification of the figure in the Griselda Master's Washington picture as Joseph of Egypt, assumed to be her Old Testament pair. Much serious work has been undertaken by scholars, led by Caciorgna, on the literary sources for these panels, and it has been shown that, while ancient texts were certainly consulted, in particular Valerius Maximus, later mentions and accounts by Boccaccio and Petrarch[73] are likely to have been equally influential. However, no serious attempt has hitherto been made to reconstruct the sequence of these panels, although an assumption that they were arranged as four couples, a heroine for each hero (an ideal bride for every groom, as it were), seems to have underlain their discussion (and usually their illustration).[74] Thus it has been assumed that we have one Old Testament pair, one ancient Greek pair and two Roman couples (or sometimes other combinations). However, Jon Caseley has suggested Tomyris, Queen of Scythia, as an alternative identification to Judith. Tomyris' virtue lay in her bloody revenge of her son's death at the hands of Cyrus, king of Persia. This unnamed youth had been tricked into a drunken stupor in Cyrus's temporarily abandoned encampment, then slaughtered in his sleep. After defeating the Persian king in her turn, Tomyris sought out Cyrus's corpse on the battlefield and had him posthumously decapitated.[75]

The date and patron of the Virtuous Men and Women are not known. The presence of what seem to be Piccolomini gilded crescents on the plinths has been much stressed.[76] Tátrai thought the series a part of the same Spannocchi commission as the Griselda panels (and, as we now know, the Ghirlandaio shop paintings of Alexander and Julius Caesar), and the inclusion of Piccolimini heraldry would not contradict this theory. The setting-up of the images of four famous men-of-arms on the ceremonial triumphal arch might further support his idea. It would perhaps have been odd to have repeated the story of Alexander (though, given that there were two brothers, the pictures may have been included in different suites) and there is no sign in any of the scenes of the colours associated with the Spannocchi. There are,

however, some coincidences of condition between both sets of panels that might suggest that later on, if not originally, they shared a common provenance (see p. 58). Bartalini has argued instead that they were made as part of the preparations for the marriage between Silvio di Bartolomeo Piccolomini and Battista Placidi of 18 January 1493, the year before the double Spannocchi nuptials.[77] The Griselda Master's initial subordinate role in the Virtuous Men and Women group might support this date, but the stylistic considerations outlined above and the technical data to follow suggests that, if this was the event that inspired the commission, its completion must have been delayed.[78]

There has been no accord as to how this commission was managed. It has sometimes been suggested that it was first given to Signorelli, who delegated it to an assistant (the Griselda Master), and that the other artists were brought in only afterwards.[79] Here, however, we will propose that it was Francesco di Giorgio who is most likely to have had overall control at the outset, even if one of the initial aims of the project may have been to obtain specimens of the work of all of Siena's leading painters (as they had already been represented, for example, in their designs for Sibyls – rather equivalent figures – on the floor of the Duomo). The length of time it took to complete the series has been similarly much debated. Some critics state that the commission had to be rushed through in time for a wedding, the several painters joining together for the sake of expediency; others argue that the production of the panels was more prolonged.[80] Secure *termini ante quem* for some of the pictures are provided by the death dates of those painters whose names are known: Matteo di Giovanni in 1495, Orioli in 1496, Neroccio in 1500 and Francesco di Giorgio in 1501. Kanter has even entertained a theory whereby the division of labour can be explained by the successive deaths of these masters, one painter taking over the commission from another.[81] However, the chronology of the series is best established by thorough examination of the panels and their mode of preparation, by their stylistic and technical relationships with one another, and by, in the cases of the panels executed wholly or in part by the Griselda Master, their stylistic affinities with each of the National Gallery Griselda panels. In the absence of any secure evidence regarding the exact circumstances of the commission, it is on these last factors that the sequential dating of the project's realisation primarily depends.

The panels: structure and original order

Of the eight panels, only three, *Alexander the Great*, *Scipio Africanus* and *Tiberius Gracchus* are uncut and of their original thickness. Among the women, *Claudia Quinta* is trimmed a little along the left edge, but the panel has not been thinned; nor has that of *Artemisia*, although the latter has been cut at the bottom, losing the pedestal and inscription, while the arch has been truncated and slightly reshaped and pieces of wood added to make up spandrels. The panel of *Sulpitia* has been trimmed marginally and fillets of wood added around all the edges; in addition, it has been planed down to a thickness of 2.1 cm and three inset horizontal battens fitted. The most drastically altered supports are those of *Joseph of Egypt*, cut at the bottom and transferred from the original wood to canvas, and *Judith*, which has been reduced to less than half its original height, a new piece of wood added at the bottom for the painted parapet, and the whole structure thinned to one cm and fitted with a cradle (see Appendix for conservation history, p. 70). In spite of these mutilations, a careful examination of all eight panels has supplied enough information for a proposal as to their original order (thereby clarifying the identity of two of the figures), as well as suggestions as to how they may originally have been framed and displayed.

Each figure was painted on a panel consisting of a single vertical board of poplar. The boards that have escaped thinning are between 3 and 3.75 cm thick, and so are substantial relative to the dimensions of the panels.[82] The timber is of good quality, tangentially sawn like all poplar planks but, on the evidence of the unaltered panels, cut from close to the heart of the log so as to reduce the potential for warping.[83] If, as seems likely, all the panels were made of planks of this cut, this was an extravagant use of timber since only two boards could be cut from each length of trunk. Certainly the intact panels are in very stable condition with only the slightest of warps.

The wood includes some small knots, but, unlike those in the panels for the *Story of Patient Griselda*, they were not filled by the carpenter.[84] Horizontal marks made by the chisels used to level the backs of the planks can be seen on *Alexander*, *Tiberius*, *Artemisia* and *Claudia Quinta*, but the panel for *Scipio* (PLATE 27) has a notably smoother finish. The horizontal line scored across the upper part of this panel, immediately below the row of three gouged-out areas (PLATE 28), continues around its sides.[85] Since the incision coincides exactly with the diameter of the circle of the arch, it was probably made to guide the carpenter in cutting out the arch. Starting at the corners of the

PLATE 27 *Scipio Africanus*. Back.

PLATE 28 *Scipio Africanus*. Detail of back.

rectangular piece of wood (indeed the top of the arch is slightly flattened, confirming that this was the upper edge of the plank[86]), the carpenter gradually chiselled away the wood to obtain the arch, the incision at the side ensuring that he did not carve wood from below the spring of the arch. On this panel and that for *Tiberius*, the faceted edges that result from this way of cutting arches are particularly evident (PLATES 29 and 30). Once this prototype had been made, the other panels could be shaped to the same pattern. Confirmation that the arched shape is original and not a later alteration is supplied by the dribbles of gesso which have run down the edges both around the arches and along the straight edges of the uncut panels (PLATES 31 and 32).

This laborious cutting of the arches would not have been undertaken if the frames were of tabernacle construction with an entablature, since rectangular panels could then be used and the corners framed out with spandrels. The upper mouldings of the frames must therefore have had an arched profile. It is most unlikely that these relatively small panels were framed individually, and so, on the evidence of three similar-sized *Chaste Women* attributed to Cozzarelli, and still in their original frame (private collection, Siena), and also a later Sienese frescoed grisaille cycle of Famous

Men and Women by Vincenzo Tamagni at Montalcino,[87] it seems likely that they were framed together in some way, rather as if they were a secular altarpiece. However, this does not necessarily mean that they were all completed at the same time; rather the evidence points to their having been delivered one by one, and framed only afterwards, once all were painted.[88]

The first clue as to how they were grouped comes from the fact that the panels for the Women are all slightly narrower. Although they have been more affected than those for the Men by cutting and alterations the crucial measurement, that between vertical lines incised into the gesso a centimetre or so in from each edge to denote the areas that were to be covered by the sides of the frames, has survived, and shows that the width of the painted area was between 45.4 and 46.3 cm on all four. The uncut panels for the Men average at 51 cm wide with a distance between incisions of 49.2 and 50 cm (none is absolutely parallel). Given this disparity in width, it is difficult to envisage a frame design in which the Men and Women could have alternated, either as pairs or in a long row. Equally unlikely are triptychs with one wider male figure and narrower females on either side, in which case four panels would be missing. The Men, there-

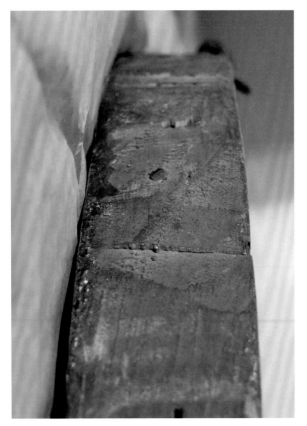

PLATES 29 AND 30 *Scipio Africanus* and *Tiberius Gracchus*. Details showing tool marks on the sides of the arches.

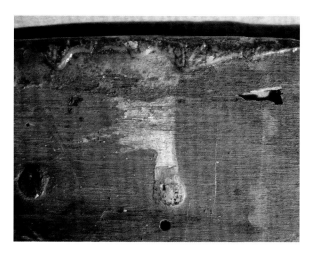 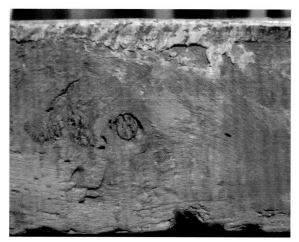

PLATES 31 AND 32 *Scipio Africanus* and *Tiberius Gracchus*. Details showing dribbles of gesso on the sides of the panels.

fore, were in one group and the Women in another (appropriately, for exemplars of continence); the panels for the Women are narrower probably because the space into which they were to be fitted was slightly smaller.

Throughout the process of design and execution, *Scipio* seems to have been the test panel on which the model for the rest of the series was to be based, and some details of the framing seem to have been worked out only once there had been considerable progress in the painting of this panel. At the upper left edge, just below the spring of the arch, are two sets of curves, apparently scored into the wet paint of the sky rather than into the gesso and using a relatively blunt-ended tool, perhaps the end of the brush (PLATE 33).[89] These appear to be trial profiles to determine how much of the picture surface would be covered by projecting elements of the frame pilasters. The slightly higher profile, with a cornice and then a second projection for a moulding below, is the one that was adopted, and was scored using a similarly blunt tool into the gesso of the panel used for *Sulpitia* for example (PLATE 34). There seems to have been some uncertainty, however, since the other more curving profile was incised with a sharper point into the gesso of *Claudia Quinta* (FIG. 9). It is just possible that the first profile to be drawn was that on *Claudia Quinta* and the revision was made on *Scipio*, but since the latter appearss always to have been the trial panel this seems less likely. The best indication of the profile eventually selected appears in the X-radiograph of *Judith* (FIG. 10), where, in addition to the incisions, the areas to be covered by the frame were left in reserve when painting the sky. Similar reserved areas (slightly inside the incisions) appear in the X-radiograph of *Joseph* (FIG. 11), although not in the other three panels painted

entirely by the Griselda Master. In these the frame projections were either sharply incised, as in the case of *Artemisia*, or summarily indicated in iron-gall ink and the areas covered with the paint of the sky, as in *Alexander the Great* and *Tiberius Gracchus*. In addition, on these two panels there are arcs incised approximately 2.5 cm below the arched tops of the panels, with the gesso above left unpainted since it was to be covered by the frames. These arcs also appear (sometimes only as fragmentary traces as a result of later alterations to the panels) on *Joseph*, *Judith*, *Artemisia*, *Sulpitia* and *Claudia Quinta*.[90] There is no incised arc, however, on *Scipio*, and the paint of the sky seems to have extended to the edge of the panel all around the arch (the gesso has flaked from the very top, and the area is now filled and retouched); this is further evidence in support of the argument that the latter was painted before the details of the frame had been resolved.

All eight panels, even those much altered by later cutting and radical conservation treatments, have evidence of the attachment of two horizontal cross battens (PLATE 27). Most unusually, they were nailed to the backs of the panels from behind. In the fourteenth and early fifteenth centuries, when it was still common practice to fix battens to panels with nails, the battens were usually attached by hammering the nails through from the fronts of the panels before the application of gesso, gilding and paint layers – even when the battens are long gone, the heads of the nails remain visible in X-radiographs. The fitting of battens in advance avoided the risk of damage to the paintings. By the late fifteenth century, however, in Siena as in Florence, it was no longer usual practice to fix battens with nails. Instead they were inset into channels with dove-tail profiles (as in the case of the

(left) PLATE 33 *Scipio Africanus*, detail of PLATE 21. Raking-light detail showing capital incisions in wet paint.
(centre) PLATE 34 *Sulpitia*, detail of PLATE 25, showing capital incision in gesso.
(right) FIG. 9 *Claudia Quinta*. X-ray detail.

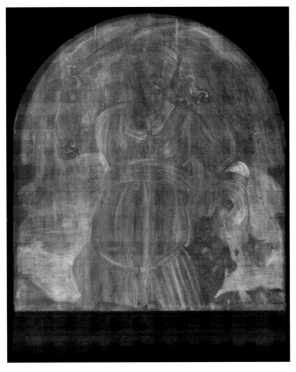

FIG. 10 *Judith* or *Tomyris of Scythia*. X-radiograph.

bly the first marks were caused by attempts to lever off the battens, gouging holes in the wood.[92] Once the battens were removed it was possible in some cases to pull out the protruding nails or to cut them level with the back of the panel, but more often the gouges were enlarged and the remnants of the nails bent back into them. The nails have the square profiles characteristic of hand-beaten nails and the heads of two of them are still present in the panel for *Artemisia* (PLATE 35); they originally projected by at least 2.5 cm and so the battens must have been of this depth. Their width can be determined by the lighter areas, about 7–8 cm wide, to be seen on some of the panels. Traces of glue and horizontal splinters from the battens on *Scipio* and *Alexander* indicate that they were glued as well as nailed, again an unorthodox practice in the construction of panels for altarpieces.

Furthermore, it can be demonstrated that the painted panels were in fact damaged by the fitting of the battens. In most of the X-radiographs (FIGS 12–15) sections of the pointed ends of the nails are visible; the point of the upper left nail in the panel of *Scipio*, however, has clearly bent over. Once a nail has bent in this way it cannot continue to penetrate the wood from behind and so this would normally be taken as evidence that the battens were fitted first, on the assumption that the nail came through the front face of the panel and was hammered flat before the application of the gesso. In this instance the point must have come through the front of the panel but only after it had been painted, causing the area of damage visible on the surface and subsequently restored (PLATE 36). Similar raised lumps and areas of damage appear on some of the other panels where the nails have been hammered in too far, notably on *Alexander* (PLATE 37); here two large splinters of wood have been pushed up above and below the emerging point of the nail.

If the battens were not attached by the skilled craftsman who carpentered the panels, then questions

FIG. 11 *Joseph of Egypt* or *Eunostos of Tanagra*. X-ray detail.

Griselda panels), or they ran through rows of *ponticelli* (little bridges), carved wooden loops attached to the backs of panels.[91] Both were systems that allowed a degree of flexibility in the structure provided that the battens were not too heavy and rigid.

The oblong chiselled depressions in the backs of the unthinned panels (PLATE 28) were made during eventual removal of the battens, almost certainly when the paintings were split up and dispersed. Most proba-

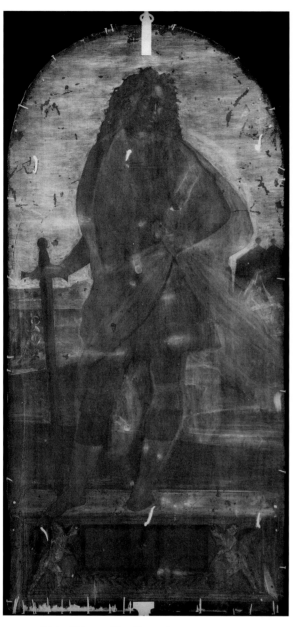

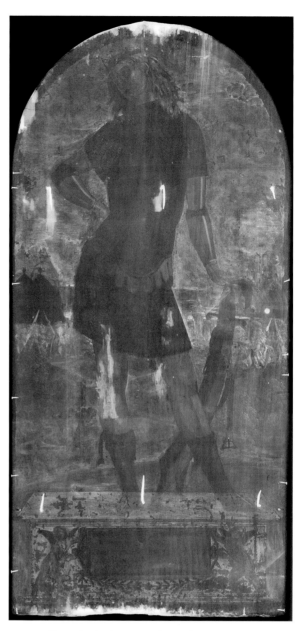

FIG. 12 *Scipio Africanus*. X-radiograph.

FIG. 13 *Alexander the Great*. X-radiograph.

arise as to when and why they were fitted and who was responsible. The manufacture of the nails and other pieces of evidence such as the lighter marks left by the removal of the battens indicate that they were very old and probably 'original' to the complete structures of panels and frames. Given the considerable thickness and relatively small dimensions of the panels themselves, there was no need to add battens to restrain them from warping. It is likely, therefore, that they were associated with the fitting of the completed panels in their frames and that, given the crude method of attachment, this task was assigned to the frame maker or another carpenter. If the groups of panels were arranged like those of a polyptych, the use of continuous battens nailed to both frame and

(left) PLATE 35 *Artemisia*. Detail of nail from batten.
PLATES 36 (centre) AND 37 (right) *Scipio Africanus* and *Alexander the Great*. Details of surface disruption caused by nails from battens.

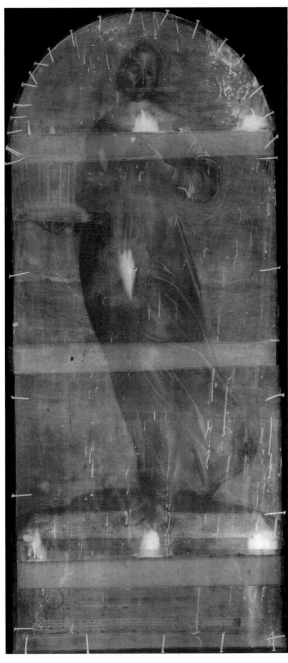

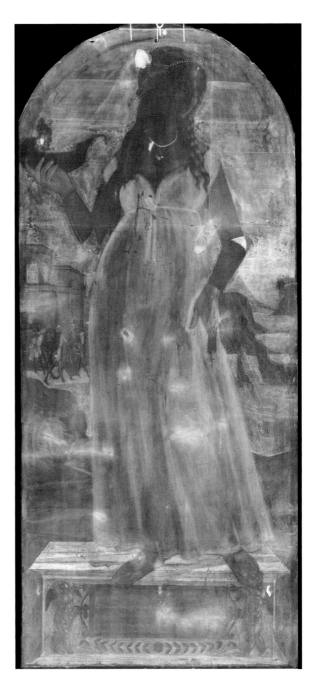

FIG. 14 *Sulpitia*. X-radiograph.

FIG. 15 *Claudia Quinta*. X-radiograph.

panel might improve the stability of the whole piece of furniture (which is how it should be considered). This might have been particularly necessary in this case because a row of arched tops would not have had the structural rigidity of a rectangular top with an entablature as in the three *Chaste Women*.[93] Moreover, the panels for the Virtuous Men and Women are remarkably heavy for their size because of the unusually dense poplar employed in their construction.

That common battens were indeed used is suggested by the fact that the nail holes in all four panels for the Women are at the same height. The lack of a nail hole at the left end of *Judith* might even indi-

cate that the upper batten was slightly too short, and so did not extend to the very edge of the construction (assuming that this panel was on the far left); it is equally possible that a shorter nail was used (the panel is no longer of its full thickness) or that the carpenter omitted to insert a nail at this point, fixing the end of the batten into the frame alone. Of the panels for the Men, those for *Scipio* and *Tiberius Gracchus* had battens at the same level as the Women; on *Alexander* and *Joseph*, however, the upper batten was positioned slightly lower and the lower one a little higher. When the battens came to be removed the gouge marks on *Alexander* (and also the damage on *Joseph*[94]) indicate

FIG. 16 *Alexander the Great*. Infrared reflectogram mosaic detail of inscription on reverse.

PLATE 38 *Tiberius Gracchus*. Detail of inscription on reverse.

that both battens were levered up from below, whereas on the others the upper batten was approached from above, and the lower from below. The Men, therefore, may have been framed as two pairs, perhaps because they were divided by an architectural feature; alternatively, there was insufficient timber of suitable length and so the Men were fitted with two sets of shorter battens. Indeed the upper batten from *Scipio* and *Tiberius* may have extended some way into the next panel, explaining the need for the upper batten of the first pair to be levered off from below since access from above was blocked by the overlapping length of wood.

Confirmation that the panels were divided by the sex of the subjects represented, and almost certainly in groups of four, is the discovery of indications as to their probable original order painted on the backs of some of them in large letters and in a hand probably of the late eighteenth or early nineteenth century,[95] that is, shortly before they are likely to have been dispersed. It cannot be excluded that they had been taken out of their frames and reordered before they were numbered, but, if they were fixed in the secure way suggested by the nails and battens, it was probably not considered worthwhile to dismantle the structure until each painting came to be perceived as having an individual value, most probably in the early nineteenth century.

Of the heroes, the panels with numbers are *Alexander*, where the word 'primo' is clearly legible in infrared (FIG. 16), *Scipio*, which has traces of the word 'terzo', now difficult to read even with infrared reflectography because of water runs down the back of the panel,[96] and *Tiberius Gracchus*, numbered as 'quarto' and legible with the naked eye because of the clean state of the wood (PLATE 38). The transferred Washington panel would, therefore, be second. This order seems to have been dictated by the historical chronology of the figures, the Greek Alexander first, Scipio third, quite correctly followed by his son-in-law, Tiberius Gracchus. Although we cannot be sure that painters and patron were consistent in their adherence to a chronological sequence, this may make the identification of the second figure with Joseph less

likely, since in most chronologies adopted in the fifteenth century, Joseph was supposed to have lived very much earlier than Alexander the Great,[97] and so a panel which represented him is more likely to have been placed first. The identification of the figure as Eunostos of Tanagra, who as a Greek might have been temporally associated with Alexander, is therefore worth revisiting. Caciorgna argues that the three episodes represent the wife of Potiphar's first amorous approaches to Joseph (centre left), her second more violent attempt to seduce him when she grabbed his cloak (right) and his subsequent (cloakless) arrest (left), as laid out in Genesis 39.[98] This interpretation seems at first sight to be correct, but the events can also be made to fit Eunostos' story, especially since, in the absence of an established iconography, the painter may have amplified the short account in Plutarch's *Moralia* by reference to the better known Joseph legend, which had already been painted in Siena. As Parri proposed, the first scene (which does not appear in Plutarch) would represent a first encounter between Eunostos and his cousin Ochne (centre left), with Ochne's failed seduction of Eunostos on the right, while, on the far left, he is ambushed and killed by her three brothers, Echemus, Leon and Bucolos.[99] Although explained by Caciorgna as merely a menacing gesture, the murderously raised sword of one of these heavily armed figures, whose number may be significant, might be thought excessive if this were merely the arrest of the unarmed servant Joseph. The question should remain open.

Of the Women, there may be traces of a reverse inscription on *Artemisia*, now sadly illegible even in infrared, since a more recent label has been glued over part of it, and possibly similar inscription remnants, seen in an equivalent position, on the *Claudia Quinta*, but these too are quite unreadable.[100] Since Artemisia, Sulpitia and Claudia Quinta all appear in Boccaccio's compendium of Famous Women, *De mulieribus claris*, and in that order, the identification of the Bloomington panel with Tomyris of Scythia, who also appears in Boccaccio's book (chapter XLIX), and preceding Artemisia (chapter LVII), becomes more possible.[101] This theory would supply two heroines

from Greek antiquity and two from Roman history to match the two pairs of men. Moreover, Tomyris, as the conqueror of a Persian army, would have made an appropriate counterpart to Alexander and, given her maternal role, might also be thought more suitable than Judith. In this order, the poses of the putti on the pedestals of both Men and Women, or at least on those that survive, alternate between having legs open or crossed. There may even be a pattern in the cutting of panels: marked damp stains are visible at the lower edges of *Alexander* and *Scipio* and it is possible that the panel between them, *Joseph* or *Eunostos*, was so badly affected by damp and rot that the pedestal was cut away. Similarly with the Women, the most cut panel, *Judith* or *Tomyris* (whose left end position has already been indicated by the absence of a nail hole on the left), is next to one that has lost its pedestal, *Artemisia*. The Women, however, are unlikely to have been on an opposite wall to the Men, since then their order would have to be reversed so that Tomyris, if it is she, could face Alexander and so on. Instead they should probably be imagined as being placed above cupboards or other large pieces of furniture, either on the same wall as the Men and perhaps divided from them by a door or chimney-piece, or at right angles to one another.

Technique, attribution and collaboration

Although there is general agreement as to the identity of the five painters who worked on the Virtuous Men and Women, we have already seen that opinions diverge as to the reasons for the collaboration, the timescale of the project, and the precise division of labour. So as to gain a better understanding of the possible sequence of execution, detailed technical examinations have been made of the panels. Methods employed have included infrared reflectography of all eight, X-radiography of all but one (*Tiberius Gracchus*) and the taking of paint samples for analysis from *Alexander the Great* and the four panels in collections in the United States, which were brought together for examination at the National Gallery of Art, Washington.[102] Many of these samples have been mounted as cross-sections for the investigation of layer structures; pigments have been identified by microscopy, supplemented by EDX analysis in the scanning electron microscope; sources of red lake dyestuffs established by HPLC; and binding media investigated by FTIR, GC–MS and histological staining of cross-sections.[103]

In the following discussion the eight panels have been divided into three groups: the first consists of the two panels in which the main figures were painted by Francesco di Giorgio[104] and Neroccio de' Landi, and the landscapes and small figures by another artist, here identified as the painter of the Griselda panels; the second is made up of the four panels executed entirely by the Griselda Master; and the final two panels are those painted by Pietro Orioli and Matteo di Giovanni, who may have worked more independently from the other painters.

Scipio Africanus

The argument presented in the previous section that *Scipio Africanus* (PLATE 21) was a prototype for the others extends to the underdrawing and painting of the picture. Infrared reflectography reveals that the main figure was drawn on the panel with a technique of astonishing boldness (FIG. 17). Using a brush and liquid black ink or paint the artist established the figure's contours with a heavy fluid line, the control and confidence most evident around his calves and feet, and on the arm and hand holding the sword (although here some of the black lines are in the upper paint layers). The features were drawn with a similar heavy line, the nose slightly shorter than in the final painting and the upper lip fuller and a little higher. His writhing curls were indicated with rapid squiggles of the brush, which at his hairline stand up stiffly in the shape of a lyre. Most remarkable of all is the underdrawing of the billowing cloak, brushed in with wide sweeping strokes and areas of broadly hatched shading which merge to form solid areas of wash. Underdrawing of similar breadth, and also making extensive use of washes for shading, has been found on parts of Francesco di Giorgio's *Coronation of the Virgin* of 1472–4 for Monteoliveto Maggiore (now in the Pinacoteca Nazionale, Siena).[105] The underdrawing of the extraordinary foreshortened figure of God the Father in his whirling vortex is particularly close to that of *Scipio*, and the shading of the scooped-out folds of the ultramarine mantle of the female martyr saint (perhaps Santa Giustina) on the right is directly comparable. The deep shading to establish the concave form of the folds is exactly as would be expected in the underdrawing of a painter who was also a sculptor and wood-carver.

Compared with the *Coronation* altarpiece, however, the underdrawing on Scipio's cloak is notably freer and more improvised. Many alterations and deletions were made while working on the underdrawing and at the painting stage. The exceptionally broad strokes for the fabric that puffs out from his left shoulder and curves around to be gathered in his hand were reduced, the painted contour actually following the heavier darker line immediately

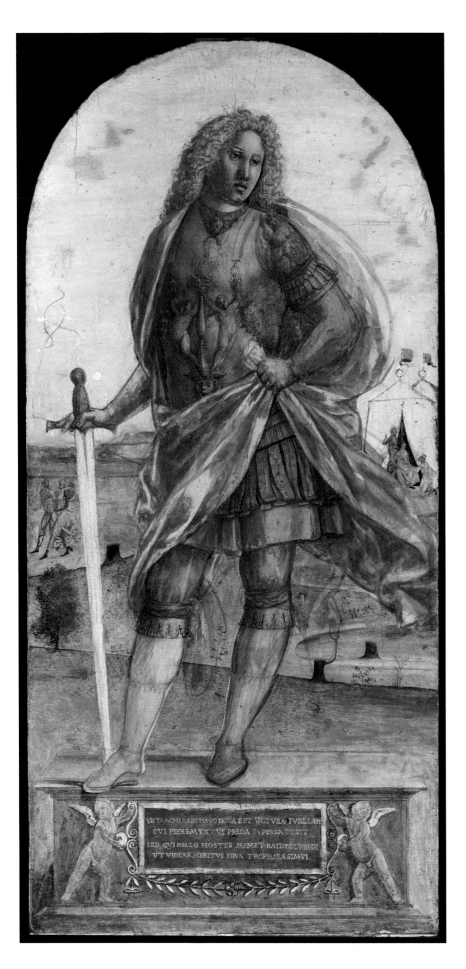

FIG. 17 *Scipio Africanus*.
Infrared reflectogram scan.

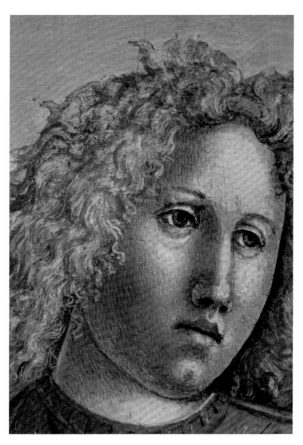

PLATE 39 *Scipio Africanus*. Detail of PLATE 21.

PLATE 40 *Scipio Africanus*. Detail of PLATE 21.

above the tent, which in the infrared image appears suspended, unlinked to the rest of the folds. Additional broad lines encroached into the area now occupied by the figures in front of the tent, and the hanging folds of drapery between and to the right of his legs were never painted; the decision to dispense with them was probably taken at this early stage since underdrawing is present for the revised arrangement with the fabric pulled up around the back of the leg. The strange leaf-shaped marks visible even with the naked eye on the figure's right calf may also be connected with this phase of the underdrawing and are perhaps accidental splashes of wash – there is no logical reason why a large plant, for instance, should have been drawn in this area, especially since the outlines of the legs had been so firmly established. Indeed, the only part of the setting that may have been indicated at the same time as the principal figure is the horizon line at the left with the two broadly drawn intersecting hills, neither of which was followed in the painting. Although, on the evidence of those paintings to have been examined by infrared, it was Francesco di Giorgio's usual practice to make relatively complete underdrawings, that for *Scipio*, with the figure set in his space and the draperies so fully, if roughly, modelled, very much suggests a demonstration piece, setting out the general design of the series, perhaps for the patron or, more importantly, for the other artists involved in the project.

The painting of the figure seems to have proceeded in advance of the rest of the picture, and probably before any decisions had been taken as to the treatment of his surroundings. From an examination of the surface it seems likely that it was executed entirely in egg tempera, although the addition of a little oil for some colours cannot be excluded.[106] The area for his head, including his hair, was underpainted with a flat pale green, almost certainly green earth with lead white. This is now easily visible, especially in the hair, because of the damaged condition of the upper paint layers (PLATE 39). The face was modelled with short intermeshed strokes of greenish-brown verdaccio in the shadows, blending into a warm coral pink for the cheeks and lips, and crisp highlights of almost pure lead white on his brow, eyelids, nose and especially the curves of the upper lip. The further side of his face, and also the hands, were outlined with black. The technique is not particularly refined, and the brush seems to have been loaded with a rather thick tempera, containing relatively little water, so as to obtain maximum coverage with each stroke. The impression of rapid execution is confirmed by the free painting of the hair with the curls indicated with

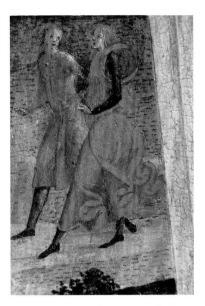

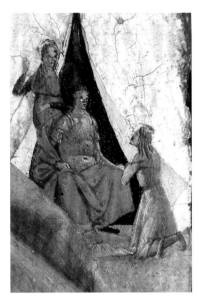

PLATE 41 *Exile*. Detail of PLATE 2.

PLATE 42 *Scipio Africanus*. Detail of PLATE 21.

PLATE 43 *Scipio Africanus*. Detail of PLATE 21.

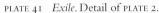

flourishes of white, interspersed with a pale pinkish brown and a darker brown.

The breastplate and cuirass were laid in with a yellow brown, probably based on an ochre, and the detail of the ornament shaded with strokes and washes of black and dark brown and lit with touches of yellow and lead white, similar to those in the hair (PLATE 40). More highlights of gold leaf were then applied. The true colour of the red lake and white cloak is difficult to judge because of the discoloured yellow varnish, but it seems likely to have been a relatively cool pink, the hatched strokes indicating that it was probably painted in egg tempera, although some oil may have been used. In the X-radiograph (FIG. 12) it can be seen that because of the poor covering power of red lakes, the heavy black underdrawing was first partially obliterated with rapidly brushed-in lead white paint, including in the areas where the underdrawn folds had become redundant. This lead white layer over the drawing can now be seen in the area of the tents as a result of the loss of the original gilding. The light orange of the hose continues down to the feet – in the underdrawing there is a suggestion of some form of sandal. The pale blue boots were painted over this, enlarging the projecting right foot slightly beyond its underdrawn contours. A similar pale blue paint, flat and without body, was also used for the sword blade.

The consistency of the blue paint of the sky is very different. Again the discoloured varnish and scumbles of restoration obscure its colour, but it probably contains lead white and ultramarine. The texture is stiff and sticky, with very evident brushmarks, indi-

cations that the medium is very likely to be oil. The colour was worked quite carefully around the contours of the figure but an aggressive cleaning, probably with an aqueous reagent, has tended to erode the areas painted thinly in tempera more than those in oil, resulting in a somewhat disturbing cut-out effect, particularly around the head and hair. The painting of the rest of the landscape is also strongly brushmarked, indicative of oil, while the details, notably the plants and tree stumps, the horizontal flecks for grass, and above all the style and character of the little figures, reveal that Francesco di Giorgio delegated the completion of his panel to the painter of the Griselda panels.

The figures are squeezed in rather awkwardly, and indeed the reduction of the drapery folds on the right may have been to allow more space for them. It is possible that the decision to include small narratives to illustrate the acts of continence and devotion for which the Men and Women were celebrated was taken only after the main figure had been drawn. A stimulus for this idea may have been Luca Signorelli's Berlin *Portrait of a Man*, with its groups of small-scale figures on either side of the subject.[107] The little figures on *Scipio* are underdrawn with a finer line than the main figure, and the legs of Aluceius, who on the left departs with his betrothed, are shown complete beneath the folds of his tunic. His stiff-legged gait is typical of figures by the Griselda Master (PLATES 41 and 42), and the exaggerated proportions of the figures and the spiralling folds of the girl's dress are perhaps closest to those in *Reunion*, almost certainly the first of the Griselda panels to be painted. The

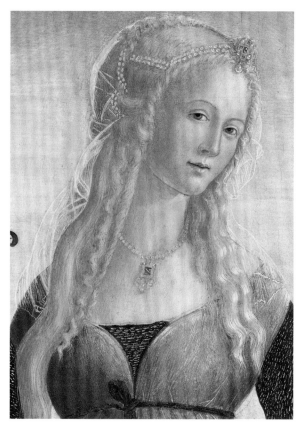

PLATE 44 *Claudia Quinta*. Detail of PLATE 26.

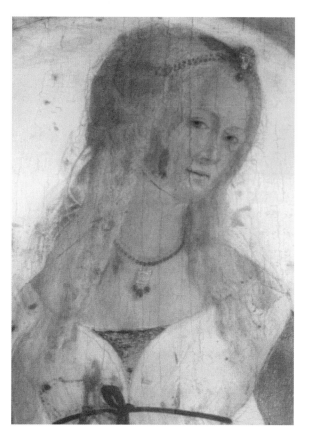

FIG. 18 *Claudia Quinta*. Infrared reflectogram mosaic detail.

figures on the right are delightfully expressive, but are much compromised by the poor condition of this area (PLATE 43). The tent was mordant gilded in the same way as the tents in *Alexander* (PLATE 19), but now only traces of gold leaf remain at its very edges. The distant view on the other side is also badly damaged, but it is still evident that the underdrawn hills were replaced with the glimpse of sea or lake that was to become a feature of the landscapes in all the panels.

The paint of the pedestal is worn but brushmarks characteristic of oil paint remain visible. It was clearly applied after completion of the figure, including the addition of the blue boots, since it goes around the enlarged contour. The further line of the top of the pedestal, however, may have been drawn at an early stage since in infrared it can be seen to pass under the blade of the sword. In addition, two short horizontal lines appear just below the underdrawn outline of the boot. This suggests that Francesco di Giorgio indicated roughly the edges of the platform in his underdrawing. No other lines for the pedestal register in infrared because they have been drawn using a red lake paint, as have the little putti who support the inscription panels. Since red lake underdrawing also features on the pedestals in *Alexander* and *Tiberius Gracchus*, both attributed entirely to the Griselda

Master, and the putti in the former were clearly drawn from the same flipped cartoon as those in the *Scipio*,[108] it is reasonable to assume that the *Scipio* pedestal was also gilded and painted by him, probably according to a design first sketched by the senior artist. The question of responsibility for the inscription (repainted and regilded in this instance) is discussed on p. 56.

Claudia Quinta

Neroccio's underdrawing of the main figure in the panel of *Claudia Quinta* (PLATE 44 and FIG. 18) could not be more different from the bold underdrawing to be seen in the *Scipio*. His lines are fine and delicate, contours are sometimes indeterminate and in places the line becomes hesitant and wavery, for example that around her right breast for the plunging neckline of her dress.[109] The veils around her head are indicated with broken scratchy lines, slightly wider than the painted veils, and her necklace with a chain of little scribbled loops, just above the painted pearls (these are surprisingly dark in infrared, which suggests that the highlights and lustre were painted over an unusually dark grey base colour). The columnar drapery folds are all carefully drawn and shaded with generally short lines of diagonal hatching, the spacing

between the parallel lines varying from area to area (FIG. 21). Although the painted details do not always follow exactly the underdrawn lines, as in the veil and necklace, and also the sandals, there are no real pentimenti in the underdrawing or in the earlier stages of painting of the figure.

The whole head, including the hair, and the hands and feet were underpainted with a flat layer of green earth and lead white. The colour is fairly pale but enough green earth is present for the areas of flesh to appear characteristically dark in infrared images. The flesh tints, confirmed as painted in tempera, are composed essentially of vermilion and lead white, but the presence of chalk and dolomite as well suggests that they may have been added as extenders to reduce the opacity of the colours.[110] In his flesh painting, and especially when painting women, Neroccio made much use of the opalescent effects to be obtained by hatching dilute and translucent scumbles of pink and white over the cool green of the underlayer. Tonal variation was achieved largely by subtle variation of the thickness of the upper layers. The thinness and delicacy of this technique have tended to make his flesh tints vulnerable to damage by harsh cleaning methods such as the abrasives used in the past, but in this instance the areas of flesh are relatively well preserved.

The sleeves and the bodice visible at the neckline were painted probably with azurite in egg tempera, now darkened, and decorated with flecks of gold leaf applied with a mordant. On parts of the sleeves the flecks are aligned vertically and on others they run horizontally around the arms. Their application and also the decoration of the hem line take no account of whether the fabric is catching the light or whether it is in shadow, by this date a rather old-fashioned approach to gilding on textiles. The rich warm red of the dress is painted with red lake and vermilion over a local *imprimitura* of lead white bound in tempera (PLATE 45). Analysis indicates that the medium of the red paint above, however, contains both egg and oil, probably in the form of a tempera grassa.[111] Neroccio modelled the folds by hatching and cross-hatching exactly as when working in tempera; the oil may have been added to increase the translucency of the red paint.

The pedestal has the appearance of having been painted in tempera – there is no sign of brushmarks like those to be seen in the stiff oil paint of the pedestals painted by the Griselda Master, and in the X-radiographs the application has the fluidity of an aqueous medium. Neroccio had some difficulty with the pedestal since his figure is considerably taller than the others in the series, suggesting that she had been

PLATE 45 *Claudia Quinta.* Cross-section of a sample from the red dress of the large figure, showing an underpainting of lead white over the gesso ground, and then a thin layer of red lake with a little vermilion. Photographed at a magnification of 320×.

PLATE 46 *Claudia Quinta.* Cross-section of a sample from the dark green grass in the foreground, showing coarsely ground malachite and a little lead-tin yellow in a matrix of discoloured binding medium applied directly over the gesso ground. Photographed at a magnification of 320×.

drawn and painted before the measurements and design for the pedestal were supplied to him. He tried to make the pedestal fit by pushing its base down to the very bottom of the panel – the other panels which still have their pedestals have an unpainted border of approximately 1.5 cm at the lower edge – but even then Claudia was left poised precariously with only her heels on the plinth. Her foot hangs over the head of the putto on the right, with presumably unintentional comic effect. Although the pose of the putti with their crossed legs is the same as those on *Tiberius Gracchus*, Neroccio's are more upright than those of the Griselda Master and so he must have drawn his own little cartoon, which was then flipped for the opposite figure. The underdrawing of the putti is in black and therefore it registers in infrared; since no pounce dots are visible, it is assumed that the design was transferred by tracing.

These problems with fitting in the pedestal suggest

PLATE 47 *Claudia Quinta.* Detail of PLATE 26.

PLATE 48 *Reunion.* Detail of PLATE 3.

FIG. 19 *Claudia Quinta.* Infrared reflectogram mosaic detail.

FIG. 20 *Reunion.* Infrared reflectogram mosaic detail.

Scipio, however, there are many similarities with those in the Griselda panels: for example, the way that forward motion of a group of men is indicated by tilted bodies and long stiffly strutting legs that interlace in triangles (PLATES 47 and 48). They wear the same little red caps and their features, although much abbreviated, appear similarly earnest and animated. The underdrawing for the figures is also directly comparable. The figures and landscape details in the *Claudia Quinta* are drawn with a firm fluent line[113] very unlike the delicate and somewhat tentative drawing in the main figure. The construction of the fluttering draperies and the drawing of the limbs of the little figure of Claudia towing the ship with the image of Cybele are close to those of figures in *Reunion,* especially the supposed new bride who greets Griselda (FIGS 19 and 20). The sketching of the distant view of hills, water and overhanging crags (FIG. 21) can be compared with similar landscape elements in *Marriage* (FIG. 4). A cross-section has confirmed that the underdrawing for the background lies directly on the gesso and there is no sign of any earlier landscape drawn in the manner of the main figure. This does not mean, however, that this underdrawing was neces-

FIG. 21 *Claudia Quinta.* Infrared reflectogram mosaic detail.

that the main figure of Claudia was executed at a very early stage in the whole project, perhaps even simultaneously with the panel of *Scipio.* This might explain why the incisions for the capital profiles follow the alternative version incised into the paint on *Scipio,* and not the design adopted for the other panels. It also reinforces the supposition that the first artist that Francesco di Giorgio would call on for assistance in this undertaking would be one with whom he had previously worked in partnership. Whether it was always part of the plan to use the painter of the Griselda panels, perhaps still an assistant in Francesco's workshop, for the landscapes and subsidiary figures of the *Claudia Quinta* is less certain.

It has been argued recently that Neroccio was responsible for the whole painting, including the background figures.[112] As with the little figures in

sarily executed at the same time as that for the main figure, which, if it was painted simultaneously with *Scipio*, could have been begun before firm decisions had been taken as to the treatment of the backgrounds. Moreover, in common with *Scipio*, the narrative elements fit somewhat uncomfortably and there is not much sense of a continuous landscape space.

The painting technique of the landscape also supports the attribution to the Griselda Master, especially in the way that the choice of medium was determined by which pigments were to be used. The sky, therefore, was painted with ultramarine and lead white in walnut oil,[114] but malachite was chosen for the dark green of the patches of grass in the foreground and so the medium is egg tempera (PLATE 46).[115] This is exactly as in the hill on the left in *Marriage* and the colour has almost certainly darkened in a similar way.[116] Over the lighter greens of the middle distance there are the familiar horizontal dashes, this time lighter than the base colour. The men are dressed in combinations of scarlet, ultramarine, ochre and green, but for the little figure of Claudia (PLATES 49 and 50) the Griselda Master chose his favourite bluish pink based on red lake, ignoring the

PLATE 49 *Claudia Quinta*. Detail of PLATE 26.

warmer red of the main figure. As on the Griselda panels – and indeed, on *Alexander* – the medium for the red lake is egg tempera. The gold leaf for the statue of Cybele in the ship was applied with a mordant laid over the paint of the water and shaded with black in the same way as the gilding on the Griselda panels (the figure in the ship held by the large Claudia is almost entirely a modern restoration). Although the horses on the gateway to Rome on the left have highlights of yellow paint rather than the

FIG. 22 *Claudia Quinta*. X-ray detail.

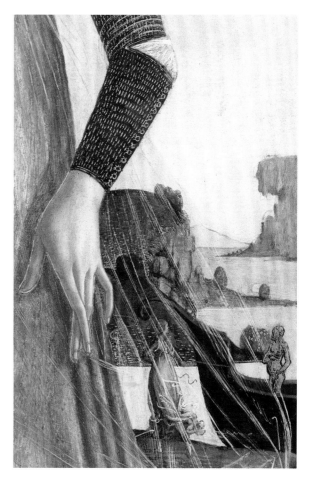

PLATE 50 *Claudia Quinta*. Detail of PLATE 26.

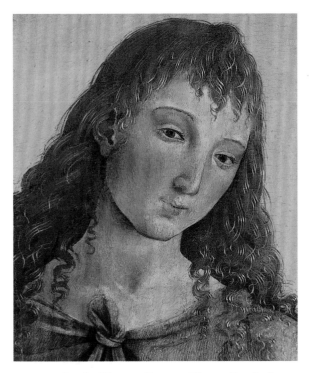

PLATE 51 *Joseph of Egypt* or *Eunostos of Tanagra*. Detail of PLATE 20.

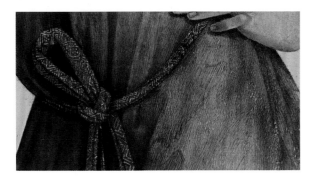

PLATE 52 *Joseph of Egypt* or *Eunostos of Tanagra*. Detail of PLATE 20.

FIG. 23 *Joseph of Egypt* or *Eunostos of Tanagra*. X-ray detail.

gold leaf of the very similar horses on the triumphal arch in *Marriage*, gold leaf was used on the landscape, just as in that panel. Here the gilding is in the form of highlights on bushes and the Griselda Master's typical horizontal dashes on the cliff tops behind Claudia towing the boat.

Neroccio's part in making the painting was not complete, however, for once the landscape and small figures were in place he seems to have returned to paint the gauzy veils that start from Claudia's head-dress, come down over her dress and then float out in front of the little narrative on the right. That he was responsible for the veils is suggested by their wispy character and technique, almost certainly tempera, which is particularly well suited for the rendering of translucency. The veil painted by the Griselda Master on the little version of Claudia is by contrast solid and full of movement. In addition, on the main figure there is a suggestion of a shadow cast by the edge of the veil on the skirt, executed in a paint that appears to be identical to that of the final glazes of the rest of the dress and therefore likely to have been added by Neroccio himself.

In the X-ray and infrared images it can be seen that originally another piece of veil billowed out from Claudia's upper arm (FIGS 21 and 22). This was eliminated by adding a further layer of sky paint, resulting in extra opacity in the X-radiograph – this is particularly clear at the junction with the less dense area where the edge of the veil that was not suppressed slants up between the cliff and Claudia's arm. That the alteration was made by the Griselda Master and not Neroccio is indicated by the technique, a stiff oil paint, and by the fact that a now meaningless piece of veil remains wound round the upper arm where it was painted over the blue and gold outer sleeve. If, as was surely the case, the Griselda Master was still the most junior member of the team working on the Virtuous Men and Women, this alteration to a work by one of the leading painters active in Siena at the time would indicate a notable increase in his involvement. It also provides further evidence that the artist responsible for directing the project was Francesco di Giorgio, with whom the young Griselda Master was almost certainly associated at this stage in his career.

Joseph or *Eunostos of Tanagra*

If, as seems likely, the two panels assigned to other painters, *Judith* and *Sulpitia*, were produced at a relatively early stage, it was only once the set was half finished that the Griselda Master took control of the project. By then, he must have proved his competence with the completion, or near completion, of the

Griselda panels. Perhaps the patrons had also become aware of the somewhat discordant consequences of employing for the main figures four very distinctive painters, of different generations and with different techniques. To the modern eye at least, the group of Men, with three figures by the Griselda Master and the fourth by the painter who was probably his master, is better balanced and visually more satisfactory than the Women.

Confirmation that *Joseph* or *Eunostos* (PLATE 20) was the first of the large-scale figures to be painted by the Griselda Master is supplied by the fact that the paint of what remains of the pedestal was applied around his feet (FIG. 23). On the other three panels the paint of the top of the platform very clearly passes under the feet, draperies, and details such as serpents, spears and scimitar tips (FIG. 13). It may have been decided that it would be faster and more efficient to paint the platforms of all four at the same time, even if the drawings for the other three figures were not yet finished, or, more probably, it was necessary to do so because the bases of the whole set of panels had to be ready for the application of the lettering by a separate craftsman (see p. 56). Furthermore, the background details in this panel have much in common with the Griselda panels, and especially *Marriage* and *Reunion*: the draperies of the two figures (Joseph and Potiphar's wife or Eunostos and Ochne) in the scene on the right billow and coil in similarly improbable folds, and the woman's spiralling scarf in the episode on the left is even more exaggerated than the white scarves of the bystander on the right of *Marriage* and the servant in *Reunion*. The trees, with their ornamental twisting branches, are also comparable.

Unlike the Griselda panels, however, *Joseph* has a priming of lead white, bound probably in egg tempera,[117] applied over the gesso ground (not removed when the painting was transferred to canvas). It is present in paint samples from every colour area (PLATES 53 and 54) and so is distinct from the lead white underpainting of the red draperies of *Scipio* and *Claudia Quinta*. By the 1490s, the application of primings containing lead white and other pigments was common practice when painting in oil, and it was not so unusual to use the quick-drying tempera medium in a priming.[118] Since the underdrawing lies over the priming it is just possible that the priming had already been applied when the Griselda Master received the panel (Matteo di Giovanni used such a priming for *Judith* – see p. 55); alternatively, if the Griselda Master developed his oil-painting technique in response to his study of Signorelli's works in Siena, he could have picked up the use of primings from that workshop;[119]

FIG. 24 *Joseph of Egypt* or *Eunostos of Tanagra*. Infrared reflectogram mosaic detail.

PLATE 53 *Joseph of Egypt* or *Eunostos of Tanagra*. Cross-section of a sample from the dark green foliage in the foreground showing a layer of verdigris and lead-tin yellow over a lead white *imprimitura* applied to the gesso ground. Some discoloured old varnish is visible on the surface and in the crack. Photographed at a magnification of 320×.

PLATE 54 *Joseph of Egypt* or *Eunostos of Tanagra*. Cross-section of a sample from the red tunic, showing a layer of red lake over a lead white *imprimitura* applied to the gesso ground. Photographed at a magnification of 320×.

another source might have been contact with Perugino and his associates.[120] Although there is no priming on *Alexander* – the gesso was sealed with glue in the same way as the Griselda panels – there is a possibility that lead white primings are present on the two panels that have not been sampled, *Tiberius*

Gracchus and *Artemisia*. One reason for not applying a priming to *Alexander* (and the Griselda panels) might be that some of the colours were to be bound in tempera to achieve particular effects, and tempera generally works best when applied directly to the gesso; analysis of samples from *Joseph*, on the other hand, indicates that it was painted entirely in oil.[121]

On the main figure liquid underdrawing applied with a brush is evident along the edges of forms, and in the red robe a few schematic curves and some short widely spaced diagonal strokes of hatching are visible with the naked eye (PLATE 52). These disappear, however, when the painting is viewed in infrared, an indication that parts of the drawing were probably made in an iron-gall ink. Only one relatively minor change can be seen, the shortening of the index finger on the proper right hand (FIG. 24). When the Griselda Master became responsible for the whole design, the background figures could be better integrated, with more space allowed for the narrative element. Here the drawing is free and lively, with several alterations. This drawing material presumably contains carbon since it registers clearly in infrared. The landscape at the left originally consisted of two underdrawn bluffs that were replaced in the painting stage with a landscape of water and, beyond, a ramparted city with low hills behind. Other changes in the left background occur in the figures. The foot of one of the assailants was repositioned to a wider stance, and the underdrawing shows several positions for the female figure's splayed fingers in the adjacent episode.

As far as the painting technique is concerned, the most notable difference from the panels by Francesco di Giorgio and Neroccio is in the areas of flesh (PLATE 51). There is no green earth underpainting; instead the flesh tints of lead white and red earth (with the addition of some green earth in the mid-tones – the sample was taken from the figure's foot)[122] – were modelled directly over the *imprimitura*. The sky was painted with the usual mixture of ultramarine and lead white, the application perhaps less obviously brushmarked than on some of the other panels as a result of being applied over a priming, although the smoother surface can also be attributed to flattening in the process of transfer to canvas. The dark green of the foreground (PLATE 53) contains verdigris rather than the malachite employed in *Claudia Quinta* and was completed with copper-containing green glazes as in similar passages in the Griselda panels. Although the medium of the red robe is oil, the folds were shaded with the discrete brushstrokes of the tempera technique (PLATE 52). This may have been partly an attempt to create some uniformity with the earlier

figures in the series, but it may also be that when working on a larger scale the painter preferred to construct his forms using the hatched application familiar from his presumed original training in tempera and fresco.[123] As in standard oil technique, the relief was achieved by building up the thickness of the dark areas with red lake (PLATE 54), finished in the deepest shadows by fine hatched lines of black, while leaving the lighter areas more thinly covered, allowing the white *imprimitura* to reflect through. These thinner glazes have faded appreciably, and the whole drapery probably now has a warmer, more orange cast than it did originally. It should probably be imagined as close in colour to the mantles of the Marchese and Griselda in *Marriage* and, in common with them, highlighted with threads of gold, now rubbed and indistinct.

More gold leaf, applied to a mordant probably of the same composition as that on the Griselda panels, appears on the hem of the robe, now much restored, and on the blue-green sash, which is better preserved. Here the patterns were painted with a yellow-brown paint and the gold leaf then applied to the parts of the design that catch the light. As a result of the damage to the gilding, this figure has lost some of the splendour that would have allowed him to compete with his neighbour, *Alexander the Great*.

Alexander the Great

As befits his status in Greek antiquity, *Alexander the Great* (PLATE 19) was the most magnificent and ornate panel of the series. By this stage in the execution of the series the general design was well established and so, although the picture field was established by incision of the sides, base and arch, the areas to be covered by the capitals of the frame were indicated in a cursory way with lines drawn in an iron-gall ink. They are visible only because cracking of the ink has caused the paint above to wrinkle and in places to flake away (the losses could be mistaken for shallow incisions).[124] An iron-gall ink also seems to have been used for the underdrawing of the main figure. Some faint outlines can be detected in infrared, together with a few lines to indicate the anatomy of the knees, for instance. The simplicity of the underdrawing on all four of the main figures by the Griselda Master and the lack of major alterations suggests that he had made careful studies in advance and possibly even full-scale cartoons. There is no evidence of pouncing, but cartoons could have been transferred by some form of tracing. Since it was the intention to paint Alexander's breastplate with coarsely ground blue mineral pigments, lines defining the contours and structure of his torso were incised into the gesso, just as in the

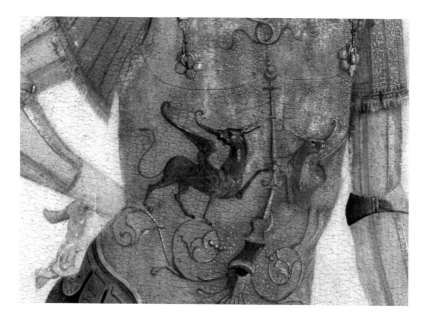

(top row, left) FIG. 25 *Alexander the Great*. Infrared reflectogram mosaic detail.

(top row, right) PLATE 55 *Alexander the Great*. Macrophotograph of PLATE 19, showing the red lake underdrawing on the pedestal.

(centre row, left) FIG. 26 *Alexander the Great*. X-ray detail.

(centre row, right) PLATE 56 *Alexander the Great*. Detail of PLATE 19.

(bottom row, left) FIG. 27 *Alexander the Great*. Infrared reflectogram mosaic detail.

(bottom row, centre) FIG. 28 *Alexander the Great*. X-ray detail.

(bottom row, right) PLATE 57 *Alexander the Great*. Detail of PLATE 19.

Griselda panels (FIGS 25 and 7). The pedestal, painted in advance of the figure, was underdrawn with the same red lake paint evident on the pedestals of *Scipio* and *Tiberius Gracchus*, and presumably also used for *Eunostos* and *Artemisia*. The ruled lines and the outlines of the putti and decorative patterns were all drawn with this red lake (PLATE 55).

There are no evident pentimenti in the main figure, but the landscapes and subsidiary scenes of this panel were extensively revised. Having first sketched in a horizon line (at the same height as that of the other panels, albeit slightly tilted), the painter then drew the conical tops of three tents on the left and one on the right (FIGS 26–8, PLATES 56–7), all at a higher level than in the final painting, and exactly at the same height as the similar tent in *Scipio*. If the small figures in front of the tents were ever underdrawn, the areas that they would have occupied are now covered by the gold of the present tents; where the gilding is damaged, however, there is no sign of any drawing. The painting of the sky (with the same combination of ultramarine and lead white in walnut oil used for the other backgrounds by the Griselda Master) and the landscape, complete with bushes, was well underway before the decision was taken to move the tents down to their present position, which allows

more space for the narrative episodes. The dots and dabs of the obliterated foliage appear in the X-radiographs and in places on the picture surface. As part of the alterations, the colour of the grass in the middle distance was also lightened by applying a layer of pale yellowish green, mainly lead-tin yellow, lead white and verdigris, over a darker green, which contains a higher proportion of verdigris.[125] In the dark green of the unaltered foreground, black pigment was added to the mixture, while the grass of the further slopes was completed with the usual horizontal dashes of verdigris. The medium for all these layers of green was walnut oil.

The gold leaf for the tents – reduced to two on the left – was then applied over the underlying layers, either paint or bare gesso, depending on the alterations, and using a mordant identical in composition to that on the Griselda panels, which has been identified as containing gum ammoniac.[126] Only once the tops and sides of the tents were gilded (but not yet shaded with black hatching) were the figures painted in, some of them partly over the gold. For a painter who had been so careful to underdraw and reserve areas for the smallest of figures in the Griselda panels, this seems surprising and suggests either hurried working or some uncertainty as to what was to be included in the *Alexander* narratives. Some of the figures may have been sketched with a dilute paint; faint lines for the buttocks and shoulder blades of the soldier with his back turned in the group on the right can be seen in infrared, but no further drawing can be distinguished because of the gilding and multiple paint layers in these areas. The painting of the figures – in oil – appears rapid and direct, and the impression of haste is reinforced by the accidental omission of the arm and red sleeve of the figure of Alexander on the left. Details of Alexander's armour that are picked out in gold on the main figure are all rendered with yellow paint in the small versions.

The costume of the main figure was originally even more splendid than it appears today. The breastplate and cuirass are now much darkened. Just as in the Griselda panels, paint samples have shown that, although these areas were underpainted with azurite, the top layer consists of coarsely ground ultramarine, probably with some red lake (PLATE 59). In the cross-section, the ultramarine particles themselves are an intense blue but they are embedded in a brown matrix of discoloured egg medium.[127] The coarse texture of the expensive mineral pigment and the fact that it was used unmixed with white indicate that the painter sought maximum intensity of colour, and therefore chose egg tempera instead of oil, which

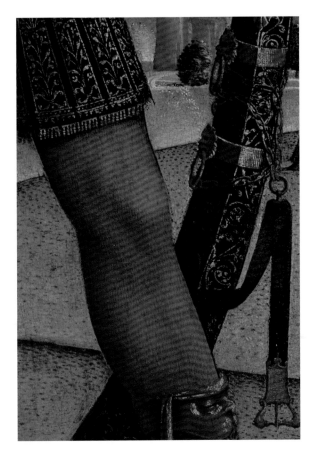

PLATE 58 *Alexander the Great*. Detail of PLATE 19.

would have made the colour darker and more saturated. Moreover, it is difficult to paint with such coarsely ground pigments in oil, especially without any lead white in the mixture. The colour of Alexander's armour has to be imagined, therefore, as closer to a pure lapis blue, appearing more purple in the shadows where shaded with red lake. This would have balanced beautifully the still intense pink of his sleeves and hose (PLATE 58), painted with high-quality red lake derived from kermes (PLATE 60), and applied in egg tempera to retain the purity of colour, just as in the Griselda panels.[128] Despite the medium being egg, which has to be applied with some form of hatched stroke, the approach to colour modelling is that of oil painting, with an upper layer of pure red lake applied over an underpainting of red lake and white. As in oil painting, the glaze was built up to its greatest thickness in the shadowed areas, which were then deepened further by hatched shading with black.

The orange-brown base colour of the open-toed boots and the larger areas of fantastic metalwork on the armour (some of it left in reserve, and other parts laid in over the blue) is a mixture of vermilion, red earth and possibly some red lead (PLATE 61); the finer patterns were painted with a more yellow brown containing lead-tin yellow and earth pigments, including some haematite (crystalline iron oxide). The parts of the design that catch the light were then picked out with gold leaf, applied with the usual mordant, and the shadowed areas hatched with black, again as in other panels by this painter. In places, the transitions between gilded highlights and more shadowed areas were refined by toning down the gold leaf with brown glazes. The Griselda Master's use of gold leaf is notably more consistent and systematic than Francesco di Giorgio's on the similar armour of *Scipio* with its highlights of both paint and gold. Scipio's very plain sword can also be compared with the elaborate gilded ornament on the black scabbard of Alexander's scimitar. Although the contrast between scabbard and armour is diminished as a result of discoloration of the blue pigments, the sword belt, painted with a bright azurite blue, with a thin ultramarine glaze, seems to have retained much of its original brilliance.

The gilding technique for the patterns on the pedestal is the reverse of that on the main figure in that the gold leaf was laid over the mordant applied directly onto the gesso (as in the architecture of *Exile*), the areas to be gilded having first been designated with the red lake underdrawing. The lilac-grey paint of the pedestal, a mixture of lead white, red lake and azurite (see PLATE 61), was worked around the

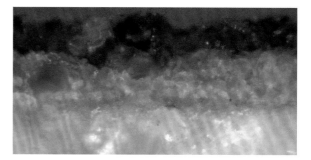

PLATE 59 *Alexander the Great.* Cross-section of a sample from Alexander's blue breastplate. Some intense blue particles of ultramarine are visible in the uppermost layer, in a brown matrix of discoloured binding medium and colourless associated minerals. Below is the azurite underpaint and the gesso ground. Photographed at a magnification of 500×. Actual magnification 440×.

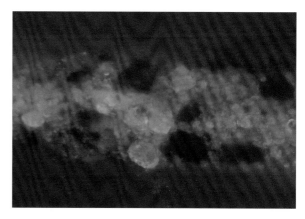

PLATE 60 *Alexander the Great.* Cross-section of a sample from Alexander's pink hose. The paint contains an intense pink kermes lake pigment similar to that used in the National Gallery panels. Photographed at a magnification of 500×. Actual magnification 440×.

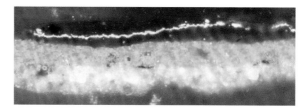

PLATE 61 *Alexander the Great.* Cross-section of a sample from the gilding on Alexander's open-toed boots. The gesso ground is missing from the sample; the lowest layer is the lilac-grey paint of the pedestal, which runs beneath the boot. The orange-brown base colour of the boot consists of vermilion, red earth and possibly some red lead. Over this is the translucent yellow-brown unpigmented mordant for the gold leaf. Photographed at a magnification of 500×. Actual magnification 440×.

FIG. 29 *Tiberius Gracchus*. Infrared reflectogram detail.

FIG. 30 *Tiberius Gracchus*. Infrared reflectogram detail.

FIG. 31 *Tiberius Gracchus*. Infrared reflectogram detail.

PLATE 62 *Tiberius Gracchus*. Detail of PLATE 22.

gilded parts, and indeed the execution of the pedestals was so rapid and efficient that the shadows cast by the putti were painted in a single application directly onto the ground, and not as a glaze over the principal paint layer as might be expected. Only the lines of the mouldings and the inevitable little horizontal flecks on the vertical face were added at a second stage, together with the black detailing on the gilded parts. The blue ground for the inscription consists of two or possibly three layers, the first lighter one based on azurite with a little white, and the upper ones of pure azurite with some ultramarine; all are applied in an egg medium, now darkened.

The flesh tints are essentially of the same composition as those of *Joseph*, but since the samples came from lighter areas some vermilion is included in the mixture. Details and outlines are generally defined with a warm brown colour, but sometimes a contour is picked out with touches of a relatively bright pink. Although the flesh is painted in oil, unblended high-

lights of lead white applied with distinct hatched strokes are a reminder of the painter's likely origins in a tempera-based tradition. In its combination of tempera and oil techniques, and also in the extent of the gilded decoration, *Alexander the Great* is perhaps the closest to the set of panels from which the Griselda Master takes his name.

Tiberius Gracchus

The Griselda Master's increasing command of the drawing of larger-scale figures and their placing within the arch-topped format of the panels is demonstrated by the supremely elegant composition of *Tiberius Gracchus* (PLATE 22). The underdrawing of the main figure is close in technique to that of *Eunostos* and *Alexander*, consisting mainly of outlines that tend to be almost as visible to the naked eye as with infrared, an indication that they are probably drawn with an iron-gall ink. A few small differences between the underdrawing and the painted contours are apparent,

for example the fingers of the hand holding the spear were shortened slightly (as were those of Eunostos), the elbow of that arm was drawn slightly lower, the bunched drapery on the right bulged out below and his rippling curls extended further to the right (FIGS 29 and 30). These changes indicate a tendency to reduce contours, moderating some of their extravagance, which is also evident on *Exile*.

As with the other panels, the underdrawing of the landscapes and the small figures of Tiberius and Cornelia is more obviously improvised: the legs of the little figure of Tiberius who discovers the serpents in his house were repositioned and tree trunks were sketched behind the arches of the loggia but never painted (FIG. 31 and PLATE 62). These are very like the underdrawn trees in *Marriage* and *Exile*, and an even closer association with those panels is suggested by the two sculpted figures on the roof of the loggia that appear in the underdrawing – partially visible with the naked eye because the lines of iron-gall ink have caused the paint above to crack (PLATE 63 and FIG. 32). Their dancing movement is typical, but the decision not to paint them is perhaps another indication of a tendency towards restraint by the painter – in addition, they would have been in competition with the sculpture of Apollo (representing the soothsayers, who according to Plutarch, foretold Tiberius' death) on the right, and therefore important in the telling of the story.

In each episode the figures of Tiberius and Cornelia were painted very quickly, with mid-tones, shadows and highlights juxtaposed or partly blended wet-in-wet; the spiral swirls that highlight Cornelia's breasts in the scene showing the discovery of the serpents could only be oil paint (PLATE 62) and it seems likely that the whole painting, with the exception of the blue background for the inscription, was painted in oil. The rich brown of the robes of the main figure is probably similar to the orange browns in *Alexander* and based therefore on mixtures of earth pigments with vermilion, red lake, black and lead white. The lining is a dark glazed green. At a relatively late stage the painter seems to have decided that the figure needed more red to bring it into line with the other panels, and so added the red scarf over the completed neckline of the tunic (PLATE 64). The scarf is decorated with a pattern of dark green paint rather than the gilding that one might expect from the other panels, and the use of gold leaf is generally more restrained, appearing only on the parts of the decorated hem of the robe that catch the light, the statue of Apollo – mordant gilded over the paint and then shaded with black, exactly as in the sculpture of Cybele in *Claudia Quinta* – and on the point of

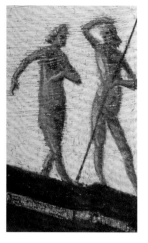

PLATE 63 *Tiberius Gracchus*. Detail of PLATE 22.

FIG. 32 *Tiberius Gracchus*. Infrared reflectogram detail.

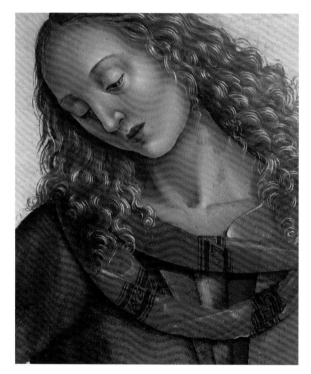

PLATE 64 *Tiberius Gracchus*. Detail of PLATE 22.

Tiberius' spear (see PLATE 78). The shaft of the spear was painted a dark green, following ruled incisions into the paint of the sky (a rare use of incision for straight lines in the work of this painter). The decorative fringe above the point of the spear and the lace tied half way up the shaft introduce further touches of red, which together with the drops of blood from the dead serpent and Cornelia's red dress in the background result in a pleasing distribution of colour across the picture surface.

In spite of extensive losses from the brown robe, *Tiberius Gracchus* is arguably the best preserved of the

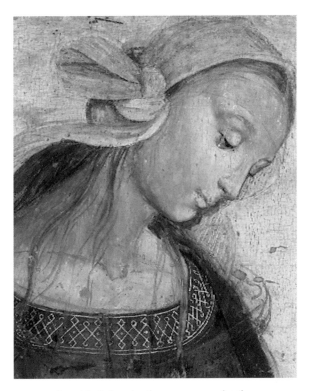

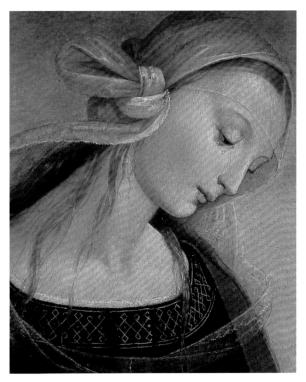

FIG. 33 *Artemisia*. Infrared reflectogram scan detail.

PLATE 65 *Artemisia*. Detail of PLATE 24.

eight panels, and especially in the areas of flesh paint. With the exception of an area of restoration at the near corner of the mouth, the head of Tiberius is in almost perfect condition, and so displays the painter's command of the structure of the head and neck, carefully modelled with even transitions from gleaming highlights through pink mid-tones to cool greyish shadows. On close inspection it can be seen that the stiff opaque oil colours were shaded with hatched strokes, without any attempt to suppress the brushwork by blending. Nevertheless, at normal viewing distance the impression is of a highly refined version of the technique used by Signorelli to achieve the strongly sculptural but smooth and polished flesh, almost like marble, which is a feature of his paintings towards the end of the fifteenth century.

Artemisia

In May 1857, Otto Mündler, the National Gallery's travelling agent, recorded in his Travel Diary that 'March^se Poldi has lately purchased of Baslini a single figure of Saint Barbara, called Perugino, but decidedly by L. Signorelli, exquisit [sic]'.[129] This is the panel now identified as *Artemisia* (PLATE 24). The dependence of the general design of the figure on that of the Magdalen in Signorelli's panels for the Bicchi Chapel has been noted, but the previous attribution to Perugino is also telling, and an indication of how far and how rapidly the Griselda Master had changed

style and technique towards the more modern ways of painting that were being introduced to Siena by painters such as Signorelli. Indeed, given that this chameleon master had, as Coor realised (though misunderstood),[130] once again altered his landscape style, it becomes all the more important to demonstrate its technical continuity with the Griselda Master's other panels. The underdrawing in the upper part of the figure appears at first sight to be more extensive than on the other three large-scale figures, but this may be a false impression created by the greater visibility of the drawing material (probably not, in this case, an iron-gall ink) and because − typically − the underdrawn lines and contours tend to be more exuberant than the painted forms. The broad liquid lines that indicate her collar bones, neckline and tendrils of hair are brushed in with great confidence (FIG. 33) and the right side of the figure was drawn slightly wider than in the final painting. The abbreviated arc that indicates a fold in the projecting part of the veil on the right resembles the annotations for folds visible in the costume of *Joseph* (PLATE 52), and similarly comparable widely spaced parallel hatched strokes of shading can be discerned in the lining of her cloak. However, detection of underdrawing in the folds of her cloak is made impossible because of the amount of black pigment in the paint layers above and also because of the present compromised condition of the painting. There are fairly extensive paint losses, especially in the

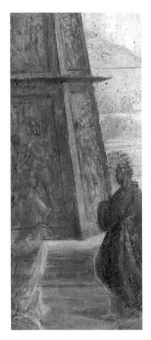

FIG. 34 *Artemisia*. Infrared reflectogram scan detail.

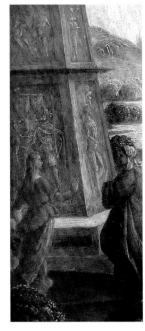

PLATE 66 *Artemisia*. Detail of PLATE 24.

PLATE 68 *Artemisia*. Macrophotograph of PLATE 24 showing the builders of the mausoleum.

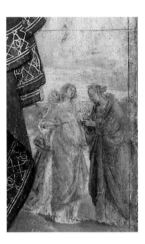

FIG. 35 *Artemisia*. Infrared reflectogram scan detail.

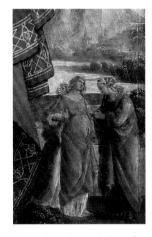

PLATE 67 *Artemisia*. Detail of PLATE 24.

The green of her dress, which has the glossy surface of a green based on verdigris rather than malachite, may also have darkened and so the figure now seems drab when compared with the pink and red costumes of the other women in the series. She must always have seemed very different in her sculptural solidity and heavy drapery folds. Nevertheless, the Griselda Master still managed to introduce some of his customary animation with her expressive hands and the fluttering twists of veil, as well as decorative details such as the scalloped edges of her cloak. All the gilded decoration on the borders of the robes has been renewed by Molteni, with little regard for the

cloak, and a recent partial cleaning of the painting has retained most of the extensive retouchings made by the Milanese painter and restorer Giuseppe Molteni in 1857, when the panel was bought by Gian Giacomo Poldi.[131] Unfortunately, Molteni's restorations, which often cover areas far larger than that of the damage, tend to become greyish and opaque with age. This, together with the patchy residues of the earlier varnish, obscures the true colour of the cloak, which is almost certainly a cool greyish purple, probably containing red lake, vermilion, lead white and azurite or ultramarine (as do similarly coloured areas on paintings by the Griselda Master) as well as a black pigment that is apparent in the infrared image.

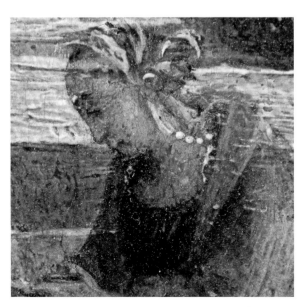

PLATE 69 *Artemisia*. Macrophotograph of PLATE 24 showing Artemisia weeping into the cup of ashes.

fall of light (PLATE 65 AND 67). Only a few scraps of original gilding can be seen at her neckline where the decoration is covered by the veil. The gilded cup is also his restoration (but following the original shape) and must originally have been mordant gilded and modelled with black in the same way as other gilded details on the panels. In the X-radiograph the brush-strokes of the sky can be seen to go around the area of the cup, an indication that the area was reserved and the gold leaf attached to a mordant applied directly onto the gesso as in larger areas of gilding on the other panels.

In general, however, the painter seems to have been less meticulous on this panel about reserving areas that had been demarcated in the underdrawing. When painting the sky, with the usual sticky brush-marked colour based on ultramarine and white, he allowed his brushstrokes to encroach well into the area reserved for the back of Artemisia's head, leaving only a very approximate reserve for the protruding knot of her scarf (PLATE 65).

This is even more noticeable in the landscapes on either side (PLATES 66 and 67). The only underdrawing visible in infrared is the thick bold line to indicate the level of the horizon (FIGS. 34 and 35), exactly as in *Alexander*. Also in common with that panel is the fact that no drawing can be detected in the little figures, although it could, of course, have been executed in a material transparent to infrared such as the red lake used on the pedestals. Mostly their positions seem to have been predetermined, since approximate reserves were left for them when brushing in the landscape elements. However, the speed of painting means that the thick sticky landscape colours often extend well under the figures. Abrasion has reduced legibility of the figures, and the girl on the left of the group now appears to be wearing a mob cap, in reality the ends of the strokes for the water. Had the mouth of the little figure of Artemisia who weeps into the cup of ashes (PLATE 69) not been rubbed away, it would be more immediately apparent that she is sister to the banished Griselda in *Exile* (PLATE 16).

In the landscape on the left (PLATE 66), the nymph-like woman in pink was painted over the mausoleum, already decorated with its relief sculp-tures; she plays no part in the recorded story and so, despite her apparently meaningful pointing gesture, she may have been added to supply an area of pink to balance the other side, and also to echo the large areas of that colour on the other figures in the series. As in the *Alexander* panel, the narrative content seems to have been less clearly defined in advance than was the

case with *Eunostos* and *Tiberius*. This may have been in part the result of pressure to finish the series, and further evidence of haste is suggested by the painting of details such as the tools of the mausoleum's builders while the paint of the sky was still soft (PLATE 68).

Sulpitia

Since Neroccio was clearly brought into the project of painting the Virtuous Men and Women at an early stage, it seems likely that it was then that Francesco di Giorgio also turned to another painter with whom he had collaborated recently, Pietro Orioli. The many differences between Orioli's *Sulpitia* (PLATE 25) and the panels produced by Francesco di Giorgio and the Griselda Master suggest that Orioli took his panel to his own workshop, and that supervision was no more than occasional.

Infrared examination has revealed a spectacular underdrawing (FIG. 36), applied directly on the ground and typical of those on Orioli's larger-scale works in the amount of detail and in the drawing of the figure with long fluid lines made with a loaded brush and extensive shading with evenly spaced parallel hatched lines.[132] Even the structure of Sulpitia's head is modelled by shading, and on the draperies the draw-ing is notably sculptural in that the angle of the hatching often varies according to the planes being described, so that in places the strokes overlap as cross-hatching. In the deepest shadows of the dress, however, some of the shading that registers in infrared is actually in the upper paint layers where black pigment was added to darken the tone of the red lake.

There are several differences between the under-drawing and the final painting. Originally Sulpitia's long hair was more loosely dressed, so that it curved out to the left of her neck (here hatching is replaced by a wash), and with the ends of the strands blowing out to the right. The veil around her shoulders billowed out more widely to the right than in the painting, and another piece of veil fluttered around her hips on the left. Her neckline was lowered slightly and given a less severe line in the final painting. In its complex contours the drawn figure has much in common with the figure of Christ in Orioli's *Ascension* of 1492 (Siena, Pinacoteca Nazionale), and therefore close to the probable date of *Sulpitia*, but in general he seems to have preferred intricate but more contained drapery shapes that emphasise the figure beneath as in the final painting. The more flamboyant underdrawing may have been in part a response to Francesco di Giorgio's *Scipio*, which Orioli then toned down, partly perhaps because unbound hair might

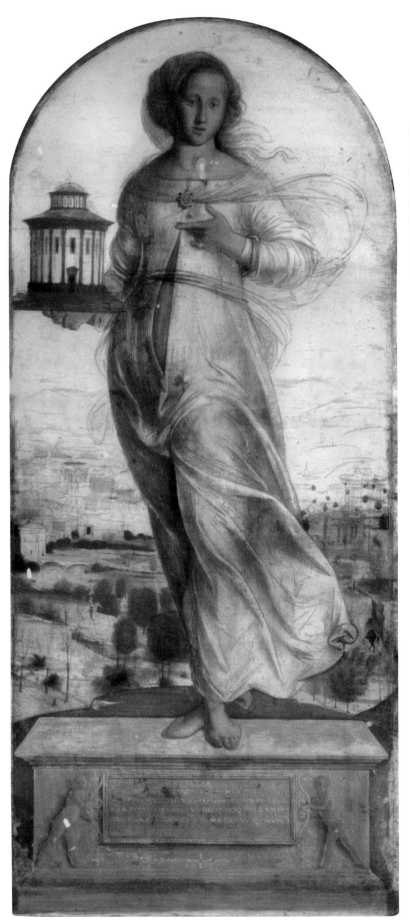

FIG. 36 *Sulpitia*. Infrared reflectogram mosaic.
(below) FIG. 37 *Sulpitia*. Infrared reflectogram mosaic detail.
(bottom) PLATE 70 *Sulpitia*. Detail of PLATE 25.

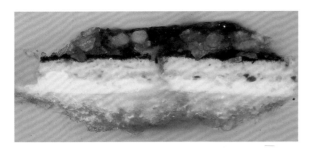

PLATE 71 *Sulpitia*. Cross-section of a sample from a dark green bush in the landscape on the left. Over the gesso there are three layers containing lead white, ultramarine, azurite and red lake (probably underpainting for the landscape, and perhaps the building behind the bush), and then a layer of black, which serves as an underpainting for the coarsely ground malachite of the foliage. Photographed at a magnification of 640×.

PLATE 72 *Sulpitia*. Cross-section of a sample from the red dress. Over the gesso is some carbon black underdrawing and then layers of vermilion, red lake, lead white and some ultramarine. This is completed with a glaze of red lake. Photographed at a magnification of 640×.

PLATE 73 *Sulpitia*. Cross-section of a sample from the flesh of the putto on the left side of the pedestal. Over the gesso is a layer of lead white with a little black (the pedestal), followed by a layer of green earth with some malachite, lead white and bone black and then a layer of vermilion, red earth and lead white. Photographed at a magnification of 320×.

have been considered inappropriate in a depiction of an exemplar of sober female virtue. The temple that she holds as an attribute was improvised freely in the underdrawing with repeatedly sketched lines for the edge of the roof and a different shape for the top.

A similarly spontaneous drawing appears in the landscape, with on the left lines of distant hills, then a

town, complete with spiky little figures in the piazza, but only followed roughly in the underdrawing, and closer to the foreground a pastoral scene with cattle, including an extra cow, probably also painted, but now obscured by a bush. On the right in the underdrawing (FIG. 37) are some hill-top towns and a little temple of the same design as the drawn version held by the main figure, and with the same rounded top to the oculus. It is unmistakably a complete structure. In the painting, on the other hand (PLATE 70), it is shown lower down and in the process of being built, with on the steps the little red figure of Sulpitia, accompanied by several female figures. This introduces a narrative element, previously absent, and it is tempting to suggest that Francesco di Giorgio in his supervisory capacity inspected the underdrawing and asked for the change. Alternatively it is just possible that the change was Orioli's idea and that this triggered the introduction of the subsidiary episodes in the other panels. Either way, the figures cannot have been easily legible at the height that the panels were probably displayed, and the rest of the detail seems to be entirely incidental to the main figure. Moreover, the scale and the bird's-eye viewpoint of the landscape are very different from the Griselda Master's backgrounds to the other panels.

The sky is painted with ultramarine and white as in the rest of the series, but it is more intense in colour (originally it was even more so, but is now rather rubbed). The other skies graduate evenly to a pale horizon, but here the blue extends down further. The sky glows pale yellow above the hills, and is streaked with pink, orange and grey clouds, some with touches of gold leaf. The distant hills must also have been painted with ultramarine, and a pale blue underpainting extends down into the landscape, appearing as the lowest layer – but with the greener blue of azurite instead of ultramarine – in a paint sample from a bush at the left end of the bridge on the left (PLATE 71). In the sample there are then layers containing more blue, and also red lake. These can probably be associated with the pinkish bridge – Orioli often introduced touches of bright, slightly unreal colour in his landscapes and architecture – and then above is a thin layer of black pigment. The trees and bushes in the middle distance appear very dark in infrared and it seems that here Orioli reverted to an old tradition of using black as an underpainting for malachite greens. The character of the particles of mineral malachite, now embedded in a darkened matrix of medium, indicates that it was probably from the same source as the pigment seen on the other panels.[133]

The multiple layer structure of the sample from the landscape is the result of superimposition of

details, but a cross-section from the figure's red dress (PLATES 72 and 74) demonstrates a technique of some complexity, and yet another variation within this series on the combination of different pigments and media for areas of pink and red. In a sample, from the shadowed left edge, there is no white underpaint or priming as in many of the other panels; instead, over the black underdrawing are several thin layers containing lead white, red lake, red iron oxides and a little black. Lighter areas obviously contain a much higher proportion of lead white. The underlayers appear to be in egg tempera, but the final glazes of red lake, either alone or with black in the deepest shadows, are bound in oil. In common with the other painters working on the panels, Orioli tended to retain the hatched application of tempera when working in oil, and it may be that this use of oil was a new departure for him.[134] His altarpieces all have the appearance of being in tempera; moreover, he seems to have preferred to leave them unvarnished and some may have remained in that state.[135]

Above all, it is in the painting technique of the pedestal (see PLATE 77) that the separation of Orioli's panel from the main group becomes apparent. Evidently he received instructions as to the pedestal's dimensions and general design, but he not only painted it a different colour, a very pale grey consisting of lead white with a small amount of carbon black, but he also applied this base colour over the entire area of the pedestal (PLATE 73). In the X-radiograph (FIG. 14), it can be seen that, unlike the other panels, no areas were reserved for the blue background of the inscription, let alone for the putti and the gilded decoration. The putti conform to the open-legged type, but have their arms differently posed, and are without wings. Their cast shadows imply that they are fully three-dimensional, whereas on the other pedestals the putti are clearly relief sculptures, although there seems to be some teasing ambiguity as to whether they might be living flesh. The technique for painting the flesh of the Orioli putti appears to be the same as that of the main figure, and the dull semi-translucent green layer on top of the pale grey of the plinth in the paint sample, taken from the putto on the left, contains mainly green earth. It is clearly an underpainting for the flesh tints of lead white and vermilion and red iron oxides. Green earth absorbs infrared and so the even tone and the relative darkness of Sulpitia's face, hands and feet in the reflectogram indicate that this traditional underpainting for flesh tints in tempera is almost certainly present there as well.

The gilded decoration of the plinth follows the set pattern only in the volutes and little crescents held by

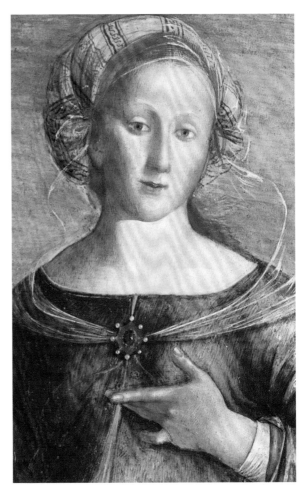

PLATE 74 *Sulpitia.* Detail of PLATE 25.

the putti; the jewelled ornament suspended beneath the inscription tablet seems to be Orioli's invention. The hair of the putti and their sashes are picked out with touches of gold, and delicate highlights of gilding are scattered across the landscape – on the blades of grass around the plinth, on the bushes and buildings and streaked across the mountains and sky – and on the figure, including the temple that she holds as well as her hair, brooch, veils and the borders of her dress. In spite of its extent, the discreet nature of the gilding leaves the impression of a less richly decorated surface than most of the other panels.

Judith or *Tomyris of Scythia*

Matteo di Giovanni belonged to the same generation of painters as Francesco di Giorgio and Neroccio, and his fame would have made him an obvious candidate in any attempt to show off the skills of all the leading artists of Siena.[136] He, like Neroccio and Francesco, had contributed designs for the Duomo pavement Sibyls. Moreover, he had actually been Orioli's master, providing another route for the younger painter's co-option. It seems possible that he was involved at an

early stage, but the cutting of the panel and the loss of most of the background with its narrative elements make it more difficult to estimate its place in the chronology of the series. Stylistically the painting seems to belong to the very end of Matteo's career. The panel may have been cut partly because the lower part was in poor condition, as was probably the case with its neighbour, *Artemisia*, but it is just possible such a drastic reduction may also have been an attempt to convert the image of Tomyris into the more saleable Judith. The iconography of both is likely to be consistent: the figure brandishing her weapon and holding a severed head by the hair – the head in this case is noticeably undersized and must be to some extent emblematic.

In addition to the identifying inscription, the cutting has eliminated episodes which would have further defined the figure. The story of Judith is well-known. The widowed Queen Tomyris, having defeated Cyrus, the invading Persian king, dipped his severed head in a wineskin of blood. The row of tents on the right implies a military encampment – a feature of both stories. The likelihood that these episodes were painted on a scale similar to the background of *Sulpitia* is suggested by the small size of these tents when compared with those in *Scipio* and *Alexander*. In front of the tents are remnants of little figures but in the infrared reflectogram (FIG. 38) it can be seen that only the head of the horse and its rider are original – the rest is restoration relating to the added parapet (see Appendix, p. 70). The reflectogram also shows the helmeted head of a soldier that was drawn but not painted, as well as a building between two of the conical hills.

On the left of the main figure Matteo sketched an elaborate walled city with the tops of the towers rising almost to the level of the areas that were to be covered by the frame capitals (FIG. 39). The greater density of the paint of the sky in this area in the X-radiograph (FIG. 10) suggests that he first covered it over with a hill, perhaps with a tower, and then brought the horizon line down to make it more consistent with that on the right, as well as with the other panels. Again it is possible to imagine Francesco di Giorgio's involvement in the alterations.

The main figure was drawn in great detail using a brush and a liquid medium, and with extensive shading in the form of parallel diagonal lines, which occasionally intersect as cross-hatching. Every drapery fold is shaded and the structure of her head and that of her victim are carefully modelled with shorter hatched lines (although some of those visible in infrared on the latter are in the final paint layers).

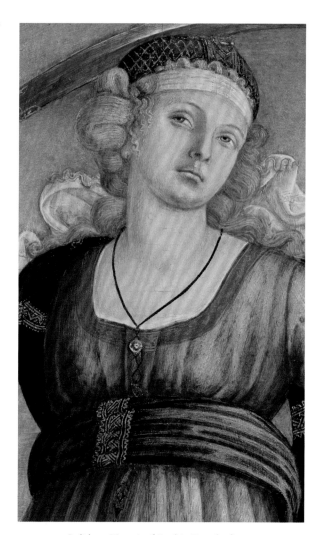

PLATE 75 *Judith* or *Tomyris of Scythia*. Detail of PLATE 23.

PLATE 76 *Judith* or *Tomyris of Scythia*. Cross-section of a sample from the red dress showing a layer of red lake and lead white over a lead white *imprimitura* applied to the gesso ground. Photographed at a magnification of 640×.

Heavily shaded underdrawings have been discovered on other works by Matteo,[137] but this one is of exceptional elaboration and refinement. Moreover, it was mostly followed with precision in the painting, the only divergences being a slight change to the edge of her scimitar to make it fit better into the arch, a

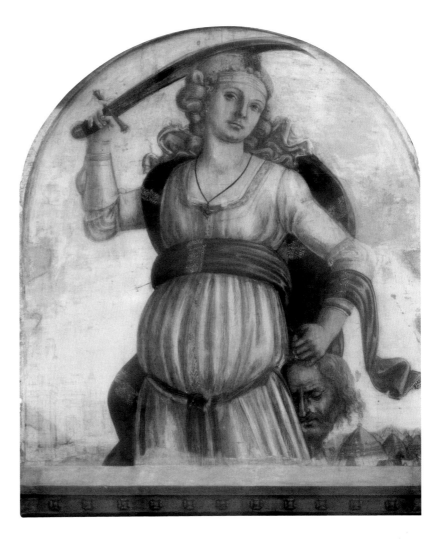

(right) FIG. 38 *Judith* or *Tomyris of Scythia*. Infrared reflectogram mosaic.

(below) FIG. 39 *Judith* or *Tomyris of Scythia*. Infrared reflectogram mosaic detail.

narrowing of the decorative band around her neckline, and the shortening of a few locks of hair.

The whole painting appears to have been executed in egg tempera,[138] but rather surprisingly the gesso and underdrawing were first covered with a substantial *imprimitura* of lead white with a little chalk, also in egg (PLATE 76). Such primings are not necessary when working in tempera and they are not always present on other paintings by Matteo.[139] It may have been used here to reduce the visibility of the underdrawing; egg tempera has relatively poor coverage and so there must have been a danger of the drawing being too visible, especially in the figure's fair flesh tones and blonde hair (PLATE 75).

The flesh paint, consisting of lead white tinted with vermilion and red iron oxide, was applied directly over the white priming, without any green earth or verdaccio underlayer.[140] The sky is painted in ultramarine and lead white as are the others in the series but instead of brushmarked oil paint, the individual strokes of tempera are visible and the sky now appears thin and rather streaky. The dress was modelled by typical tempera hatching over the white

imprimitura with layers of red lake, mixed with varying amounts of vermilion, red iron oxide and lead white. Her cap is probably ultramarine and the dark green scarf or shawl wound around her must be a copper-based pigment, probably malachite, judging by its dark appearance in infrared. The reflectogram also confirms that a triangle of pale blue sky was painted over the green scarf immediately under her arm on the right, reducing the width of the scarf and connecting the figure better to the landscape. The costume is bizarre and not always logical: a strip of blue fabric decorated with patterns in gold leaf runs down the centre of the dress, almost as if it were exposed by an opening to an underskirt, although such rich textiles can surely never have been worn in this way. It is an addition over the red, made perhaps to increase the exoticism of her costume and the amount of gilding in order to echo the richness of her probable male counterpart, Alexander. Matteo, when depicting cloth-of-gold textiles in his *Assumption* altarpiece in the National Gallery, did so using yellow paint rather than gold. Although he is likely to have been responsible for the gilded patterns on the scarf and headdress, it is just possible that this extra strip of textile was added at a very late stage, perhaps even by the painter who apparently finished the series, the Griselda Master.

The pedestals and inscriptions

The differences between Orioli's *Sulpitia* and the other panels (PLATES 77 and 78) would appear to extend to the lettering of the inscription which, though the individual letter forms are analogous, is perhaps rather more elegant in its line-spacing than that on the pedestals in *Tiberius Gracchus* and *Alexander the Great*, even allowing for the fact that the inscriptions on these last are less well preserved.[141] The inscriptions on the other two panels that have retained their pedestals, *Scipio* and *Claudia Quinta*, have both been repainted and regilded. A cross-section from the latter (PLATE 79) shows the same layer structure for the blue base as *Alexander*; above it is the gold leaf of the original lettering, and then the new blue ground, painted with a more finely ground blue pigment – this time just natural ultramarine with lead white and in an oil medium instead of the tempera of the original – and finally the gold leaf of the new inscription. In places, the old letters are just visible on this and the *Scipio* inscription; it can be seen that the spacing between the rows is closer to that of *Alexander* and *Tiberius* than *Sulpitia*, but unfortunately the letters are insufficiently clear to determine whether the inscriptions have been changed; if that were so, it might imply that they were re-gilt, perhaps at a relatively early date, in order to correct errors rather than because they were damaged.

In the repainting of the inscriptions on *Scipio* his name was obscured by the new base colour, but can still be made out when the panel is viewed in raking light. On all the panels (except *Claudia Quinta* whose name appears as the first words of her commentary), these names are almost certainly additions themselves, squeezed in above the main inscription. On the *Sulpitia* in particular, the larger, somewhat more clumsy epigraphy of the letters in the name (as opposed to the main inscription) is marked and their different appearance is emphasised when this area is

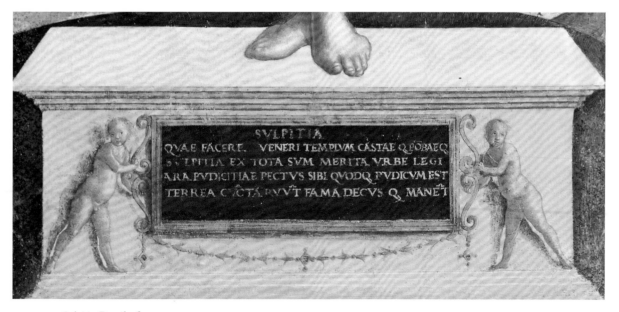

PLATE 77 *Sulpitia*. Detail of PLATE 25.

viewed in infrared (FIG. 36). It seems possible that the names were added when the panels were set up in their final position, presumably because the inscriptions were not considered adequate to explain the identity of some of the lesser-known figures. The question of who was responsible for the lettering of the inscriptions is an open one, but it should not necessarily be assumed that it was always the responsibility of the painters of each panel. Certainly the names appear to have been delegated to a single one craftsman and it is even possible, notwithstanding the difference of organisation between *Sulpitia* and the others, that another executing hand was responsible for the commentaries. Indeed it has already been suggested that the Griselda Master may have had to paint the pedestals of his panels before he had designed and underdrawn the figures, because they needed to be ready for application of the lettering, perhaps by this other craftsman.

The issue as to who may have devised the contents of the inscriptions has been discussed by Caciorgna, and may also be connected with whoever commissioned the panels.[142] Although the crescents (closer to a full ring in the case of Neroccio's pedestal for *Claudia Quinta*) have often been taken to indicate a Piccolomini commission, the crescent is, as Kanter has pointed out, omnipresent in Sienese heraldry. A feature not previously noted on the pedestals painted by the Griselda Master (who, if he were working under the direction of Francesco di Giorgio might be expected to be better informed than the other artists) are the cartwheels seen from the side which hang from the ends of the leafy garlands looped through

PLATE 79 *Claudia Quinta*. Cross-section of a sample from the blue background for the pedestal inscription showing two layers of azurite and then a little gold leaf from the original inscription. Over this is a layer of natural ultramarine and lead white and more gold leaf from the later reworking of the inscription. Photographed at a magnification of 320X.

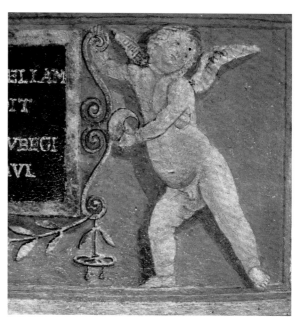

PLATE 80 *Scipio Africanus*. Detail of PLATE 21.

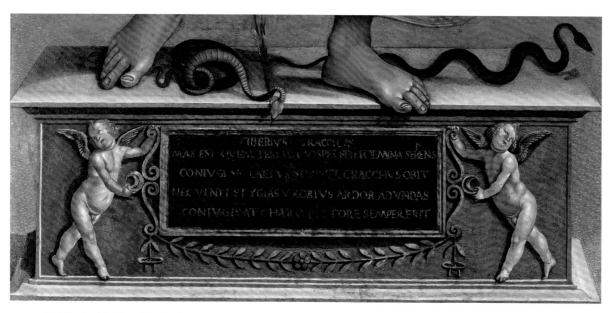

PLATE 78 *Tiberius Gracchus*. Detail of PLATE 22.

the lower parts of the volutes. Each has two objects dangling from them; they are clearest in *Scipio* – despite its abraded condition – where they appear to be shaped like spoons or perhaps drop pearls (PLATE 80). On *Tiberius* they appear more like rods. It is just possible that these objects – hardly a standard element of such ornament – might also be treated as heraldic clues. A *cassone* in the Bagatti-Valsecchi Collection in Milan, with a processional scene, has two coats of arms, Piccolomini on the left and another, yet to be properly identified, including a wheel seen full-face on the left, possibly of the Santi family.[143] This connection would not, however, explain the other elements dangling from the wheels. A solution remains to be found.

Conclusion

If the trajectory of the career of the Griselda Master, as set out in this article, is taken into account, the field or range of possible patrons is narrowed. Given that the Griselda panels themselves can now be dated with some security and if, as seems to be the case, the Master's first contributions to Francesco di Giorgio's *Scipio* and Neroccio's *Claudia Quinta* were painted before the Griselda panels, then it can be argued that the project of the Virtuous Men and Women was initiated before the end of 1493. This date would fit with the widely accepted association with the marriage of Silvio Piccolomini and Battista Placidi in January 1493, but it cannot be entirely excluded that this series too was linked to the celebrations of the double Spannocchi wedding, since the two projects appears to have been chronologically intertwined. It is certainly a curious coincidence that the small flags

carried in the procession in the background of *Reunion* and the flags that top the tents in *Alexander* and *Scipio* have all been defaced by scoring with a cross (and there is no evidence that there were ever heraldic features which might have been removed if ownership changed) (see Appendix, PLATES 85–87). These scored damages are old enough for the lines to have been filled with varnish residues and repaint that go back at least to the nineteenth century. This would suggest that both sets of panels had, for a time a least, a shared ownership, perhaps as the result of the bringing together of family collections, their purchase by a single collector, or even, conceivably, because they had in fact been originally executed for the same palace setting.

It therefore seems that halfway through the painting of the Virtuous Men and Women (assuming that the panels by Orioli and Matteo di Giovanni were begun at a relatively early stage), the Griselda Master was assigned the panels from which he takes his 'name', a commission that may well have come to him via Francesco di Giorgio. In the course of the execution of the Griselda panels, he developed rapidly as a painter, gaining in confidence as he designed the figures, their anatomies and their architectural and landscape settings, and becoming ever more sophisticated in his approach to narrative. At the same time he gradually shifted his technique away from the tempera-based tradition of the older generation of Sienese painters towards a more modern oil method, derived in part from his study of works in Siena by Signorelli (and perhaps also through looking hard at the achievements of Perugino). On completion of the Griselda narratives, and perhaps as the result of their undoubted accomplishment, he was promoted within

PLATE 81 *Marriage.* Detail of PLATE 1.

the Virtuous Men and Woman project and given sole responsibility for the four remaining panels.

Even within this sequence, the stylistic and technical evolution of this young painter was still very fast. He continued to exploit iconographic and figurative motifs taken from Signorelli and Perugino, but whereas in the *Joseph* he continued to make reference to older Sienese masters, by the time he painted *Artemisia* he had fully absorbed the lessons of these two most admired painters and combined them in a way that was stylistically more thoroughly unified. The face of Tiberius, for example, is modelled in a manner closely akin to that of Signorelli, but his features are actually more refined than those by the older painter. The background figures in this picture, though they retain their characteristic elegance and bounce, display the increasing naturalism associated with *Exile*, while the architecture is more restrained and the trees and foliage have a new feathery freshness, which is also more true to nature (PLATES 81 and 82). There is evidence, especially in the *Artemisia*, of some haste in finishing the series – perhaps at the behest of an impatient patron – but the Griselda Master's confidence in undertaking the project is remarkable. By its end he had achieved a blend of styles that had become uniquely his. We can only wonder what he might have accomplished next.

Carol Christensen is Senior Painting Conservator at the National Gallery of Art, Washington, where she most recently co-wrote the Technical Notes for the Gallery's systematic catalogue Italian Paintings of the Fifteenth Century. She has published on technical aspects of Raphael, Van Dyck and Gauguin.

PLATE 82 *Tiberius Gracchus.* Detail of PLATE 22.

Table 1. Summary of the pigments in paintings by the Master of the Story of Griselda and in the Virtuous Men and Women Series

Artist, Painting and location	Master of the Story of Griselda, *The Story of Patient Griselda: Marriage, Exile* and *Reunion* (NG 912, 913, 914), National Gallery, London.	Master of the Story of Griselda, *Alexander the Great*, Barber Institute, Birmingham.
Blue	Sky: ultramarine and lead white. Blue trousers of figure at far left: ultramarine over azurite. Blue paint on arches: ultramarine over azurite with associated greenish minerals containing Cu, Sb, As and Zn.	Sky: ultramarine and lead white. Blue of tunic: ultramarine with a little red lake over azurite. Blue of sword belt: thin layer of ultramarine over azurite with associated greenish minerals containing Cu, Sb, As and Zn. Blue of inscription panel on pedestal: thin layer of ultramarine over azurite with associated greenish minerals containing Cu, Sb, As and Zn and dolomite impurities.
Red	Opaque bright red hose of servant: vermilion with a little red earth or red lead. Red of servant girl's dress: red lake (kermes) and lead white (see p. 15).	Alexander's red hose: red lake (kermes) and lead white.
Flesh	*Marriage* and *Reunion* (NG 912 and 914): green earth underpaint covered by a layer of lead white, vermilion and black. *Exile* (NG 913): yellow-brown underpaint beneath a pink layer.	Flesh from Alexander's hand: lead white, vermilion, yellow earth and a little black.
Green	Translucent deep green hose of man (NG 914): verdigris and lead-tin yellow. Grass (NG 914): verdigris, white, lead-tin yellow and black over a layer of lead white and azurite. Green leaves of tree: verdigris, lead-tin yellow, lead white. Dark green on hillside: malachite with associated copper minerals containing Cu, Sb, As and Zn and dolomite impurities.	Green landscape: verdigris, lead-tin yellow, lead white, perhaps a little yellow earth, sometimes mixed with black.
Gilding	Mordant-gilded pattern on the arches: gold leaf over a translucent yellow-brown unpigmented mordant.	Mordant gilding on the shoes, the tents in the background landscape, and the plinth: gold leaf over a translucent yellow-brown unpigmented mordant.
Yellow and orange	Orange-yellow paint beneath mordant gilding on the arches: lead white, vermilion, yellow earth pigment containing a little zinc. Yellow tunic of standing servant (NG 914): yellow earth, a little vermilion and black.	Orange paint of shoes: earth pigment rich in iron oxide (small amount of manganese), mixed with vermilion and possibly a little red lead.
Grey and black	Grey of Griselda's habit: lead white, coarse black, vermilion, red lake, yellow earth. Grey paint of horse: coarse carbon black, lead white, colourless manganese-containing glass.	Lilac-grey paint of the pedestal: lead white with a little azurite and red lake.

Neroccio de'Landi and the Master of the Story of Griselda, *Claudia Quinta*, National Gallery of Art, Washington.	Master of the Story of Griselda, *Joseph of Egypt* or *Eunostos of Tanagra*, National Gallery of Art, Washington.	Pietro Orioli, *Sulpitia*, Walters Art Gallery, Baltimore.	Matteo di Giovanni, *Judith* or *Tomyris of Scythia*, University Museums, Bloomington, Indiana.
Sky: ultramarine and lead white. Blue of inscription panel on pedestal: azurite with associated minerals containing As, Cu, Sb, and Zn and dolomite impurities.	Sky: ultramarine and lead white.	Sky: ultramarine and lead white.	Sky: ultramarine and lead white.
Claudia's red robe: red lake (insect source?) with some vermilion.	Red of robe worn by Joseph: red lake (insect source) and lead white.	Sulpitia's red robe: red lake (insect source) and lead white over a layer of vermilion, red lake (insect source?), lead white and some ultramarine.	Red of robe worn by Judith: red lake (insect source?) and lead white.
Flesh from Claudia's left foot: pale green layer (green earth and lead white) covered by a thin layer of vermilion, lead white, chalk and dolomite.	Flesh of Joseph: green earth, lead white, red earth and some red lake (insect source?).	Flesh of putto: green underpaint (green earth, malachite, lead white and bone black) covered by a layer of vermilion, red earth and lead white.	Flesh of Judith: vermilion and lead white.
Green from foreground: malachite with associated minerals containing Cu, As, Zn and Sb, dolomite impurities and lead-tin yellow.	Foreground foliage: verdigris and lead-tin yellow.	Dark green foliage: malachite with associated minerals containing Cu, As, Zn and Sb and dolomite impurities.	
Mordant gilding: gold leaf over a translucent yellow-brown unpigmented mordant.			
		Pale grey paint of the pedestal: lead white and carbon black.	

Acknowledgements

This article has involved scientists, curators and restorers in many institutions. In Budapest we would like to thank László Baán, Dora Sallay, Miklós Szentkirályi, Imre Nemcsics and especially Vilmos Tátrai, whose earlier work on the Griselda Master was to prove so prescient. In Florence, we are grateful to Beatrice Paolozzi Strozzi and Maria Grazia Vaccari at the Museo Nazionale del Bargello, and in Milan at the Museo del Poldi Pezzoli to Annalisa Zanni, Andrea di Lorenzo and Domenico Collura for their usual generous spirit of collaboration. The examination of the Florence and Milan panels could not have been carried out without our valued colleagues at the Opificio delle Pietre Dure, Florence, in particular Cristina Acidini, Cecilia Frosinini, Roberto Bellucci, Ciro Castelli and Pasquale Poggi. The bringing together of all four Virtuous Men and Women in the United States was invaluable and we would like to thank all those who made it possible, including, in Baltimore, Joaneath Spicer, Morten Steen Hanson, Eric Gordon and Karen French; in Bloomington, Adelheid Gealt and Margaret Contompasis; and in Washington, Alan Shestack, David Alan Brown, Gretchen Hirschauer, Sally Freitag, Ross Merrill and Sarah Fisher. Several members of the Scientific Research Department at the National Gallery of Art, including Michael Palmer, Suzanne Quillen Lomax and Lisha Glinsman worked on paint samples, while X-radiography and infrared reflectography were carried out by Sarah Feinstein.

At the National Gallery, London, we are grateful to Richard Verdi and Paul Spencer-Longhurst of the Barber Institute for entrusting *Alexander the Great* to us, and to Rachel Billinge, Catherine Higgitt, and in particular to Marika Spring, who compiled the table of pigments together with Michael Palmer. We would also like to thank the following for various forms of assistance and helpful comments: Alessandro Angelini, Philippa Jackson, Fabrizio Nevola, Francis Russell, Carl Strehlke and Alison Wright.

Notes

1 M. Davies, *National Gallery Catalogues. The Earlier Italian Schools*, rev. edn, London 1961, pp. 365–7.

2 Boccaccio, *Decamerone*, X,10. The last of the sequence. Although it was very well known, this does not appear be have been an especially common subject in Italian quattrocento painting. But see, reconstructed in the Castello Sforzesco in Milan, the late fifteenth-century detached grisaille frescoes originally from the so-called Sala of Griselda, Castello di Roccabianca, near Parma, and a pair of Florentine *cassoni* in Bergamo attributed to Pesellino (see P. Schubring, *Cassoni. Truhen und Truhenbilder der italienischen frührenaissance*, Leipzig, 1923 III, p. LXI) with a very simplified rendition of the story. For the subject see S.S. Allen, 'The Griselda Tale and the Portrayal of Women in the *Decameron*', *Philological Quarterly*, LVI, 1977, pp. 1–13. We should not forget Petrach's version: 'De insigni obedientia e fide uxoria' (*Seniles*, XVII, 3).

3 B. Berenson, 'Quadri senza casa: il Quattrocento senese, II', *Dedalo*, Anno xi, III, 1931, pp. 735–67, esp. pp. 750–3.

4 G. De Nicola, 'Notes on the Museo Nazionale of Florence – IV: Fragments of Two Series of Renaissance Representations of Greek and Roman Heroes', *Burlington Magazine*, XXXI, 1917, pp. 224–8.

5 The Griselda Master has been identified as the mature Bartolomeo della Gatta by A. Marini, 'The Early Work of Bartolomeo della Gatta', *Art Bulletin*, XLII, 1960, p. 141; as the young Baldassare Peruzzi by Laurence Kanter and Michael Miller, see M. Miller, ' "Alcune cose in Siena, non degne di memoria" – Baldassare Peruzzi's Beginnings', *Allen Memorial Art Museum Bulletin*, XLVI, no. 2, 1993, pp. 3–16, esp. pp. 10–13, 15 note 42; as Rocco Zoppo by C.E. Gilbert, 'Griselda Master' in *The Dictionary of Art*, XX, London, 1996, p. 684; and as possibly the same painter as the one now called the Maestro dei putti bizzari by A. Angelini, 'Intorno al Maestro di Griselda', *Annali (Fondazione di Studi di Storia dell'Arte Roberto Longhi, Firenze)*, II, 1989, pp. 5–15; alternatively to be cautiously identified with Girolamo di Domenico in id. in L. Bellosi, ed., *Francesco di Giorgio e il Rinascimento a Siena 1450–1500*, exh. cat., Sant'Agostino, Siena 1993, pp. 424–7; or with Pietro d'Andrea da Volterra in id., 'Pinturicchio e i pittori senesi: dalla Roma dei Borgia alla Siena di Pandolfo Petrucci' in M. Caciorgna, R. Guerrini and M. Lorenzoni, ed., *Studi interdisciplinari sul Pavimento del Duomo d Siena: iconografia, stile, indagini scientifiche. Atti del Convegno internazionale di studi (Siena, Chiesa della SS. Annunziata, 27 e 28 settembre 2002)*, Siena 2005, pp. 83–99, and id., 'Pintoricchio e i suoi: dalla Roma de Borgia alla Siena dei Piccolomini e dei Petrucci', in Angelini ed., *Pio II e le arti. La riscoperta dell'antico da Federighi a Michelangelo*, Siena 2005, pp. 483–553, esp. pp. 497–9. None of these solutions is entirely satisfactory.

6 C. de Carli, *I deschi da parto e la pittura del primo rinascimento toscano*, Turin 1997, pp. 178–9. This was first attributed to the anonymous master by De Nicola 1917 (cited in note 4), p. 227, note 9. See note 22 below.

7 The attribution of another group, the female personifications of the three theological virtues, to the Griselda Master does not appear to be correct. See L. Vertova, 'Cicli senesi di virtù: inediti di Andrea di Niccolò e del Maestro di Griselda' in M. Natale, ed., *Scritti di storia dell'arte in onore di Federico Zeri*, Milan 1984, pp. 200–12, esp. pp. 205–12, supported in part by L.B. Kanter in K. Christiansen, L.B. Kanter, C.B. Strehlke, *Painting in Renaissance Siena, 1420–1500*, exh. cat., Metropolitan Museum of Art, New York 1988, pp. 344–51, cat. 75 a–c; id. 'Rethinking the Griselda Master', *Gazette des Beaux-Arts*, CXLII, February 2000, pp. 153–4, esp. pp. 469–7, note 5. Rejected by M. Boskovits, 'Master of the Griselda Legend' in M. Boskovits and D.A. Brown, *Italian Paintings of the Fifteenth Century: The Collections of the National Gallery of Art. Systematic Catalogue*, Washington 2003, pp. 496–504, esp. p. 496, note 5.

8 A.B. Barriault, *Spalliera Paintings of Renaissance Tuscany: Fables of Poets for Patrician Homes*, University Park, Pa. 1994, pp. 118–19, 148–9, cat. 9.

9 G.F. Waagen, *Treasures of Art in Great Britain: being an account of the chief collections of paintings, drawings, sculptures, illuminated mss.*, IV, London 1857, p. 75. Waagen writes, rather touchingly, 'Besides this, Mr. Barker possesses several more pictures of a frieze-like form, which he also attributed to Pinturicchio. As my mislaid notices refer to these, my memory only serves to state that two of them [probably two of these paintings] represent scenes from a tale with which I am unacquainted, that they are full of animated and often very graceful motives, unequal in execution, sometimes careful and sometimes sketchy. Generally speaking the proportions are of a length, compared with the small heads, such as I have never seen in the authentic pictures by Pinturicchio.'

10 *Catalogue of the Renowned Collection of Works of Art formed by that distinguished connoisseur, Alexander Barker, Esq. ...* Christie, Manson and Wood, 8 King Street, London, 6,8–11 June 1874, p. 17, lots 85–7.

11 V. Tátrai, 'Il Maestro della Storia di Griselda e una famiglia senese di mecenati dimenticata', *Acta historiae artium Academiae Scientiarum Hungaricae*, XXV, 1979, pp. 27–66.

12 For the Spannocchi brothers and their wedding see A. Lisini, *Medaglia d'Antonio Spannocchi*, Milan 1908; U. Morandi, 'Gli Spannocchi: piccoli proprietari terrieri, artigiani, piccoli, medi e grandi mercanti-banchieri', in *Studi in memoria di Federigo Melis*, III, Naples 1978, pp. 91–120.

13 This information and the most detailed account of the wedding ceremonies is given in I. Ugurgieri Azzolini, *Le Pompe sanesi, o' vero, relazione delli huomini e donne illustri di Siena, e suo stato*, Pistoia 1649, p. 323–4. He evidently based his account on a family chronicle: 'per quanto si legge in un antico manuscritto, che è nelle mani del dottissimo Pandolfo Spannochij, e in alter croniche della nostra città.' Confirmation for the existence of the temporary arch comes in the account by Allegretto Allegretti, *Ephemerides Seneses ab anno MCCCCL usque ad MCCCCXCVI italico sermone scriptae*, in L. Muratori, ed., *Rerum Italicarum Scriptores*, XXIII, Milan 1733, p. 840: 'Adì 17. di Gennaio 1493 [i.e. 1494]. Venne in Siena la

Donna di Giulio d'Ambrogio Spannocchi con bella compagnia, & entrò alla Porta Tufi, e uscì alla Porta Nuova, e scavalcò al Palazzetto dell' Erede di Miss. Francesco Tolomei a Maggiano … e la mattina adì 19. in Domenica fu gran freddo, e gran vento; e questo dì fanno le Nozze. E menò Donna Antonio e Giulio Spannocchi con grandissimo trionfo e onore, e con grande spesa, e con un grande Difizio d'un'Arco Trionfale alla Porta delli Spannocchi, che costà più che 100. Ducati.'

14 See B. Berenson, *Italian Pictures of the Renaissance. Central Italian and North Italian Schools*, I, London 1968, p. 252: 'Longleat (Wilts.). MARQUESS OF BATH. Two cassone fronts with Roman subjects (also listed Bartolomeo di Giovanni).' For Bartolomeo see most recently, N. Pons, ed., *Bartolomeo di Giovanni: collaboratore di Ghirlandaio e Botticelli*, exh. cat., Museo di San Marco, Florence 2004. For the Longleat panels, see L. Syson in B. Santi and C. Strinati ed., *Siena e Roma. Raffaello, Caravaggio e i Protagonisti di un Legame Antico*, exh. cat., Santa Maria della Scala, Palazzo Squarcialupi, Siena 2005, pp 199–203, cat. 2.18–20.

15 Vasari-Milanesi, III, p. 275. See J.K. Cadogan, *Domenico Ghirlandaio: Artist and Artisan*, New Haven and London 2000, p. 288, no. 73 (under 'Lost Works').

16 Ibid., pp. 374–5, doc. 43.

17 Thus Tátrai's suggestion that when, in 1625–6, Fabio Chigi listed 'In casa Spannocchij, ivi Alisandro Botticello' among the paintings to be then found in Siena, he might have been looking at the Griselda paintings with their Botticelli Venus-like female nude, becomes highly plausible. See Tátrai 1979, p. 61 (cited in note 11).

18 Boskovits 2003 (cited in note 7), pp. 496–504, esp. p. 496: 'For the moment Signorelli remains the central point of reference for the anonymous master. Not only does the latter imitate Luca's free and easy brushwork, he also re-proposes the gravity of gesture and elegance of pose seen in Signorelli's work along with his dark, gloomy shadows. The fact, too, that the Master of Griselda, while borrowing Signorelli's compositional formulas with such easy confidence, modifies and over-emphasises them, seems to point to a long acquaintance with the master's style. It is very likely that in the years around 1490 the Master of Griselda was in Signorelli's workshop and received his training there.'

19 Kanter 2000 (cited in note 7), p. 153.

20 F. Sricchia Santoro, 'Francesco di Giorgio, Signorelli a Siena e la capella Bichi' in Bellosi ed. 1993 (cited in note 5), pp. 420–3; L.B. Kanter and T. Henry, *Luca Signorelli: the Complete Paintings*, London 2002, pp. 20–1, 168–72, cat. 12–6. One of these also appears in his *Court of Pan* (ex-Berlin, destroyed).

21 Other relevant works such as the lost *Court of Pan* and the Berlin *Portrait of a Man* (see Kanter and Henry 2002, cited in note 20, pp. 26, 172–3, 174, cat. 18, 20) may also have been painted in Siena. The *Annunciation* in Volterra seems to be the only certainly non-Sienese painting that may have had some impact upon the Griselda Master, who seems to have used the arcade in which the Virgin stands as the model for his architecture in *Reunion*.

22 Certainly in his bacchic tondo, probably the Griselda Master's earliest surviving independent work (see note 6), most recently sold by Galerie Canesso in Paris to a private collector, the figure style shows little sign of non-Sienese influence and almost nothing of Signorelli (even if an iconographic model might have been the destroyed *Court of Pan* canvas). Instead the elongated figures have more in common with those by Benvenuto di Giovanni and, in particular, those in drawings by Francesco di Giorgio.

23 Angelini 2005 (cited in note 5), p. 91.

24 Where he may also have seen works by Botticelli. It is hard to imagine that the female nude in *Marriage* could have been painted without seeing Botticelli's mythologies.

25 V. Garibaldi, F.F. Mancini ed., *Perugino, il Divin Pittore*, exh. cat. Galleria Nazionale dell'Umbria, 2004, pp. 236–7, cat. I.33.

26 F. Zeri (*Italian Paintings in the Walters Art Gallery*, I, Baltimore 1976, pp. 135–8) said of the diminutive figures seen throughout the Baltimore picture that 'these reveal a hand very close to the anonymous painter called the Master of the Griselda Legend', an intriguing association, even if they are not in fact the same.

27 A. Bagnoli in Bellosi ed. 1993 (cited in note 5), pp. 410–13, cat. 87.

28 At the National Gallery, these include the two panels by Botticelli from the Saint Zenobius series (NG 3918 and 3919) and Piero di Cosimo's *A Satyr mourning over a Nymph* (NG 698).

29 See, for example, the paintings comissioned by his father for the marriage of Pierfrancesco Borgherini to Margherita Acciainoli in 1515, a series to which Pontormo is thought to have made the last contribution in *c*. 1517-18. See J. Sheerman, *Andrea del Sarto*, Oxford 1965, II, p. 233.

30 In Francesco di Giorgio's *Annunciation* (Siena, Pinacoteca Nazionale) the straight lines of the architecture are also ruled in ink instead of being incised; see L.L.Bellosi, 'Il "vero" Francesco di Giorgio e l'arte a Siena della seconda metà del Quattrocento' in Bellosi ed. 1993 (cited in note 5), pp 19–89, esp. p. 37, fig. 30.

31 In a paint sample that includes underdrawing in the layer structure, iron was detected by EDX analysis. This, together with the appearance of the drawing in infrared and also the distinctive cracking of the drawing material and of any paint applied over lines drawn with it, suggest that it is iron-gall ink. For other examples of cracking in underdrawings executed with iron-gall ink see J. Kirby, A. Roy and M. Spring, 'Materials of Underdrawing' in D. Bomford, ed., *Art in the Making: Underdrawing in Renaissance Paintings*, London 2002, pp. 26–37, esp. pp. 31–2.

32 In their stiffness of pose they are close in style to the bacchic tondo, probably his earliest independent known work; see notes 6 and 22.

33 The source for these spiralling folds, more extreme than any by Francesco di Giorgio, is possibly the draperies of Liberale da Verona and Girolamo di Cremona, for instance those of the figure in Graduals 21.6, 32.1A from the Piccolomini Library. See C. Del Bravo, *Liberale di Verona*, Florence 1967, pp. LXX–LXXV.

34 See D. Bomford, A. Roy and L. Syson, 'Gilding and Illusion in the Paintings of Bernardino Fungai' in this *Bulletin*, p. 111.

35 Neroccio's Saint Benedict predella (Florence, Uffizi) includes relatively small-scale figures with draperies ornamented in this way (see note 65 below).

36 Rocks in the background of the Longleat panel showing *Scenes from the Life of Alexander the Great* are similarly highlighted with gold. Their morphology, and the somewhat screen-like distribution of the trees, suggest an association with the Griselda panels.

37 See C. Higgitt, M. Spring, A. Reeve and L. Syson, 'Working with Perugino: The Technique of an Annunciation attributed to Giannicola di Paolo' (in this *Bulletin* pp. 96–110 and esp. note 12). Until many more paintings have been examined, it is not possible to determine how widespread the use of gum ammoniac was.

38 For publication of the results of medium analysis in the form of tables see C. Higgitt and R. White, 'Analyses of Paint Media: New Studies of Italian Paintings of the Fifteenth and Sixteenth Centuries', *National Gallery Technical Bulletin*, 26, 2005, pp. 89, 99–100.

39 For an account of this phenomenon see C. Higgitt, M. Spring and D. Saunders, 'Pigment-medium Interactions in Oil Paint Films containing Red Lead or Lead-tin Yellow', *National Gallery Technical Bulletin*, 24, 2003, pp. 75–95.

40 There are many instances of azurite and also malachite being used in oil, especially in northern European paintings, but nearly always mixed with some white or lead-tin yellow pigment. It is extremely difficult, however, to apply coarsely ground mineral pigments such as those on the Griselda panels in oil if they are used alone – they do not flow easily from the brush and have poor coverage. Pure azurite and malachite are more amenable in water-based media. In addition, the less saturating medium of egg tempera would have shown off better the intrinsic properties and colours of the pigments.

41 Associated with the azurite is a small amount of a distinctive yellowish-green complex copper mineral (EDX analysis detected Cu, Sb, Zn and As), together with some dolomite, both of which may be indicative of the source of the mineral pigment. Azurite with impurities of this composition occurs in Austrian paintings from the late fifteenth century and it has been suggested that it is a secondary mineral originating from the Fahlerz found in Schwaz in the Tyrol at the historic copper and silver mines that reached their peak in the sixteenth century; see H. Paschinger and H. Richard, 'Blaupigmente der Renaissance und Barockzeit in Österreich', *Naturwissenschaften in der Kunst, Beitrag der Naturwissenschaften zur Erforsching und Erhaltung unseres kulturellen Erbes*, Herausgegeben von Manfred Schreiner, 1995, pp. 63–6. Other Sienese panels in the National Gallery painted with azurite containing these impurities include Matteo di Giovanni's *Saint Sebastian* (NG 1461) and Benvenuto di Giovanni's *Madonna and Child* (NG 2482). Since similar impurities were found in the mineral malachite in the Griselda panels, it may therefore come from the same source. They were also found in the malachite in Matteo di Giovanni's *Saint Sebastian* (NG 1461), Orioli's *Nativity* (NG 1849), as well as in works associated with Botticelli's workshop. Occurrences of malachite with this distinctive mineral composition are fairly widespread, and so cannot be said to be characteristic of Sienese paintings; see also E. Martin, A. Duval, M. Eveno, 'Une famille de pigments verts mal connue', *Techne*, 2, 1995, pp. 76–9. We are grateful to Marika Spring for providing the information in this note.

42 EDX analysis showed that the red lake pigment is relatively high in phosphorus, which is usually indicative of an insect source for the dyestuff. The dyestuff from the kermes insect was identified by HPLC. For phosphorus in insect-derived dyestuffs and the extraction of kermes from silk see J. Kirby, M. Spring and C. Higgitt, 'The Technology of Red Lake Pigment Manufacture: Study of the Dyestuff Substrate', *National Gallery Technical Bulletin*, 26, 2005, pp. 71–85.

43 For the use of powdered glass as a drier see A. Roy, M. Spring and C. Plazzotta, 'Raphael's Early Work in the National Gallery: Paintings before Rome', *National Gallery Technical Bulletin*, 25, 2004, pp. 4–35, esp. p. 11, and M. Spring, 'Perugino's painting materials: analysis and context within sixteenth-century easel painting', Postprints of the workshop on the painting technique of Pietro Vannucci, called il Perugino, organised by INSTM and LabS-TECH, Perugia, April 14–15 2003, *Quaderni di Kermes*, 2004, pp. 17–24.

44 A much later example of the use of egg tempera to achieve bright white highlights on a damask table-cloth in a work painted otherwise in oil is Caravaggio's *Supper at Emmaus* (NG 172); see L. Keith, 'Three Paintings by Caravaggio', *National Gallery Technical Bulletin*, 19, 1998, pp. 37–51, esp. p. 22.

45 The technique is more commonly associated with painters from Northern Italy, including Mantegna, Schiavone, Zoppo and especially Carlo Crivelli. It also appears in paintings by Fra Angelico and his followers, including Benozzo Gozzoli, and in Umbria in works by Benedetto Bonfigli, but does not appear to have been widely used by Sienese painters. The marbling on Francesco di Giorgio's *Saint Dorothy and the Infant Christ* (NG 1682) and Benvenuto di Giovanni's *Virgin and Child with Saint Peter and Saint Nicholas* (NG 909), to take two examples from Sienese paintings at the National Gallery, is quite clearly painted in streaks with a brush.

46 They include Francesco di Giorgio, Neroccio de' Landi, Pietro Orioli and Benvenuto di Giovanni. In Florence the most important workshop still using green earth underpaintings for flesh was that of the Ghirlandaio brothers. Some of the Umbrian followers of Perugino (although not, it seems, Perugino himself) also employed the technique: see C. Higgitt, M. Spring, A. Reeve and L. Syson (pp. 96 of this *Bulletin*).

47 For the most compelling account of these pictures, see R. Bartalini in Bellosi ed. 1993 (cited in note 5), pp. 462–9, cat. 103.

48 When the *Tiberius Gracchus* is first recorded in the Esterházy Collection.

49 It has sometimes been thought that two other paintings in Boston and Tours and another group of three by Girolamo di Benvenuto and an artist close to Genga in private collections were also part of the series (for the former see B. Berenson, 'Les peintures italiennes de New York et de Boston', *Gazette des Beaux-Arts*, ser.iii, Vol. XV, 1896, pp. 195–214, esp. pp. 205–7 (attributed to Peruzzi); P. Hendy, *The Isabella Stewart Gardner Museum. Catalogue of Paintings*, Boston 1931, pp. 333–5; A.S. Weller, *Francesco di Giorgio, 1439–1501*, Chicago 1943, p. 295; for the latter see R. Longhi, 'Un intervento Raffaellesco nella serie "eroica" di Casa Piccolomini', *Paragone*, 175, 1964, pp. 5–8 – opinions now rightly and universally excluded.

50 See M. Natale, *Museo Poldi Pezzoli Dipinti*, Milan 1982, pp. 149–51, cat 184.

51 P. Scarpellini, 'Pietro Perugino e la decorazione della sala dell'Udienza' in Scarpellini ed., *Il Collegio del Cambio di Perugia*, Milan 1998, pp. 67–106, esp. pp. 97–105.

52 L. Venturi (trans. C. van den Heuvel and C. Marriott), *Italian Paintings in America*, vol. II ,1933, pl. 280, accompanying text.

53 First proposed by H. Comstock, 'Suggested identification for Signorelli's classical figure', *Connoisseur*, 94, October 1934, pp. 258–60, with a source in Plutarch's *Moralia* (*Quaestiones Graecae*, 40). Followed by most commentators subsequently. See especially L. Parri, 'Eunosto di Tanagra: un "eroe" Greco sconosciuto nel ciclo tardo-quattrocentesco senese denominato "Spannocchi-Piccolomini"', *Bollettino senese di storia patria*, XCVIII, 1991, pp. 287–98.

54 M. Caciorgna, 'Da Eunosto di Tanagra a Giuseppe Ebreo. Un dipinto del ciclo "Piccolomini" a Washington', *La Diana*, I, 1995, pp. 235–58. Followed, for example, by Boskovits 2003 (cited in note 7), p. 502, n. 6.

55 P. Scarpellini, *Perugino*, Milan 1984, p. 82, cat 43.

56 Bellosi ed.1993 (cited in note 5), pp. 308–9, cat. 58.

57 The panel was first tentatively identified as *Artemisia* by Coor (G. Coor, *Neroccio de' Landi, 1447–1500*, Princeton 1961, p. 95, n. 331), although she noted that 'the scene in the right middle distance, in which the main protagonist appears for the third time, remains unexplained'. This identification was accepted by Tàtrai 1979 (cited in note 11), pp. 37–8, and subsequently by Caciorgna. Caciorgna, however, misidentifies the woman in pink and white in the scene on the right as Artemisia.

58 Scarpellini 1984 (cited in note 55), p. 101, cat. 106; Garibaldi and Mancini, ed. 2004 (cited in note 25), pp. 234–5, cat I.32.

59 See R. Toledano, *Francesco di Giorgio Martini, pittore e scultore*, Milan 1987, pp. 106–8, cat. 40.

60 Kanter 2000 (cited in note 7), pp. 150–1.

61 This collaboration was first proposed by De Nicola 1917 (cited in note 4), p. 227, and has been almost uniformly accepted since.

62 Though the putti were in fact once thought by Berenson to be the work of the Griselda Master. See Berenson 1931 (cited in note 3).

63 Coor 1961 (cited in note 57), p.95; Boskovits 2003 (cited in note 7), p. 538.

64 Kanter 1988 (cited in note 7), p. 344; id. 2000 (cited in note 7), pp. 148–50.

65 Followed by Boskovits 2003 (cited in note 7), p. 538.

66 Coor 1961 (cited in note 57), pp.167–8, 187, 191–2, cat 17, 55, 63.

67 See De Nicola 1917 (cited in note 4), pp. 227–8. Although, this is Kanter's theory in relation to the *Scipio*, he denies the Griselda Master's involvement in the latter picture, 1988 and 2000 (cited in note 7), p. 344 and p. 150. R.L. Mode, 'Ancient paragons in a Piccolomini scheme' in R. Enggass and M. Stokstad, ed., *Hortus imaginum: Essays in Western Art*, Lawrence 1974, pp. 73–83, esp. p. 77, dated the *Scipio* to *c*.1494–5, believing that 'the Griselda Master was the ultimate reconciler of scenic disparities during the successive phases of the *uomini famosi* project'. Gertrude Coor had a still more complicated theory whereby the 'whole series was commissioned to Signorelli' but the main figures in three of the eight (i.e. *Alexander*, *Eunostos* and *Tiberius Gracchus*) and all of the *Artemisia* were executed by one of two assistants assigned to the project (one of his sons), while the Griselda Master, whom she considers another Signorelli assistant, was responsible for the backgrounds of the three heroes painted by Signorelli's son and those in the paintings by Francesco di Giorgio and Neroccio. By these complicated means, she explains the undoubted disparity between the *Artemisia* landscape and background figures and those in the other panels. See Coor 1961 (cited in note 57), pp. 94–5.

68 A. Angelini, 'Da Giacomo Pacchiarotti a Pietro Orioli', *Prospettiva*, 30, 1982, pp. 72–78; id. 'Pietro Orioli e il momento "urbinate" della pittura senese del Quattrocento', *Prospettiva*, 30, 1982, pp. 30–43.

69 M. Caciorgna in M. Caciorgna, R. Guerrini, *La Virtù Figurata. Eroi ed Eroine dell'antichità nell'arte senese tra Medioevo e Rinascimento*, Siena 2003, pp. 333–5.

70 Bellosi ed. 1993 (cited in note 5), pp. 444–7.

71 The inclusion of this panel was first proposed in 1941 and argued more fully by Coor 1961 (cited in note 57), p. 94, note 329. This suggestion has been credited by a majority of critics. See Longhi 1964 (cited in note 49), p. 7; F. Rusk Shapley, *Paintings from The Samuel H. Kress Collection*, I, *Italian Schools*, XIV–XV *Century*, London 1966, pp. 157–8; Mode 1974 (cited in note 66), p. 76; Zeri 1976 (cited in note 26), I, pp. 135–7; Tàtrai 1979 (cited in note 11), p. 38; E. S. Trimpi, 'Matteo di Giovanni: Documents and a Critical Catalogue of his Panel Paintings', PhD diss., University of Michigan 1987, p. 114, cat 14; C.E. Gilbert, 'On Castagno's Nine Virtuous Men and Women: Sword and Book as the Basis for Public Service' in M. Tetel, R.G. Witt and R. Goffen, eds, *Life and Death in Fifteenth-Century Florence*, Durham and London 1989, pp. 174–92, 242–6, esp. pp. 190–2; Bartalini 1993 (cited in note 70), p. 462; Barriault 1994 (cited in note 8), p. 151; Gilbert 1996 (cited in note 5), p. 684; M. Caciorgna, 'Temi profani e tradizione classica nella bottega di Matteo di Giovanni. L'esempio di Clelia' in D. Gasparotto, S. Magnani, eds, *Matteo di Giovanni e la pala d'altare nel senese e nell'aretino, 1450–1500*, pp. 189–97, esp. p. 190. More recently, it was challenged by M. Natale 1982 (cited in note 50), p. 150; A. De Marchi in F. Sricchia Santoro, ed., *Da Sodoma a Marco Pino. Pittori a Siena nella prima metà del Cinquecento*, Siena 1988, p. 85; Boskovits 2003 (cited in note 7), p. 502, note 11.

72 Though, as Bartalini 1993 (cited in note 70), p. 462, points out, she appears elsewhere with other famous women of classical derivation.

73 Coor points out that Artemisia, Sulpitia, Tiberius Gracchus, Scipio Africanus, Alexander – and Judith – all appear in Petrarch's *Trionfi*. See Coor 1961 (cited in note 57), p. 95, note 331. Judith, 'casta e forte', perhaps crucially, is included among a series of classical heroines, though none of these in the procession of the Triumph of Chastity. We should not forget that the story of Judith is included among the scenes on the Duomo pavement, the cartoon almost certainly furnished by Francesco di Giorgio, with a city on the left and an encampment on the right, as in the underdrawing of the Bloomington panel.

74 See Mode 1974 (cited in note 66), p. 75, who considered 'the first pair in the series' Judith and Scipio Africanus. It is sometimes thought that further panels may have been painted. Gilbert, for example, suggests that a panel of Hippo may be missing, Gilbert 1996 (cited in note 5), p. 684. Trimpi 1987 (cited in note 70), p. 115, points out that E. Romagnoli saw 'due fatti eroici' by Matteo in the Palazzo Spannocchi before 1835, perhaps indicating the presence of another picture. However this description is unlikely to refer to the *Judith*.

75 The subject had already been treated in Siena in the 1470s in the workshop of Liberale da Verona. The subject of a *cassone* panel displayed in New York in 1988 was not identified at the time of the exhibition (see K. Christiansen in Christiansen, Kanter, Strehlke 1988 [cited in note 7], pp. 297–8, cat 58), but the mount annotated by Elizabeth McGrath in the photo collection, Warburg Institute, London, notes that it depicts the assassination of the son, still feasting in this scene. She appears as one of Castagno's famous men and women from the Villa Volta di Legnaia (now

Uffizi), albeit without the head of Cyrus. Mentioned by Valerius Maximus, IX.10, ext.1. It is just possible that the heroine brandishing a sword and a decapitated head at Montalcino (see note 87 below), who is missing her inscription and has similarly been identified as Judith, is also Tomyris, since there too she would be the only Old Testament figure in a row of Greek and Roman worthies (however, admittedly David and Joshua are represented elsewhere in the room and the presence of Judith here might support her identification in Matteo's panel).

76 Mode considered the most likely patron Giacomo di Nanni Piccolomini. See Mode 1974 (cited in note 66), p. 75.

77 See Bartalini 1993 (cited in note 70), pp. 462–9.

78 Bartalini has suggested that the *Joseph* panel may have inspired Girolamo di Domenico in his frescoed figure of Saint Sigismond at the Oratorio di San Rocco, Seggiano, finished by mid-1493. Kanter and Boskovits, however, did not find this comparison compelling, and indeed the similarity seems generic rather than specific.

79 This view was first posited by Berenson 1931 (cited in note 3), p. 753, supported by Coor 1961 (cited in note 57), p. 94, and has been restated most recently by Boskovits 2003 (cited in note 7), p. 503, note 24: 'The close affinities between the Master of Griselda's and Signorelli's styles on one hand, and the unknown artist's relative isolation in the Sienese cultural context on the other, makes it very probable that he received this prestigious commission through Signorelli. The limited number of contributions of his Sienese colleagues seems to indicate that their collaboration was not planned from the beginning, but was instead the result of a decision taken after the work had begun.'

80 The theory of a lengthy commission was based in the past partly on the assumption that the *Sulpitia* was the work of Pacchiarotto and partly on a supposed date of 1498 for Signorelli's Bichi panels, in which the Magdalen has correctly been identified as the source for Artemisia. See e.g. Coor 1961 (cited in note 57), p. 94, note 329, who wrote 'Matteo di Giovanni's death date, 1495, furnishes a *terminus ante quem* for the beginning of the series of Virtuous Men and Women. The *Judith* was probably the first painting of this series, closely followed by the *Claudia Quinta*, *Scipio Africanus*, *Eunostos of Tanagra*, [sic] *Tiberius Gracchus* and *Alexander the Great*. The last painting from Signorelli's shop seems to have been the *Virtuous Woman* in Milan [not yet identified] … This figure is compositionally and stylistically close to the Mary Magdalen in the left panel of Signorelli's altarpiece wings of 1498 [sic] for the altar of St. Christopher in Sant'Agostino, Siena … The last painting in the whole series, Pacchiarotto's *Sulpicia* … is usually dated close to *c*.1500.'

81 Kanter 2000 (cited in note 7), p. 151. Mode 1974 (cited in note 66), p. 74, also believed that the project was 'carefully carried out in stages, not pushed to completion'. Earlier theories of a lengthy gestation for the project were founded in part by the belief that Pacchiarotto was responsible for the Baltimore *Sulpitia*, and the painter's supposed birth date (not before 1474). Ludwin Paardekooper has recently challenged Erica Trimpi's assertion that Matteo died in 1497, preferring Romagnoli's date given as 1 June 1495. See L. Paardekooper, 'Matteo di Giovanni e la tavola centinata' in D. Gasparotto and S. Magnani (eds), *Matteo di Giovanni e la pala d'altare nel senese e nell'aretino, 1450-1500*, Montepulciano 2002, pp.19–37, esp. p. 31.

82 Sienese panels of this period often seem to have been of exceptionally solid construction: a *Virgin and Child* by Benvenuto di Giovanni in the Collection (NG 2482) measures only 61.5 × 42 cm, yet the panel is four cm thick.

83 We owe this and many other points concerning the manufacture of the panels to our discussions during the examination of *Scipio* with Ciro Castelli of the Opificio delle Pietre Dure, Florence.

84 X-ray opaque putties are visible in some of the radiographs, especially those of *Alexander the Great* and *Sulpitia* (FIGS 13 and 14), but these were applied later, often to fill the holes made by attempts to remove the nails from the battens.

85 Since scored lines to guide the carpentry are also present on the Griselda panels, it could be argued that both sets of panels were made by the same carpenter. However, such incisions are probably relatively common.

86 The top of *Claudia Quinta* is also similarly flattened, and probably for the same reason rather than a later trimming of the panel as has usually been supposed. A piece of wood one cm high (not original) is now attached to the top of the arch with nails and screws.

87 The Cozzarelli panels are illustrated in *Siena e Roma: Raffaello, Carvaggio e i protagonisti di un egame antico*, exh. cat., Santa Maria della Scala, Palazzo Squarcialupi, Siena 2005–6, cat. no. 2.15, pp. 194. For the Tamagni frescoes, see R. Guerrini, *Vincenzo Tamagni e lo scrittoio di Montalcino*, Siena 1991, p. 31.

88 A parallel case might be the piecemeal execution and delivery of the Mercanzia panels (also arch-topped) painted by Piero del Pollaiuolo and Botticelli, although these panels (much larger than the Virtuous Men and Women) were almost certainly at least at first framed individually see A. Wright, *The Pollaiuolo Brothers: The Arts of Florence and Rome*, New Haven and London 2005, pp. 228–30 and 241.

89 Since the lead-containing paint of the sky has been removed in incising the profiles they appear dark in the X-ray image. In the X-radiographs of *Claudia Quinta* and *Sulpitia*, for instance, the incisions are mostly filled with the sky paint and therefore show as white.

90 On *Sulpitia* and *Claudia Quinta* the incised arcs are complete but they and the originally unpainted gesso above have now been covered by later repainting.

91 At the National Gallery large Sienese panels of this period with their original carpentry include Matteo di Giovanni's *Assumption of the Virgin* (NG 1155), which has wide shallow battens set into dovetail channels, and Orioli's *Nativity with Saints* (NG 1849) which has two horizontal battens running through *ponticelli*.

92 This suggestion was made by Roberto Bellucci during discussion of the panel of *Scipio* and is supported by the presence of jagged gouge marks in the wood of *Alexander* where the chisel seems to have slipped in the effort of levering up the battens.

93 There is no obvious provision for the fitting of the Cozzarelli panels (see note 87) in their frame; nor does there seem to be any indication as to their original fitting. They are now held by metal straps across their corners. We are grateful to the owner of these pictures for giving us access to them.

94 The loss that can most clearly be associated with the removal of the battens is the oval one to the right of the figure and level with the frame projections. The two very large losses from the sky are more likely to be associated with the transfer from the original panel. There is a smaller loss at the expected level in the figure's chest, while the absence of any sign of a nail on the left can be explained by the likelihood of it not having been hammered through the full thickness of the panel – not all the nails have caused disruption of the surfaces of the panels.

95 We are grateful to Giorgia Mancini for her dating of this script.

96 All the letters can just be made out, the most distinctive being the tail of the 'z'; the final 'o' is partly covered by a label.

97 This issue is by no means straightforward. Various attempts at a chronology unifying sources from Antiquity and the Old Testament were made in Italy and elsewhere in Europe during the fifteenth century, and there also existed independent visual traditions such as the *Neuf Preux*, known in Italy. The most relevant are likely to have been Giotto's sequence commissioned by Robert d'Anjou for his Castelnuovo in Naples, nine men (and perhaps the nine women whom their accompanying inscriptions condemned), two from the Old Testament (Solomon and Samson), two from ancient history (Alexander and Julius Caesar) and five from ancient myths who may have been regarded as properly historical. We do not unfortunately know their order. Still more relevant was the vast cycle commissioned by Cardinal Giordano Orsini for his palace on Monte Giordano, Rome, of which there survive manuscript copies and written descriptions. This placed Joseph in the 'Third Age', Alexander in the 'fifth', followed by Scipio in the same age. Neither Tiberius or Eunostos were included. Judith appears at the beginning of the 'Fifth Age', post-dating Lucretia, who who might be held to stand for the Roman Republican heroines in the 'fourth'. See R.L. Mode, 'The Monte Giordano Famous Men Cycle of Cardinal Giordano Orsini and the Uomini Famosi Tradition in Fifteenth Century Art', PhD. diss., University of Michigan 1970, passim; A. Amberger, *Giordano Orsinis Uomini Famosi im Rom: Helden der Weltgeschichte im Frühhumanismus*, Munich and Berlin 2003, passim. Cozzarelli's heroines in the Chigi Zondadori triptych show a Greek (Hippo), followed by an Etruscan (Camilla) and a Roman (Lucretia). This matter requires further research.

98 Caciorgna 1995 (cited in note 54), pp. 243–4. She also states that the staff that the main figure holds is a baton of command which she links to Genesis 41: 'And Pharaoh said unto Joseph, Forasmuch as God hath shewed thee all this, there is none so discreet and wise as thou art: Thou shalt be over my house, and according unto thy word shall all my people be ruled: only in the throne will I be greater than thou. And Pharaoh said unto Joseph, See, I have set thee over all the land of Egypt. And Pharaoh took off his ring from his hand, and put it upon Joseph's hand, and arrayed him in vestures of fine linen, and put a gold chain about his neck; And he made him to ride in the second chariot which he had; and they cried before him, Bow the knee: and he made him ruler over all the land of Egypt. And Pharaoh said unto Joseph, I am Pharaoh, and without thee shall no man lift up his hand or foot in all the land of Egypt.' If a reference to this passage was intended, it might be thought odd that no ring or chain is depicted. The staff is perhaps explained as a symbol of princely status: Eunostos after all was the son of Elieus, king of Tanagra.

99 L. Parri 1991 (cited in note 53).

100 It is possible that these are accidental marks, some of them derived from water stains or related to the woodgrain, and that the Women were not numbered.

101 See Bocaccio, *Famous Women*, ed. V. Brown, Cambridge, MA, and London 2003.

102 The opportunity to examine the four panels together was immensely valuable and we are particularly grateful to all those who made it possible.

103 The mounting and examination of paint cross-sections was carried out by Marika Spring at the National Gallery of London and Michael Palmer at the National Gallery of Art, Washington. Jo Kirby performed HPLC analysis of red lake samples from the British paintings. In London the medium analysis by FTIR and GC–MS was undertaken by Catherine Higgitt and in Washington GC–MS was executed by Suzanne Quillen Lomax. Michael Palmer also carried out staining tests on the cross-sections since these can give indications as to the presence of different media in the layer structure. In addition Lisha Glinsman carried out XRF analysis on areas of white in *Tomyris* to confirm the different composition of the lead white pigment on the added parapet.

104 The idea that the *Scipio* and a high proportion of the other paintings traditionally given to Francesco di Giorgio were actually painted by an anonymous assistant, the so-called 'Fiduciario di Francesco' (Toledano 1987 [cited in note 59] and Bellosi ed. 1993 [cited in note 5], p. 262, cat. 103), seems to us unsustainable, and especially in the case of *Scipio*, which, as will be shown, was executed with a boldness and degree of creative improvisation that seem characteristic of a master developing a project rather than a faithful executor of his instructions.

105 Reproduced in Bellosi ed. 1993 (cited in note 5), cat. no. 56, pp. 300–4. On a smaller scale, the *Annunciation* in the Pinacoteca Nazionale has similar underdrawing, as does the *Nativity*, now shared by the National Gallery of Art, Washington, and the Metropolitan Museum, New York.

106 *Saint Dorothy with the Infant Christ* (NG 1682), admittedly an early work, is in egg tempera, as is the Washington/New York *Nativity* and most of Francesco's panel paintings have the appearance of, and are described as, tempera paintings. The *Nativity with Saints Bernard and Thomas Aquinus* (Siena, Pinacoteca Nazionale) is reported as having final touches in oil (see Bellosi ed. 1993, cited in note 5, cat. no. 61. p. 314).

107 Kanter and Henry 2002 (cited in note 20), p. 174, cat 20. Comparison with Francesco di Giorgio's medal suggests that he might be identified as Jacopo Petrucci, which would mean that the portrait was accessible to Sienese painters

108 This was confirmed by overlaying and flipping tracings of a putto, in this instance from *Alexander*, but the same process was carried out on the other panels to confirm that designs had been reversed.

109 Similar thin and rather tentative underdrawing features in Neroccio's *Portrait of a Lady* in Washington, although here the outline of the face has been transferred from a cartoon by pouncing. The underdrawing on the much larger altarpiece of *The Virgin and Child with Saints*, also in Washington, is bolder, but the lines of underdrawing have been made with a remarkably fine brush for the size of painting, and the lines of hatched shading tend to be irregular in length and spacing.

110 The pigments were identified by EDX analysis of the cross-section. Medium analysis was by GC–MS. A small amount of oil was found as well as the egg, but this could well have come from a subsequent varnish layer.

111 GC–MS analysis of samples at both Washington and London found both egg and oil; but staining tests and FTIR seemed to indicate that egg was used for the lead white underpaint. Both media were identified in the red lake and vermillion layer, the samples varying in the amount of oil present (confirmed as walnut). On balance, therefore, the paint is probably a *tempera grassa* rather than an egg layer contaminated by later oil varnishes. Significant amounts of phosphorus were detected throughout the red lake layer, an indicator of an insect source for the dyestuff (see note 42).

112 See note 64.

113 The lines of drawing are more visible in infrared than is usually the case with paintings by the Griselda Master; presumably the ink has a higher carbon content.

114 Confirmed as walnut oil by GC–MS analysis in Washington and London.

115 EDX analysis identified the same impurities in the malachite as those found in the malachite from the Griselda panels. See note 41.

116 The foreground dark greens are covered with insoluble nineteenth-century repaint, not removed in the recent restoration (see Appendix). It does not, however, appear significantly different in colour from the original paint beneath it.

117 Indicated by results of staining cross-sections with amido II stain.

118 An example of this period at the National Gallery is Michelangelo's *Entombment* (NG 790). See M. Hirst and J. Dunkerton, *Making and Meaning: The Young Michelangelo*, London 1994, pp. 108–9.

119 Of the two Signorelli altarpieces of the 1490s in the National Gallery, *The Circumcision* (NG 1128) of about 1491 does not have a priming, but a layer of lead white, almost certainly in oil, is present in samples from *The Adoration of the Shepherds* (NG 1133), painted in about 1496.

120 For white or off-white primings in paintings by Perugino see Spring 2004 (cited in note 43), p. 21, for similar primings in works by Raphael see Roy, Spring and Plazzotta 2005 (cited in note 43), p. 5.

121 Identified by GC–MS analysis. The oil is probably walnut oil, as in the other panels by the Griselda Master, but the palmitate/stearate ratio is affected by the small amount of egg in the samples (coming from the white priming layer) and so it is not possible to be certain.

122 No vermilion could be detected in the sample, but it may be present in lighter areas and on the figure's cheeks, for example. Vermilion was found in the flesh paint of *Alexander*.

123 Perugino (and subsequently Raphael) sometimes used hatched or cross-hatched strokes in the shadows of draperies painted with red lake, or purple mixtures containing red lake, even when working in an oil medium. This is a faster way of achieving an impression of depth of tone than the layering of glazes, when each application needs time to dry before the next can be applied.

124 See note 31.

125 In a sample from a tree at the right edge the lowest green layer contained ultramarine mixed with lead-tin yellow. Perhaps this was a case of using up surplus ultramarine that had been ground in oil and would have been wasted if not used before it dried.

126 See note 37.

127 The cause of discoloration is not clear, but analysis by FTIR microscopy detected a relatively high amount of calcium oxalate both within the film and on the surface of the layer, which may be linked with the deterioration; the oxalate-type crust would add to the disfiguring effect of the discoloration of the binding medium. See Higgitt and White 2005 (cited in note 38), pp. 88–104, particularly the Appendix, p. 93.

128 See note 42.

129 C. Togneri Dowd, ed., 'The Travel Diary of Otto Mündler', *The Walpole Society*, 51, 1985, p. 154. Mündler clearly mistook the mausoleum for Saint Barbara's tower.

130 See note 66.

131 In August 1857 Mündler observed that the painting, this time described as 'a small whole-length figure of Saint Lucia, by Luca Signorelli', was 'much restored by Cavalre Molteni'; see Tognieri Dowd (cited in note 129), p. 162. It is possible that Molteni was responsible for the slight recutting of the shape of the arch in order to give it the same curvature as that of a *Saint Catherine of Alexander* by Bergognone; the two panels are identically framed as pendants. For Molteni's work for Gian Giacomo Poldi see A. di Lorenzo, 'Molteni restauratore per Gian Giacomo Poldi Pezzoli' in *Giuseppe Molteni e il ritratto nella Milano romantica*, exh. cat., Museo Poldi Pezzoli, Milan 2000, pp. 69–75. The subject was also identified in the past as Saint Barbara.

132 Underdrawing very similar in extent and character can be found in Orioli's altarpiece, *The Nativity with Saints* (NG 1849), and, on a smaller scale, on another late work *The Adoration of the Shepherds*, ex-Kinnaird Collection, once on long-term loan to the National Gallery.

133 See note 41. It might be expected that the top layer of pure malachite, and indeed the other layers in this sample, would have been applied in egg tempera. As with the other paint samples from this panel, analysis by GC–MS also indicated the presence of oil (see note below).

134 In the sample of red drapery it was possible to distinguish use of the two media in the different layers. When the other three samples were stained for identification of protein the paint layers tended not to stain. This can be an indication that they are in another medium (oil), but these results contradicted those of earlier staining tests carried out at the Walters Art Gallery by Elizabeth Packard in 1966–7, which indicated layering of oil over egg (report in the Conservation File at the Walters Art Gallery). The more reliable technique of GS–MS analysis found egg and oil in all the samples, but the situation is further complicated by the presence of residues of an old oil-based varnish. Porous tempera layers can absorb oil from varnishes, giving ambiguous results. On balance, it seems likely that *Sulpitia* was painted in egg tempera, but that some areas were completed in oil.

135 Analysis of samples from his altarpiece in the National Gallery (NG 1849) by GC–MS and FTIR found egg tempera. Gum ammoniac was found in the areas of mordant gilding. The three altarpieces in the Pinacoteca in Siena, *The Virgin and Child with Saints Onofrio and Bartholomew*, *The Ascension of Christ* and *The Visitation*, all appear not to have been varnished. Leaving tempera paintings without a varnish seems to have been a particular practice in Siena in the later fifteenth century; in the National Gallery collection two panels by Matteo di Giovanni and one by Benvenuto di

Giovanni remain in this state: the smaller *Virgin and Child with Saints* in the Ashmolean Museum, Oxford, has a similarly unvarnished surface.

136 Only Benvenuto di Giovanni is missing.

137 For other elaborate underdrawings by Matteo, see R. Bellucci and C. Frosinini, 'Un "modello" per la diagnostica integrata', *Kermes*, 53, January–March 2004, pp. 29–38, esp. pp. 32–3.

138 The medium of all the paint samples was found to contain egg alone.

139 No priming is present in paint samples from Matteo's *Saint Sebastian* (NG 1461) and *Christ Crowned with Thorns* (NG 247).

140 The two paintings cited in the previous note, both late works, do not have green earth underpaintings either.

141 The gilding of the inscription on *Tiberius* is slightly worn and there are losses from the blue in the centre; that of *Alexander* is more damaged and with large losses from the blue towards the left side.

142 She suggests the Marchigian poet and humanist Benedetto da Cingoli. See M. Caciorgna, ' "Mortalis aemulator arte deos". Umanisti e arti figurative a Siena tra Pio II e Pio III' in Angelini ed. 2005 (cited in note 5), pp. 151–81, esp. pp 157–9. She notes (M. Caciorgna, 'Immagini di eroi ed eroine' in R. Guerrini, ed., *Biografia dipinta, Plutarco e l'arte del Rinascimento, 1400–1550*, La Spezia 2001, p. 299, note 274) that the metre of the inscription of *Claudia Quinta* is different from the others, confirming the suggestion that it was altered.

143 See S. Chiarugi in C. Pirovano, ed., *Museo Bagatti Valsecchi*, 1, 2003, pp. 94–6, cat 29. The wheel is also an element within the Urgurgieri *stemma*. Possible marriages between these families remain to be researched. Caciorgna 2005 (cited in note 142), p. 178, note 50, points out that since only the Piccolomini crescent has been identified, the commission might not have been connected with a wedding in the family for which the *stemma* of each family would be normal.

Appendix on condition and restoration history

Master of the Story of Griselda, *The Story of Patient Griselda* (PLATES 1–2)

Apart from minor cracks in *Reunion*, the supports of all three paintings are in very good condition, retaining their original thickness and dimensions.

The most recent cleaning and restoration (by Jill Dunkerton) took place in 2003–4. The only previous documented restoration is that carried out by a Mr Bentley (not one of the restorers regularly employed by the National Gallery) in 1874, the year that the National Gallery acquired the panels. After 130 years the varnish had become very discoloured and many of his retouchings had altered, especially where he used bronze powder to restore damaged gilding. In addition, at that time it was thought that the episode in *Marriage* in which Griselda is stripped naked was not suitable for public display and so Bentley was asked to paint draperies over the naked figure (recorded in the Manuscript Catalogue and Conservation Record). He also changed her right arm and hand, presumably because the pose was thought to be indecorous. X-radiography confirmed that the original naked body was still present underneath the nineteenth-century draperies; the overpainting was therefore removed, restoring the original intention of both painter and writer (PLATES 83 and 84). There are relatively few losses from this first panel, mostly flake losses in areas of wood faults, woodworm exit holes and some abrasion, mainly in the dark blue-green draperies and also in some of the flesh tints, especially the naked figure of Griselda where the upper layers (executed in oil) have not adhered well to the underpainting in egg tempera.

The other two panels, on the other hand, have been extensively abraded by a past cleaning, almost certainly with an aqueous cleaning material which penetrated cracks in the paint and began to erode the vulnerable gesso ground. Residues of an old and possibly original oil varnish are present on all the panels and the damage is likely to have been caused during its removal – almost certainly at an earlier date than the restoration of 1874. Why the first panel should have escaped this damage is a mystery, since they have always been together and indeed even *Marriage* appears to have been cleaned at some time with a powerful solvent or reagent for a dribble has removed the upper glaze layers in the area immediately above the dog lying in the foreground. The most badly eroded areas in the damaged pictures are the skies and foregrounds, and also the table-cloth in *Reunion*, although many of the figures are affected as

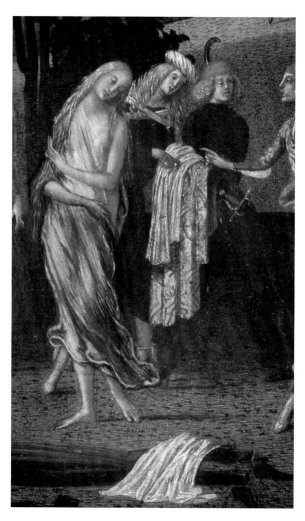

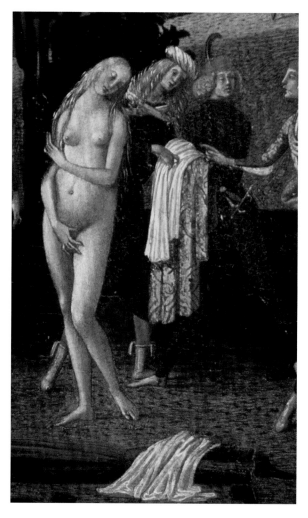

PLATE 83 *Marriage*. Detail before cleaning.

PLATE 84 *Marriage*. Detail of PLATE 1 after cleaning and restoration.

well, especially those dressed in costumes containing vermilion or earth pigments which can be vulnerable to cleaning damage. The gilding on the architecture is also damaged, especially on *Exile*, and needed extensive restoration in order to give some semblance of unity of condition across the three panels.

All the red and green flags carried in the procession in *Reunion* have been damaged by scoring with a cross (PLATE 85). The amount of dirt and varnish in the incisions indicates that this damage is likely to have occurred some time before the nineteenth century when the paintings left Siena.

Master of the Story of Griselda, *Alexander the Great*, Barber Institute, Birmingham (PLATE 19)
The panel retains its original thickness and dimensions and is in good condition apart from some woodworm damage and damp stains along the lower edge. The nails used to attach the battens have caused disruption of the picture surface.

The most recent cleaning and restoration (by Jill Dunkerton) took place at the National Gallery, London, in 2005–6. There is no record of treatment since acquisition by the Barber Institute in 1951 and so the previous restoration must date from before then, perhaps while it was in the Cook Collection. The varnish layers were only moderately discoloured but the surface was disfigured by blanching of retouchings that contained zinc white. The condition of the paint surface is uneven: some colours, for instance the pink sleeves and hose, are in very good condition; other areas are eroded by cleaning in a similar manner to *Exile* and *Reunion*, and residues of a very old varnish are also present. Areas affected by flaking and erosion include Alexander's head and crown, his cuirass, parts of the sky and landscape, and the gilded tents. The worst damage is in the pedestal where there has been extensive flaking of paint from gesso as well as abrasion. The flags flying from the tents have been vandalised by score marks (PLATE 86) in the same way as those in *Reunion*.

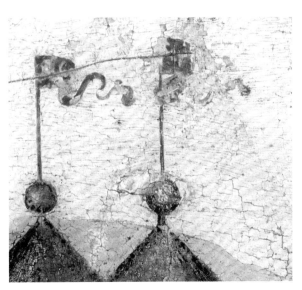

PLATE 85 *Reunion*. Detail, after cleaning, before restoration.

PLATE 86 *Alexander the Great*. Detail, after cleaning, before restoration.

Master of the Story of Griselda, *Joseph of Egypt* or *Eunostos of Tanagra*, National Gallery of Art, Washington (PLATE 20)

The painting has been cut around all the edges, and the entire lower part of the pedestal with the inscription has been lost. According to records of the Kress Collection, the painting had been transferred onto fabric before 1940. On acquisition by the National Galley of Art the transfer canvas was relined and then stretched around a blind stretcher. The transfer may have occurred as part of a restoration in the 1930s (a reproduction published in 1930 shows the picture with darkened retouchings not present by the time it was acquired by Kress). The panel was probably cut down at an earlier date, however, since stepped edges at the junctions between arch and capitals also appear on *Artemisia* (see below), which has been similarly truncated at the base. Both may have been cut – perhaps because of severe damage – when the panels were dispersed for sale.

A yellowed varnish and darkened retouchings were removed during treatment (by Carol Christensen) in 2004–6. There are two large losses in the sky on either side of the figure's head, which may have been caused during transfer, and further losses from the remains of the pedestal. The paint texture has been flattened by the transfer and is now uncharacteristically smooth. There is general wearing, especially in the background, including the small figures on the right, and to areas of gilded decoration.

Francesco di Giorgio and the Master of the Story of Griselda, *Scipio Africanus*, Bargello, Florence (PLATE 21)

The panel retains its original thickness and dimensions and is in good condition. The nails used to

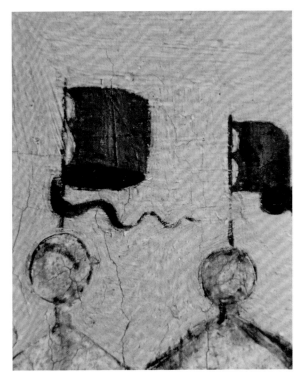

PLATE 87 *Scipio Africanus*. Detail of PLATE 21.

attach the battens have caused some disruption of the picture surface.

The painting has not been cleaned recently and so a discoloured greyish-yellow varnish results in a muted appearance. Moreover, the sky, which is evidently abraded, has been extensively scumbled over with retouching. The gold leaf of the tents has been rubbed off (except at the very edges) and left unrestored, and the distant landscape on the left is much damaged. The pedestal has not been affected by the

extensive flaking evident on *Alexander* and *Tiberius Gracchus*, but it has been drastically overcleaned, losing most of the gold around the inscription tablet and almost of all the glazes and fine detail from the painted areas. The blue ground of the inscription has been repainted and the letters reapplied in gold leaf. In the X-radiograph (FIG. 12) scattered flake losses and scratches can be seen, mainly in the sky and around the edges. Although the main figure is rather better preserved, erosion of the upper surface of the hair, for example, contributes to the cut-out effect of the head against the sky.

The green flags on the tents have been scored with crosses (PLATE 87) similar to those in *Reunion* and *Alexander the Great*.

Master of the Story of Griselda, *Tiberius Gracchus*, Szépmüvészeti Múzeum, Budapest (PLATE 22)

The panel retains its original thickness and dimensions and is in good condition. There is some disruption of the picture surface as a result of the attachment of the battens.

In the cleaning and restoration carried out by Györgyi Juhász in 1991, a discoloured varnish, retouchings and fillings of various ages and composition were removed (a similar miscellany of fillings was found on *Alexander*, suggesting that some may date from when the panels were still together). *Tiberius* is arguably the best preserved of the Griselda Master's contributions to the series and, especially in the flesh tints, it is less eroded by previous cleaning than most of the other panels. Nevertheless, there are extensive and sometimes large flake losses, including from the near corner of his mouth and from either side of his neck, as well as from both hands and the last three toes of his right foot. A long wide scratch runs through the building and figures on the left, and there are more large flake losses from the red scarf and the fictive pedestal. The most extensive damage is to the brown tunic where the paint appears to have crumbled away in large areas, particularly in the shadowed parts of the folds.

Matteo di Giovanni, *Judith* or *Tomyris of Scythia*, Indiana University Museum of Art, Bloomington (PLATE 23)

Only the upper half of the painting survives. The lower part may have been lost because of damage, or alternatively, it may have been cut to remove details associated with the story of Tomyris and Cyrus (if indeed this is the original story), turning it into the more easily recognised subject of Judith. A poplar strip, 7 cm wide, upon which the false parapet is painted, has been attached with a half-lap join along the bottom edge. The use of poplar and the presence of lead white in the paint suggest that the parapet was added while the painting was still in Italy, probably in the nineteenth century. The arch has been trimmed irregularly. In 1938, while still in the Kress Collection, the panel was planed down to a thickness of 1 cm, waxed on the back, and cradled by Stephen Pichetto.

The present varnish was applied following restoration by Mario Modestini in 1955. The paint layer is unevenly preserved. The figure is in generally good condition but there is heavy retouching in the sky, which appears somewhat worn. At the junction between the original panel and the addition there is extensive retouching, extending well into the original; most of the little horse and rider, and the figure to the right of them, are modern restorations. The extent of the restoration is evident in infrared (FIG. 38).

Master of the Story of Griselda, *Artemisia*, Museo Poldi Pezzoli, Milan (PLATE 24)

The panel retains its original thickness but the lower part with the pedestal and inscription has been removed. The edges have been trimmed slightly, as has the wood of the arch. The spandrels that make the panel into a rectangle are a later addition. The crescent of unpainted gesso, visible at the tops of the unaltered panels, has here been scraped away, together with the top surface of the wood, exposing the woodworm channels. The shape of the arch has been altered slightly, resulting in a stepped edge at the junction between arch and capitals similar to that on *Eunostos*. Some alterations may date to the division of the panels; others from a restoration by Giuseppe Molteni in 1857. He may have cut the arch back further in order to turn the panel into a pendant to a painting by Bergognone in the same collection (see note 131). The metal crosspieces set into the back were fitted by him (similar ones have been found on panels in the National Gallery that he is known to have restored).

The surface received a light cleaning (by Nuccia Comolli Chirici) in 1993. The heavily discoloured varnish was thinned to some extent, but because of the extensive retouching and regilding by Molteni (see main text, p. 49) it was decided that the cleaning should not proceed further. The appearance of some of the discoloured retouchings, mainly on the face and in the sky, was improved and a final matt varnish applied.

Pietro Orioli, *Sulpitia*, The Walters Art Gallery, Baltimore (PLATE 25)

The panel has been thinned by about 1 cm, judging from the thickness of intact panels in the series, and the back coated, filling the exposed woodworm channels. The three inset battens on the back are not original. The wood around the arch may have been trimmed slightly but this cannot be confirmed since none of the edges is visible because of a narrow wooden collar fitted around the panel. This appears to have been added at two separate stages; the wood on the sides and bottom was cut with modern machine tools and is attached with modern nails, while the collar surrounding the arch appears somewhat older (a few nails securing it are of the old square-headed type, with an uneven taper). It is possible that the collar on the arch was added when the paintings were dispersed, while the present edge strips may be replacements for ones applied at the same time as that on the arch.

The painting was cleaned and restored by Eric Gordon at the Walters Art Gallery in 1992–3. It is one of the best preserved in the series, but there are retouched flake losses in the sky, in the figure's throat, the middle fingers of her left hand, and down the shadowed side of her dress. Residues of a darkened old varnish are present (as on many of the other panels); past efforts to remove this have resulted in some abrasion (but without erosion of cracks), especially to the sky. There is extensive retouching around the edges and over large losses on either side of the pedestal. Later repaint extends the pedestal at the lower edge, covering the original border of unpainted gesso.

Neroccio de' Landi and the Master of the Story of Griselda, *Claudia Quinta*, National Gallery of Art, Washington (PLATE 26)

The panel has retained its original thickness. It has been trimmed slightly at the left edge with the result that the arch now starts at a higher level. A small segment of wood has been attached with nails at the top to complete the curve of the arch, but the top of the panel may originally have been flat (see main text, p. 25).

During the cleaning and restoration carried out by Carol Christensen in 2004–5, some old repaint was left: for instance the extension of the sky over the gesso border of the arch, originally unpainted as in the other panels, and also some dark green overpainting of the grass in the lower part of the picture which does not, however, appear significantly different in colour to the original paint beneath it. The inscription on the pedestal has been repainted and the lettering redone, probably at a relatively early date. A large loss in the sky on the left also includes part of the ship held by Claudia and almost all of the figure of Cybele. The old regilding of this figure was left in the recent restoration. There are many scattered losses and scratches in the sky and on the main figure's dress, and the surface is generally abraded with the mordant-gilded patterns worst affected – some of this gilding has been renewed in the recent restoration. The flesh tints, on the other hand, are mostly well preserved.

The *Madonna di Loreto:* An Altarpiece by Perugino for Santa Maria dei Servi, Perugia

CAROL PLAZZOTTA, MICHELLE O'MALLEY, ASHOK ROY, RAYMOND WHITE AND MARTIN WYLD

THIS ARTICLE is an in-depth examination of Perugino's *Virgin and Child with Saints Jerome and Francis*, otherwise known as the *Madonna di Loreto* (NG 1075), in the National Gallery (PLATE 1).[1] The first section introduces the circumstances of its commission in 1507, and discusses its iconography, subsequent history and eventual acquisition by the Gallery. The second part is concerned with the relationship between Perugino's reputation, and the prices and the practices of his production, and includes an investigation of the design, materials and techniques employed in the painting. The third part reviews the condition and conservation history of the altarpiece. Finally, the picture is considered in the light of its position in Perugino's career and the question of its attributional status is assessed.

Commission

Perugino's altarpiece was made for a chapel in the Servite church of Santa Maria dei Servi on the Colle Landone at Porta Eburnea in Perugia.[2] The chapel's construction and decoration had been endowed by Giovanni di Matteo di Giorgio Schiavone, a carpenter of the nearby parish of San Savino. As Schiavone's last testament of 7 April 1507 makes clear, the chapel's function was commemorative rather than funerary, since he left provision for his burial in an existing chapel dedicated to the Annunciation, bequeathing ten florins for an altar cloth or chalice and a further five florins for funeral masses to be recited by the friars.[3] Having no surviving children, Schiavone left the main substance of his estate, consisting of two houses and their contents, to his wife Florita, the only beneficiary named in the will other than the Servite friars, seven of whom were witnesses to this document. Florita was to be responsible for making annual offerings of wine and grain to the confraternity of the Annunciation. In addition to these settlements, Schiavone had set aside 30 florins for the construction of a new chapel, a sum that was to be supplemented with rent from other properties, the title (but not the right of sale) of which he bequeathed to the friars. His executors were to make up the total amount required

for the construction and the decoration of the chapel by selling the contents of a workshop located near the church that Schiavone had rented from the friars, an arrangement which sheds light on the carpenter's association with Santa Maria dei Servi.[4] Schiavone directed that the chapel (situated in a bay off the north side of the nave, close to the pulpit[5]) was to be decorated with an image of the Madonna di Loreto with Saints Jerome and Francis. His wording suggests that he intended a mural painting.[6]

Schiavone must have died almost immediately, because only two months later his prompt executors drew up a contract with Perugino (dated 7 June 1507).[7] The contract differed slightly from the will in that a panel painting ('*unum tabulam de lignamine*') rather than a mural was specified. This was to be in Perugino's own hand ('*de eius manu*'), and was to depict, more specifically than the will had described, 'an image of the glorious Virgin with her Son standing, similar to that of Loreto, with figures of the Blessed Jerome as Cardinal and Saint Francis with the stigmata'. Perugino was to get the woodwork made up at an agreed price of three *soldi* per foot, and was to use 'fine colours' and 'gold ornaments'. A fee of 47 florins was also to cover a '*pledula*' (discussed below) with fictive brocade vestments ('*paramentis brochatis*'). The contract stipulated that all work was to be concluded by the following September, allowing the painter just under four months for completion. Beyond this deadline, with the exception of justifiable impediments, the fee would have to be returned in full.[8]

Subject

The altarpiece was to represent a standing Madonna with the Child in her arms, modelled on that of Loreto, combined with the two named saints in their specific iconographies as cardinal and with the stigmata respectively. In other words it was to be first and foremost a *sacra conversazione* and not a conventional depiction of the Madonna di Loreto, which in the fifteenth and early sixteenth centuries most often featured the Madonna, with or without her Child,

PLATE 1 Perugino, *Madonna di Loreto* (NG 1075), 1507. Panel, 189.1 × 157.5 cm (painted area, within a drawn contour: 182.7 × 151.9 cm).

standing beneath a tabernacle with angels supporting the columns (the more familiar iconography of the transportation of the Santa Casa or Holy House only became mainstream in paintings after the turn of the sixteenth century).[9] The image of the Virgin then venerated at Loreto was a fourteenth-century carved wooden sculpture of Marchigian manufacture of a standing Virgin holding the Christ Child, both wearing crowns, which had replaced an earlier icon as the principal object of devotion there (FIG. 1).[10] The sculpture was much replicated in the Marches and Umbria, and the model Schiavone's heirs had in mind could easily have been a more local cult object in Perugia. For example, a polychrome sculpture attrib-

FIG. 1 Unknown Umbrian or Marchigian artist, *Madonna di Loreto*, late fourteenth century. Spruce with polychromy, 93 cm (height). Loreto, formerly Basilica Santuario della Santa Casa (destroyed by fire 1921).

PLATE 2 Attributed to Ambrogio Maitani, *Standing Madonna and Child*, c. 1330. Wood with polychromy, 100 cm (height). Perugia, Galleria Nazionale dell'Umbria, inv. 1030.

FIG 2. Unknown artist, *The Madonna di Loreto crowned by angels and the church of Santa Maria surrounded by a fortress*, early sixteenth century. Woodcut, Bertarelli Collection.

uted to Ambrogio Maitani of a standing Virgin, crowned and carrying the Christ Child (PLATE 2), attracted intense devotion at the convent of Sant'Agostino and was particularly associated with the feast of the Madonna di Loreto.[11] Perugino would probably have known this sculpture because the monks of Sant'Agostino commissioned an altarpiece from him for the church in 1502, and it may be no coincidence that the poses of the figures in Perugino's painting resemble the statue quite closely (more than the Loretan prototype). The pedestal on which the Virgin stands in the painting could well reflect the central group's loose dependence on a sculptural source. However, the low walled enclosure which Martin Davies suggested might be a further nod towards the Loretan theme of the Holy House frequently appears as a backdrop in other devotional subjects and is unlikely to be specifically related to that iconography.[12] The motif of the coronation of the Virgin by a pair of angels in the altarpiece, unspecified by the patron or his executors, may derive from similar formulae in woodcut illustrations in early printed books relating the legend of the translation of the Virgin's Holy House, which had a wide circulation from the late fifteenth century onwards (FIG. 2).[13]

Predella

The contract for the altarpiece specifies a '*pledula*', but the generally accepted notion that this was a figurative predella element is implausible for a number of reasons. Firstly, the '*pledula*' is not mentioned in immediate conjunction with the woodwork for the main panel, as was more usual, but in a subsequent clause, along with the '*paramentis brochatis*' that Perugino was also to provide for it. Martin Davies rightly observed that the term was more likely to have denoted 'a simple pedestal or base' since no subjects are specified'.[14] (Indeed a similar term, '*predula*', was employed in a contract for an altarpiece by Perugino destined for San Pietro in Perugia of 1495, but there it was specified that it should be '*historiatam, pictam, et ornatam*'.[15]) The '*paramentis brochatis*' were almost certainly fictive ornamental vestments for this pedestal which the artist was to paint in imitation of brocade.[16] The very low fee paid for the altarpiece (see discussion below) would surely have excluded a figurative predella and indeed anything at all elaborate.[17]

Following the picture's acquisition by the National Gallery in the late 1870s, the then director Frederic Burton recalled seeing the original frame, reputed to have been made by Perugino himself, surrounding a copy of the altarpiece in Santa Maria Nuova, lamenting that the Gallery had not been able to acquire it with the picture prior to its subsequent transfer to the Pinacoteca in Perugia.[18] This frame had for many years been lost sight of, but, in response to research

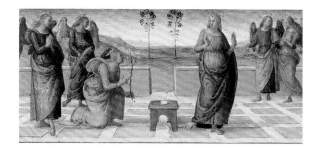

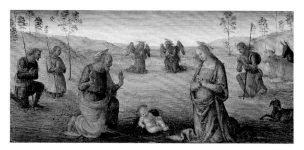

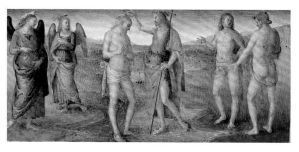

PLATE 4 Perugino, *Annunciation, Adoration of the Shepherds* and *Baptism of Christ*, predella panels, probably second decade of sixteenth century. Panel, 16.6 × 37 cm; 16.1 × 36.8 cm; 17 × 36.5 cm. Perugia, Galleria Nazionale dell'Umbria, inv. 269, 268, 267.

PLATE 3 The frame of *Madonna di Loreto* (NG 1075), recently rediscovered in Perugia, Galleria Nazionale dell'Umbria.

conducted for this article, it has recently been re-identified in the deposits of the Galleria Nazionale (PLATE 3).[19] The relatively simple rectangular tabernacle construction, consisting of an entablature, pilasters and a base elegantly decorated with painted grotesques and some gilding in the capitals and upper mouldings, could clearly never have incorporated a figurative predella, and the dimensions support this. From its appearance, the frame's decoration could plausibly have been carried out in Perugino's workshop as the tradition circulating in the nineteenth century proposed.[20] Its superficial elegance could have been achieved at relatively little cost, in accordance with the terms of the contract, and would have been complemented by the fictive brocade antependium of the '*pledula*' below.

The rediscovery of the original frame also eliminates the association with NG 1075, much propounded in the recent literature, of three small predella panels depicting the *Annunciation*, the *Adoration of the Shepherds* and the *Baptism of Christ*

(PLATE 4) also formerly in Santa Maria Nuova and now in the Galleria Nazionale dell'Umbria.[21] In a scholarly entry in the permanent collection catalogue of 1989, Francesco Santi argued convincingly for the association of these panels with Perugino's late *Transfiguration* of *c.*1517 painted for Andreana Signorelli's chapel in Santa Maria dei Servi. In support of this, he drew attention to eighteenth- and nineteenth-century records associating the panels with the *Transfiguration*, as well as pointing out the Christological subject matter of the scenes (Christ's Baptism, after all, would be particularly eccentric in the Marian context of the *Madonna di Loreto*), and the late style of the panels.[22] Continuing attempts to associate the predella panels with the *Madonna di Loreto* have tended to ignore these arguments, emphasising instead other far less persuasive evidence.[23] In addition, some scholars had objected that the total width of the predella panels (110.03 cm) was insufficient to make up a predella for the *Transfiguration* (185 cm), but Santi reasonably argued that some scenes or decorative elements may not have survived.[24] In short, the frame's rediscovery now provides empirical evidence to support the meticulous scholarship of both the London and Perugian National Gallery curators of the last century regarding the interpretation of the contract and the absence of a figurative predella.

Subsequent history

Perugino's long-standing links with the Servite order are attested by the many commissions he painted for Servite churches in Tuscany and Umbria throughout his career.[25] For Santa Maria dei Servi, the order's headquarters in Perugia, he had already executed, more than thirty years earlier (by 1475), an *Adoration of the Magi* probably for the pre-eminent Baglioni family (PLATE 5), whose chapel was seemingly located in a bay adjacent to the one in which Schiavone's was situated.[26] The carpenter may have aspired to emulate the ruling family in their choice of artist, who in the interim had become very famous, but posterity did not serve him as well as he might have wished. Writing little over forty years later, Vasari recorded only two works by Perugino in Santa Maria de' Servi, the *Adoration* and his later *Transfiguration* of 1519, completely overlooking Schiavone's more modest commission.[27]

In fact, the painting remained on its altar in Santa Maria dei Servi for only thirty-five years. It was moved when the church was demolished in 1542 to make way for the Rocca Paolina and the Servites transferred their quarters to Santa Maria Nuova at Porta Sole.[28] Here it occupied an altar dedicated to

PLATE 5 Perugino, *Adoration of the Magi, c.* 1475–6. Panel, 242 × 180 cm. Perugia, Galleria Nazionale dell'Umbria, inv. 180.

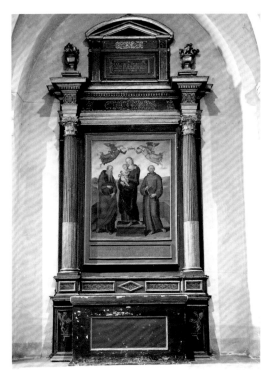

FIG. 3 Giuseppe Carattoli after Perugino, *Madonna di Loreto,* 1822. Canvas, 160 × 120 cm. Here shown in its present location on the altar of the Santi Fondatori in Santa Maria Nuova, Perugia.

Saint Francis belonging to the Cecconi family, subsequently passing by bequest to the Crispolti family and thence by descent to the Della Penna.[29] In 1821, Fabrizio della Penna persuaded the Servites to part with the work for a mere 350 scudi (the equivalent of about £70)[30] and the provision of a copy by Giuseppe Carattoli (which remains in the church, FIG. 3),[31] enabling him legitimately to remove the work to his private picture gallery in the Della Penna palace.[32] It was here, in September 1856, that the painting was inspected by Otto Mündler, the National Gallery's roaming agent then travelling throughout Europe in search of paintings to add to the growing collection in Trafalgar Square, under the supervision of its first director, Sir Charles Eastlake. In Mündler's judgement, the painting, although 'much spoken of', and 'very graceful' in parts of its composition, was on the whole 'very defective, thinly painted, dry, wanting rilievo and still more wanting freshness and light', adding that 'moreover, the picture has suffered'.[33] Eastlake, who himself visited Perugia a couple of month's later, principally to inspect the tiny Madonna *in tondo* by Raphael in the collection of the Conestabile della Staffa family (unfortunately – despite Eastlake's enthusiasm – not acquired by the National Gallery and today in the Hermitage Museum, St Petersburg[34]) was even more categoric in his opinion that the painting was not suitable for the National Gallery collection: 'The Penna Perugino … besides its original defects of unpleasant symmetry in the angels above, is so entirely stripped of its surface by time, or picture restorers, that it presents little more than the mere composition, without roundness of parts. It was not therefore a question of greater or less price (though the price asked is high). I considered the picture altogether ineligible, and the more so because it could never have borne a comparison with the admirable specimen now in the National Gallery.'[35]

The 'admirable specimen' to which Eastlake referred was the group of three panels from the Certosa di Pavia altarpiece, acquired for the Gallery, following complex negotiations, from the Milanese collection of Duke Ludovico Melzi earlier in the same year. Clearly the discrepancy in quality between this exquisite work painted by Perugino at the height of his powers for none other than Duke Lodovico Sforza of Milan and the far humbler and more routine *Madonna di Loreto* in more dubious condition would have been all too apparent and its purchase impossible to justify.

There was no further thought of acquiring the painting until twenty years later, when, in November 1876, an amateur dealer and Conservative MP for Plymouth, Sampson S. Lloyd, approached the Trustees alerting them to the sale of Baron Fabrizio Ricci della Penna's collection in Perugia, and the availability of the Perugino in particular.[36] He described the painting's colouring as 'mellow but *pale*' and went on to observe that 'it appears in excellent preservation, and has been … in the possession of that family and in the same palazzo, for centuries', though qualifying these exaggerated claims with a declaration both of his amateur knowledge of art and of his personal interest in the transaction.[37] Nevertheless, Burton, who had been appointed as the third director of the National Gallery in 1874, took the tip seriously, and having evidently visited the Della Penna collection, reported back to the Trustees that the picture was 'a fine work', but too highly priced at 100,000 francs (£4000).[38] He suggested making a lower offer, which was eventually agreed by the Trustees at £3200 and the painting was purchased in late 1879.[39] By this date the possibility of acquiring altarpieces by major Renaissance artists was growing ever more challenging and Burton, who bought widely and prestigiously, may have thought it expedient to add a characteristic example of the artist's late oeuvre to the Peruginesque material already in the collection. He may not necessarily have had access Eastlake's reports noting that he had viewed and rejected the painting. As it turns out, Eastlake and Mündler's reservations regarding the picture's schematic appearance (which as we shall see were influenced by the circumstances of its commission and the serial cosmetic treatments it received in the nineteenth century) have been borne out by the picture's long-term relegation to the Lower Galleries or store. Nevertheless, the two directors' differing responses illustrate how subjective and contingent upon circumstances decisions regarding the eligibility of works for acquisition could (and still can) be.

Reputation, price and the practices of production

The *Madonna di Loreto* is among several altarpieces by Perugino with a surviving contract and this provides information not only about who ordered the work but also about how long it was to take, the quality of the materials to be used and how much it cost.[40] As the contract stipulates, Perugino was to receive only 47 florins to produce the altarpiece. This is a surprisingly low amount for a work commissioned from one of the most sought-after painters in Italy. The table of priceable commissions by Perugino given in Appendix 2 demonstrates that the *Madonna di Loreto* (number 13 in the list) was the least expensive of Perugino's documented paintings. Indeed, the fee was even lower than might appear at first glance, for Perugino was to supply both the painted composition

and the carved woodwork of the altarpiece. The price of altarpiece carpentry varied widely in the period, but considering that the average cost was about 18 per cent of the expenditure for painting, woodwork and gilding combined, the value of this commission was very low.[41]

The table makes it clear that the *Madonna di Loreto* was undertaken in a period soon after the painter had been engaged on large and expensive works for prominent clients, including Mariano Chigi, the head of the banking family centred in Siena (number 9), Isabella d'Este, the Marchioness of Mantua (number 11) and the friars of the venerable convents of the Augustinians in Perugia (number 10) and the Servites in Florence (number 12). This suggests that its low price cannot be explained entirely by a fall-off in prestigious commissions. Furthermore, as has been argued elsewhere, the price is unlikely to have been directly related to the altarpiece's size (though in fact it is the second smallest of the documented works in the table).[42] Instead, the price was probably set with regard to a social relationship. It may be that Perugino had had a working relationship with the carpenter Schiavone and because of that was willing to produce the altarpiece for a very small fee.[43] Evidence exists to show that painters sometimes reduced their fees in this way for people with whom they had a personal connection.[44] Schiavone was not poor, but the bulk of his modest estate was invested in property. The declared cash component of his will amounted, at 45 florins, to fractionally less than the cost of the altarpiece, and this sum was bequeathed in its entirety to the Servites. Since the balance required to build and decorate his chapel was to be raised from property rental and the liquidation of other assets, one can deduce that Schiavone had relatively limited funds at his disposal. Perugino may have been confronted with the additional challenge of producing a panel painting for the equivalent price of a fresco, since that was what Schiavone seems to have envisaged in his will.[45] Had the altarpiece been commissioned while Schiavone was alive, he might have provided the woodwork himself, but since the contents of his workshop were to be sold to pay for the chapel, it seems that his business was wound up at his death.

The idea that the price reflects a professional connection between the two men leaves open, however, the question of how a painter of Perugino's reputation might approach the making of such an inexpensive altarpiece, particularly in the light of the high demand for his work. Findings made in the course of the recent conservation treatment of the *Madonna di Loreto* described below provide scope for

addressing this question and thus for exploring the relationships between reputation, cost and production practice in the careers of leading painters working around 1500.

Early in his career, Perugino had recognised the advantage of recycling his designs, a practice that had been pioneered in the Verrocchio workshop in the 1470s.[46] He developed this while he was establishing his reputation and by the 1490s, as Rudolf Hiller von Gaertringen has demonstrated, Perugino habitually reused cartoons to repeat figures in disparate works, reversed cartoons to make 'new' figures, re-proportioned existing designs for individual figures and figural groups, and occasionally re-staged whole compositions.[47] These processes allowed Perugino to delegate the making of underdrawings and thus to prepare works quickly, maximising the productivity of his shop. They were also a means of producing a characteristic and consistent product, the very product that established Perugino's reputation and upon which it, in turn, depended. [48]

The reuse of designs reduced the time and labour spent on planning a work, and this was clearly expedient for a painter whose business required him to produce a large quantity of works quickly. The reliable predictability of his product may explain why Perugino rarely produced contract drawings for new works even though it was common practice after the middle of the fifteenth century for painters to do so.[49] Making such drawings for presentation was time-consuming, and for most works Perugino and his clients must simply have discussed subject matter before agreeing formally to a brief written description, perhaps with reference to a common type of subject matter, as in the contract for the *Madonna di Loreto*. The process of recycling designs also had the potential to minimise expenditure and thus bring down the cost of a work. The process is unlikely to have been developed by Perugino primarily to reduce prices, however, as is made clear by a 'family' of works derived from the composition of the altarpiece made for the Perugian convent of San Pietro. Each of these was valued at 200 florins or more, making the works among the most expensive altarpieces produced by any painter in the period.[50] Nonetheless, the cost benefit of recycling designs cannot have been lost on Perugino and was clearly particularly crucial for works that he contracted to make for a low fee.

Perugino agreed to produce the Schiavone altarpiece quite quickly, in under four months, although this was clearly long enough for the production of a work of quality, since he frequently accepted similarly short deadlines.[51] In practice, however, as Appendix 2

shows, he very often ignored the deadlines initially agreed, regardless of whether or not a penalty clause was included in the terms of the contract.[52] Paradoxically, he seems to have been at his most elusive and dilatory when producing works for prestigious clients who often were not on the spot to monitor progress (notably Ludovico Sforza, Mariano Chigi and Isabella d'Este), and it is possible that when producing a low cost, routine work, there was more chance that he would deliver on time, particularly if he could devote less attention to detail and finish and rely to a larger extent on workshop assistance. The contract stipulation that Perugino should paint the altarpiece 'with his own hand' merely restricted the production of the work to the painter's shop,[53] and it remains questionable how much he contributed to the execution of this work himself. There is no record of whether he fulfilled the timetable of the contract in this instance,[54] though the fact that the altarpiece appears to have been rapidly executed would at least not contradict this.

The use of materials indicates both care over the costs and attention to quality. While azurite, employed for the mantle of the Virgin, was a much cheaper blue than ultramarine, it was nonetheless among the most costly pigments available and it satisfied the contract stipulation for the use of 'fine colours'.[55] In addition, the application of a red lake glaze over the azurite, to make it look like ultramarine, suggests that care was taken to make the work appear costly. This approach is further exemplified by the use of vermilion, a cheaper red, as an underpaint for the more expensive red lake glazes used to complete Saint Jerome's robe.[56] These are not uncommon techniques, but their use here suggests an attention to detail that the price might contradict.

In summary, the altarpiece would have been perceived as having all the hallmarks of a characteristic work by Perugino. Clearly this was important, even in a very inexpensive work. Furthermore, it is likely to have been as important for Perugino as it was for his clients, because works of art reflected on him, and were factors in the perpetuation of his reputation, no matter what they cost. Indeed, from the early 1480s, a reputation for quality, skill and an ability to attract patrons of status were strengths that Perugino brought to the bargaining table whenever he engaged with clients. His reputation was on the line every time he turned out a new work. For this reason, it was important for the Perugino enterprise to produce an attractive, well-finished altarpiece that displayed the characteristic elements of his shop, no matter what price he had negotiated.

Materials and technique

The altarpiece shows every sign of being the most economical form of workshop production, from the simplicity of its design, to the broad unlaboured application of the paint layers, and the use of relatively low cost materials. It is also evident from both the design and the manner of painting that this must be a work produced at some speed. The composition was built up in very few layers of paint, the oil-based technique permitting rapid execution without the need for extended periods set aside to allow underlayers to dry before application of the finishing layers. This is in marked contrast to the technique of some of Perugino's more elaborate altarpieces, for example the Certosa di Pavia panels (NG 288), in which almost every feature involves a number of layers of paint and fine surface detail.[57] It may also be significant that some of the materials used in the painting are notable for their rapid drying properties in oil, and where they are slow driers, for example the red lake of Saint Jerome's cloak, a siccative (drying agent) is incorpo-

FIG. 4 Perugino, *Madonna di Loreto* (NG 1075). X-ray detail of brushwork in Saint Francis's drapery.

FIG. 5 Perugino, *Madonna di Loreto* (NG 1075). X-ray detail of brushwork in Saint Francis's drapery and landscape, right.

79

PLATE 6 Perugino, *Madonna di Loreto* (NG 1075), detail of PLATE 1 showing Christ's knee and the Virgin's thumb, with underdrawing clearly visible through thin paint layers.

PLATE 7 Perugino, *Madonna di Loreto* (NG 1075), detail of PLATE 1 showing the right angel's drapery below the wing, with underdrawing clearly visible through thin paint layers.

FIG. 6 Perugino, *Madonna di Loreto* (NG 1075). Infrared reflectogram detail showing pouncing on Christ's sash.

rated.[58] The identification of a heat-bodied oil medium as the paint binder, in this case walnut oil, is consistent with a need for faster drying times than a non-heat-thickened oil would achieve.[59] The broadly brushed strokes of paint, indicative of rapid application, can be seen from close examination of the surface of the painting, particularly in the sky and simple landscape background, both of which are largely single layers of paint; similar fluid brushwork is evident in the architectural enclosure surrounding the figures and the plinth on which the Virgin stands. This simplified technique and broad brushwork emerge perhaps even more clearly from X-ray images of the paint layers (FIGS 4 and 5).

The altarpiece was painted using techniques and methods typical of Umbrian production.[60] The poplar panel, made up of five vertical planks, carries a moderately thick gesso ground with a very thin off-white, oil-based *imprimitura* containing lead white, a small amount of lead-tin yellow and finely ground manganese-containing glass.[61] Drawn lines on all four sides mark the boundaries of the painted area. The composition was almost certainly scaled up from a small design, though no drawings for it are known.[62] Underdrawing can be seen with the naked eye because the paint layers are so thin (PLATES 6 and 7). Examination with infrared reflectography reveals that this drawing is based on pricked cartoons. The figures were transferred to the panel using fully elaborated cartoons, as is evident from the careful pouncing in areas of detail such as the Child's sash (FIG. 6). As in other works by Perugino, the *spolveri* are closely spaced, and more so in the head of the Christ Child than in the other figures.[63] The lines were joined up freehand in a fluid medium containing carbon, although for a liquid medium the quality of the line is surprisingly fine. The straight edges of the architectural elements were incised, as were the drapery folds in the Virgin's dark blue dress (a standard practice enabling the underdrawing to remain visible after the application of the opaque pigment).

The similarity of pose between the two angels has led to speculation that the same cartoon was used for both. It has now been possible to establish that this was indeed the case by making a tracing of the underdrawing revealed in infrared reflectography of the left-hand angel and superimposing it with the aid of a

PLATE 8 Perugino, *Madonna di Loreto* (NG 1075). Diagram showing superimposition of the underdrawing of the left-hand angel (yellow) over that of the right-hand angel (black), based on infrared reflectography.

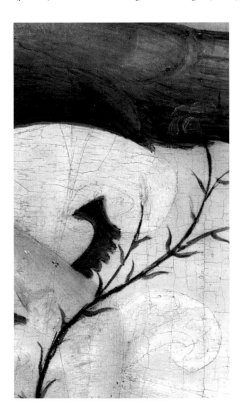

FIG. 7 Perugino, *Madonna di Loreto* (NG 1075).
Infrared reflectogram detail showing the first, more upright, position for the lily held by the right-hand angel.

computer onto the underdrawing of the right-hand angel (PLATE 8). The presence of a more vertical position for the lily in the underdrawing of both angels provides additional confirmation that the same cartoon was used, rather than that one was copied from the finished version of the other (FIG. 7). The final position for the lily, redrawn more gracefully between two sections of fluttering drapery, represents an improvement on the initial design made before painting began. The use of the same cartoon to generate pairs of angels occurs in numerous works by Perugino and was a quick and efficient means of creating a symmetrical design.[64] The angels in the present work nevertheless give the impression of having been designed for a different purpose, the template probably deriving from Perugino's stock of patterns. No other work by Perugino contains angels in exactly these poses, but many are closely related. Graceful in themselves (as the underdrawing reveals), their wooden appearance here results principally from their having been tilted too far forward in order to squeeze them into the limited area of sky above the figures' heads.

As noted in the discussion of the cost of the altarpiece, no lapis lazuli ultramarine occurs in the picture.

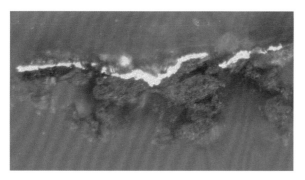

PLATE 9 Paint cross-section from the dark blue of the Virgin's robe consisting of coarse natural azurite. There is a trace of red lake glaze at the surface and a fragment of mordant gilding. The gesso and *imprimitura* are not present. Original magnification 245×; actual magnification 210×.

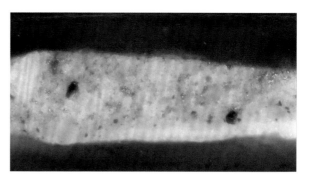

PLATE 12 Paint cross-section taken from the stone enclosure around the figures, showing lead white combined with haematite and a little black pigment over the off-white *imprimitura*. Original magnification 280×; actual magnification 215×.

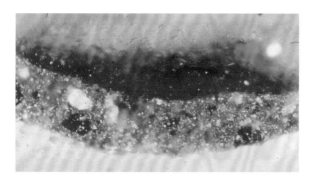

PLATE 10 Paint cross-section taken from Saint Jerome's cloak, showing layers containing vermilion, red lake (kermes) and a final red lake glaze. Original magnification 340×; actual magnification 265×.

The blues are all based on mineral azurite, which has been applied very thickly in a single layer directly over the *imprimitura* for the Virgin's mantle, and then thinly glazed with red lake overall, in order to shift the colour towards a more purplish hue (PLATE 9). This effect has been substantially lost as a result of radical darkening of the azurite-containing underlayer.[65] The azurite used, however, is of a coarse-textured strongly blue colour and therefore probably not a cheaper grade. Poorer quality azurite occurs in the sky paint, with white, and with white and red pigments (both red lake and haematite) to represent the soft plum colours of the Virgin's dress (where it occurs over a layer of vermilion) and Saint Jerome's inner sleeves, which are more simply painted as a single layer over the *imprimitura*. The rather stronger coloured mulberry-toned paint of the stone enclosure within which the figures stand is made up of lead white combined with haematite (PLATE 12), a pigment also used by the Perugino workshop to create this same tonality in fresco.[66]

The rich red fabric of Saint Jerome's outer cloak is more elaborately worked than the paint layers elsewhere, in such a way as to render a greater density of colour and saturated effect particularly in the shadows. The garment is represented in three or four layers of paint: a lowermost undercolour of virtually pure vermilion, a darker richer tone laid over in which red lake pigment is combined with the vermilion, and one or two fairly thick layers of red lake glaze (PLATE 10). The red lake has been identified by high performance liquid chromatography (HPLC) as based on the dyestuff derived from the kermes scale insect,[67] and the glaze paint layer in which it occurs also contains substantial quantities of pulverised colourless glass, most likely added as a drying agent.[68]

At the other end of the scale, Saint Francis's habit is one of the more simply painted parts of the picture,

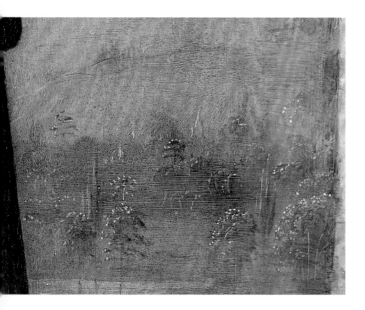

PLATE 11 Perugino, *Madonna di Loreto* (NG 1075), detail of PLATE 1, showing background landscape to the right, simply laid in.

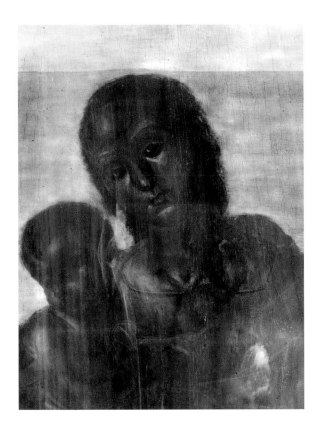

FIG. 8 Perugino, *Madonna di Loreto* (NG 1075). X-ray detail of the heads of the Virgin and Child showing the thinness of the flesh paint layers.

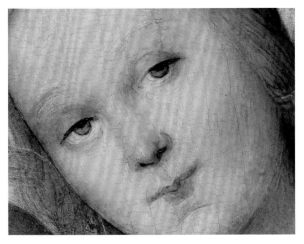

PLATE 13 Perugino, *Madonna di Loreto* (NG 1075). Detail of the Virgin's face.

consisting for the most part of one layer of slightly greenish-brown paint, containing lead white with coal black pigment[69] and a little yellow earth. A thin brownish glaze for the shadows composed of coal black, a translucent brown and some red lake is worked over the undercolour to construct the form. The background landscape is similarly simply laid in, with a few cursory twists of the brush to suggest a line of small trees and bushes in the middle distance which

were never completed (FIG. 5). The mid-green solid colour of the landscape contains white pigment, some azurite and green earth (*terra verde*),[70] and a proportion of yellow, with azurite predominating in the most distant bluer parts at the horizon and also used to represent the detail of the middle distance section of landscape with a few small trees and the suggestion of buildings (PLATE 11). The small rounded yellow-green touches on foliage are common in Perugino's designs; sometimes they are mordant gilded.

The flesh paints are very thinly and sparsely modelled and as a result register as dark, rather featureless non-radioabsorbent shapes in the X-ray images (FIG. 8), but this effect has also been noted in works by Perugino involving a more complex and refined method of painting, for example the *Marriage of the Virgin* in Caen (Musée des Beaux Arts)[71] and the Certosa di Pavia panels in the National Gallery.[72] Some slightly thicker pinkish highlights in lead white and a little vermilion are applied in a cursory and economical manner over the thin base of flesh paint emphasising the facial features and reflections of light (PLATE 13).

Many of Perugino's works employ beautifully constructed and carefully applied finishing decorative details in mordant gilding as patterns of golden embroidery on the necklines, hems and linings of the draperies of the principal figures, often with greatest attention paid to representations of the Virgin. The *Madonna di Loreto* is no exception, although the mordant-gilded lines and patterns on the Virgin's robe and dress are restrained and simplified. The mordant is not heavily pigmented and therefore scarcely registers on the X-ray image, except for the scalloped pattern at the hem of her dress where it was applied sufficiently thickly for the pattern to emerge as a thin white trace in the radiograph.

Condition and conservation history

Until recently, Perugino's altarpiece had not been displayed on the Gallery's main floor for many years due to lack of space, uncertainty about attribution and its very dulled surface. In comparison with other works by Perugino and his contemporaries in the National Gallery and elsewhere, the *Madonna di Loreto* had an unusually flat and colourless appearance. The possibility of cleaning the picture had been discussed several times but other priorities and the difficulty of predicting what could be achieved resulted in treatment being postponed. During planning for the 2004 Raphael exhibition (*Raphael: From Urbino to Rome*) it became clear that substitutes would be needed to fill the gaps in the Sainsbury Wing created by the absence

PLATE 14 Perugino, *Madonna di Loreto* (NG 1075). Detail of sky and distant landscape at the horizon, left-hand side, showing remnants of copal/oil varnish trapped in the texture of paint and probably applied during or shortly after 1821.

of the Raphaels. Perugino's altarpiece was an obvious candidate as a substitute for a Raphael altarpiece of comparable date and scale. There was also renewed curatorial interest in the *Madonna di Loreto*.

Preliminary investigations showed that the varnish applied after acquisition in 1879 was considerably discoloured and that the paint surface was further obscured by a thick layer of surface dirt. A short entry in the Gallery's 'Manuscript Catalogue' for the year 1879 refers only to cleaning while recording that the state of the painting was good. Cleaning tests established that the varnish,[73] which must have been applied in 1879, was easily soluble and the many discoloured retouchings covering small paint losses were not difficult to remove. It had been apparent before cleaning began that there were extensive residues of a grey/brown layer engrained in the texture of the paint. The paint surface showed signs of extremely rapid and rather summary execution leaving pronounced ridges – particularly in the sky, the landscape and Saint Francis's robe (PLATE 14).[74] In addition, the boldly applied and dramatic small highlights in the flesh paint were notably pastose. The X-radiograph of the Virgin's head (FIG. 8) shows the very sparing use of white lead typical of all the flesh paint in the altarpiece.

Chemical examination of the greyish residue, which was concentrated in the more thickly painted areas, showed that it was the remains of a surface coating composed of heat-bodied walnut oil combined with a copal, probably Congo copal.[75] The residues were much more noticeable near the heads of the Virgin and Child and the two saints and to a lesser extent near the two angels. It was clear that this

surface coating had been difficult to take off and that a past restorer had realised that any attempt to remove it from the generally very fine paint of the heads of the main figures would lead to damage. The angels had not fared quite so well. Both their heads and draperies had a slightly ethereal appearance. There the copal and walnut oil had been difficult to remove safely in the nineteenth century and by the time the recent treatment began in 2002 it was effectively insoluble, so no further attempt was made to remove it.

Saint Jerome's red robe was marred by many small spots and lumps of a dark brown material, which appeared to have been broadly applied with a brush or sponge. A broad and distinct smear was visible towards the bottom of the red robe. Examination by gas chromatography–mass spectrometry (GC–MS) showed that a form of copaiba balsam had been applied to the red layer in the past.[76] The use of copaiba balsam is an English form of Pettenkofering. It is known that a small number of National Gallery paintings were treated by these methods around 1880 with the intention of reviving or refreshing their appearance. It was used as a way of imparting some transparency to dull or chilled varnish layers and to revive the dull or matt paint. Unfortunately, however, although the desired effect is achieved temporarily, the residues of the balsam attack and adversely affect the paint layer itself by causing swelling, thus rendering the oil medium 'tenderised' and more vulnerable. Indeed, solubility tests on Saint Jerome's red cloak

PLATE 15 Perugino, *Madonna di Loreto* (NG 1075). A thick discoloured varnish (composed of a mixture of dammar and Venetian turpentine resins) was uncovered as a result of removal of an old putty filling from a narrow strip of damage on the front surface of the panel. Probably applied after the (partial) removal of the earlier, disfiguring copal/oil varnish during the late 1830s to late 1840s or early 1850s.

PLATE 16 Perugino, *Madonna di Loreto* (NG 1075). Thick brownish resinous dribbles were exposed following removal of an area of re-paint under Saint Francis's proper right foot. Analysis suggests that they are discoloured splashes of an 'Old Master glow' (tinted varnish), composed of mastic resin, fortified with essential oil, now polymerised and tinted with a coloured resin (accroides), derived from a form of 'grass' found in Australia of the genus *Xanthorrhoea*. Marked darkening may well have been caused by contamination by residual traces of alkaline cleaning materials. The accroides resin is likely to have been available in the latter part of the 1860s or early 1870s.

showed that the paint in the darker shadowed areas was unusually soluble. Traces of copaiba balsam were also found on some of the flesh paint.

Significant traces of two other surface coatings were found. One was discovered at the right edge, under a strip of old filling. The edge of the panel had been damaged by an impact and a narrow strip of the front surface had been pushed forward. Putty was used to repair the damage, analysis of which demonstrated that it contained linseed oil as a binding agent. Under this was found a thick and discoloured varnish, which proved to be a mixture of dammar resin and larch turpentine (PLATE 15). It is likely that the whole surface of the panel had been covered by this layer when the damage to the panel occurred and the repair made. The picture must then have been cleaned but the putty was not removed, thus preserving the varnish underneath it.

An area of re-paint under Saint Francis's right foot covered some thick dribbles of a brown layer (PLATE 16). These dribbles, though clearly resinous, could have been mistaken for blood from Saint Francis's stigmata, as they were of a similar colour. Analysis showed that this layer consisted of degraded remnants of a mastic varnish, rich in essential oil – now polymerised as polyterpene – which had been tinted with accroides resin, also referred to as 'Botany Bay' or 'Blackboy' gum and which was obtained from the

Australian grasses of *Xanthorrhoea* spp. (Liliaceae). In effect, this material appears to be the residue of a toned varnish formulation, that is, an 'Old Master glow', which had – for some reason – dropped or dribbled and built up to a moderate thickness in this area. No other trace of it was identified on the paint surface. Moreover, this mastic-containing material, with its (eventually) insoluble polymerised terpene, exhibited some indication of local exposure to an alkaline agent. We are able to deduce this from the depletion of mastic resin acids in the now, open-textured surface of this material. In addition, evidence suggests that, locally, some areas of the grey paint of the floor in the vicinity of Saint Francis's feet had an oil medium, which had undergone alkaline attack.[77] Such an environment would, with a modest passage of time, cause the accroides resin's tinting components to become dark brown, much as the case here. This resin retains its colour quite well and is not prone to heavy darkening or fading under normal, ambient conditions. Depending upon the species of origin, the collected resin can range from a lemon to a golden yellow through to an orange colour.

It is rare to find evidence of more than a few of the treatments to which old paintings have been subjected and it is surprising to find that four separate surface coatings were applied to NG 1075 between 1821 and 1879. This can be deduced because none of the four layers of varnish could have been used before the early nineteenth century, given the types of resin employed, and it is unlikely that the painting would have been revarnished in Santa Maria Nuova.

The sequence of different surface coatings applied to the altarpiece could be as follows. At some stage after it was removed from the church to his house by Baron Fabrizio della Penna in 1821, the painting may have been cleaned and then varnished with a walnut and copal mixture.[78] This remained on the surface long enough to discolour but not for so long as to become completely insoluble. After the partial removal of this layer, a varnish composed of dammar resin mixed with Venetian turpentine (larch resin) was applied to the surface. Remnants of this survived under the filling at the right edge during the next cleaning. Whereas dammar varnish is one of the palest varnishes and among those which discolour more slowly, in this instance because of the unfortunate inclusion of Venetian turpentine we can be sure that the varnish darkening would have been accelerated, necessitating removal and replacement. Venetian turpentine was probably included with the intention of plasticising the film and thereby attempting to overcome dammar's tendency to brittleness. (The use

of dammar as varnish was first reported by Lucanus in 1829 and was in use in Germany by the early 1840s, where it spread to other parts of the Continent. Certainly its use had spread to Italy by the later 1840s or the beginning of the 1850s.[79])

It seems likely that, as a result of discoloration, this dammar-based varnish may have been removed and replaced by the fourth varnish, in this case an accroides-toned mastic varnish, rich in myrcene-based polyterpene. Although *Xanthorrhoea* sp. resins were first mentioned by Captain J. Phillips, the first Governor of New South Wales, in 1789, we have no indication of its export until much later – the 1850s or early 1860s.[80] Thus, it is reasonable to suggest that the toned mastic/polyterpene varnish may have been applied in the latter part of the 1860s or early 1870s. From its removal to Baron Fabrizio's household in 1821, the painting passed down two further generations before his grandson put the family collection up for sale in 1875. It is probable that these attempts to improve the picture's appearance were made during this period.

Conclusion

The picture was painted at a turning point in Perugino's career, when the brilliant artistic achievements of the last decades of the fifteenth century on which his considerable fame rested began to be superseded by new developments being pioneered by younger artists in Florence and elsewhere. Paradoxically, at around this time, Perugino seems to have become increasingly reliant on repetitions and reconfigurations of extant works, to the detriment of his reputation. The extensive correspondence of 1503–5 between Isabella d'Este and her agents regarding the commission of a mythology by Perugino for her *studiolo* conjures up a truculent personality, slow to produce, with a high opinion of himself, and injudicious in his sense of priorities.[81] When Perugino did finally deliver his *Combat of Love and Chastity*, the result was deemed by his patron both technically and aesthetically *retardataire*.[82] In the following two years (1505–7) he completed what was to be his last work in Florence, the double-sided high altarpiece for SS. Annunziata, for which Vasari reports he was roundly censured by his contemporaries.[83] Meanwhile in Perugia, where he is documented as having set up a second workshop from 1502,[84] Perugino received increasingly few new commissions, and apart from the huge altarpiece for Sant' Agostino, contracted in 1502, but not supplied until 1523, seems to have been mainly taken up with completing works for the city commissioned years before (such as the *Marriage of the*

FIG. 9 Perugino, *Deposition*, c. 1505, Florence, Galleria dell'Accademia. Infrared reflectogram showing detail of the Magdalen.

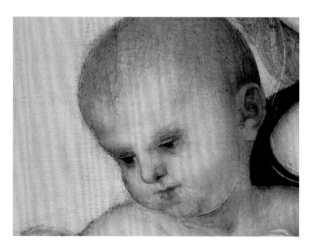

PLATE 17 Perugino, *Madonna di Loreto* (NG 1075). Detail of the Child's face.

Virgin for the Chapel of the Holy Ring in the Cathedral) or embarking on new ones for more provincial centres. Apart from the commission for Sant' Agostino, the *Madonna di Loreto* was the only other documented commission he received for a church in Perugia in the five years after the workshop was set up. It is no surprise that in these very years several prestigious Perugian commissions were assigned to Perugino's precociously talented young

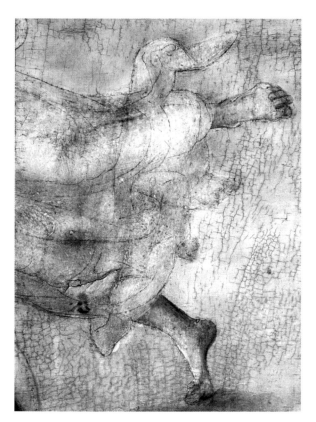

FIG. 10 Perugino, *Madonna di Loreto* (NG 1075). Infrared reflectogram showing detail of the angel's legs and feet.

colleague Raphael, who in 1505 was judged to be the best painter in the city.[85] As if in confirmation of this, the Christ Child in the *Madonna di Loreto* (PLATE 17) pays homage to Raphael's altarpiece for the chapel of the Ansidei family of 1505, reversing the earlier direction of influence between the senior and junior masters.[86]

In view of Raphael's presence in the city, and the challenge this represented to Perugino's status and reputation, it is surprising that the quality of the altarpiece for Santa Maria dei Servi is so unremarkable, though the low budget for the project agreed with Schiavone's heirs was clearly a determining factor. The condition of the picture apart, its evident weaknesses, well summarised by Eastlake and Mündler, prompt two alternative hypotheses regarding its attributional status. According to the first, Perugino painted the work himself, grasping the nettle of a cheap commission and carrying it out at considerable speed (from its appearance the painting must have been executed much more rapidly than in the four months allowed). In the face of limited resources, it may have been more practical and economical for Perugino to have painted the prepared panel himself. The patently pedestrian and mechanical quality of the altarpiece might support or undermine this theory: passages

such as the heads of the Virgin and Saint Francis seem a far cry from the skill Perugino had demonstrated in works only slightly earlier in date. Therefore one either has to accept a rapid decline in his painterly powers or propose an alternative solution: such a straightforward project could easily have been delegated to a reliable workshop member accustomed to turning out recognisable products in Perugino's signature style and worthy of his name. This hypothesis receives support from the fact that, apart from the angels' lilies, there is no deviation whatsoever from the transferred cartoons, and furthermore, the quality of the underdrawing is far less fluid and creative than that evident in other published underdrawings by Perugino (compare FIGS 9 and 10).[87] The most subtly rendered passages include the heads of Saint Jerome and the Christ Child (PLATE 17), the folds of Saint Jerome's purple surplice, and the buildings emerging from the misty lakeside forest in the landscape to the right of Saint Francis, which perhaps bear the hallmarks of Perugino's own more sophisticated touch.[88] Certainly there are plenty of comparisons for the stylistic quirks of the *Madonna di Loreto* in Perugino's later oeuvre, but until we have more information on the composition of his workshop in the sixteenth century, the questions of attribution and division of labour in this and other late works remain open.

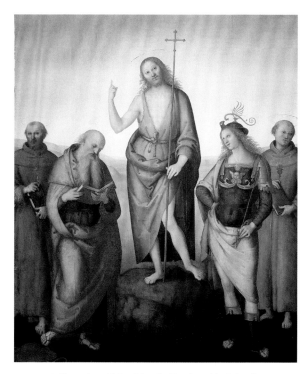

PLATE 18 Perugino, *Saint John the Baptist with Saints Jerome, Francis, Sebastian and Saint Anthony of Padua*, c. 1510. Panel, 205 × 173 cm. Perugia, Galleria Nazionale dell'Umbria, inv. 280.

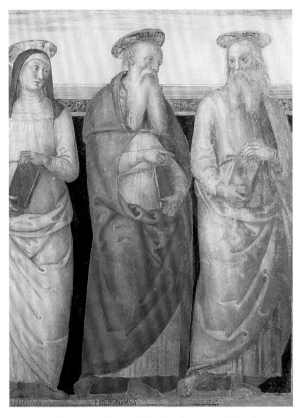

PLATE 19 Perugino, *Saints Scholastica, Jerome and John the Baptist,* 1521. Detail of the *Holy Trinity flanked by Saints* by Raphael and Perugino, fresco, width at base 390 cm. Perugia, San Severo.

Perugino must, however, have been satisfied to some degree with the design of the *Madonna di Loreto* since he (or his enterprise) returned to a similar formula when painting another altarpiece representing *Saint John the Baptist with Saints Jerome, Francis, Sebastian and Saint Anthony of Padua* for San Francesco al Prato, also in Perugia, executed within the next five years (PLATE 18). The figure of the Baptist raised up on a rocky dais-like mound in a similar pose to the Virgin in the *Madonna di Loreto,* and the morphology of the figures of Saints Jerome and Francis are all highly comparable.[89] There are many echoes of the two saints in later works that Perugino painted for a variety of Umbrian destinations, and Saint Jerome even crops up again virtually unaltered as late as 1521 in Perugino's contribution to the fresco that Raphael had begun in the Camaldolese monastery of San Severo, though tellingly, the lower half of the fresco for which Perugino was responsible is rarely illustrated (PLATE 19).[90]

Michelle O'Malley is the Director of the Office for Research Support in the School of Humanities at the University of Sussex. She has recently published *The Business of Art: Contracts and the Commissioning Process*

in Renaissance Italy and is currently working on issues of quality in relation to price and demand in the careers of Italian painters around 1500.

Acknowledgements

The authors are particularly grateful to Rachel Billinge for her assistance in recording and interpreting the underdrawing of the *Madonna di Loreto.* We would also like to thank Valentina Ricci Vitani for research carried out in the Perugian libraries and archives, and for photographing and transcribing Schiavone's will and the contract for the *Madonna di Loreto* (Appendix 1A–B). Thanks are also due to Giorgia Mancini for her assistance in checking and interpreting these documents. The article has greatly benefited from discussions with Tom Henry and Luke Syson, who kindly read it in draft.

Notes

1 The authors wish to acknowledge Martin Davies's thoroughly researched entry in *National Gallery Catalogues: The Earlier Italian Schools,* rev. edn London 1961, pp. 407–10, as the foundation from which this article springs.

2 Santa Maria dei Servi was destroyed in 1542 to make way for the Rocca Paolina, so evidence for the original location of the altars is gradually being reconstructed from documents: see F. Palombaro, 'Ricostruire Santa Maria dei Servi', and M. Regni, 'Apporti documentari per la ricostruzione delle vicende di Santa Maria dei Servi', in *Perugino: Il divin pittore,* exh. cat., eds V. Garibaldi and F.F. Mancini, Perugia (Galleria Nazionale dell'Umbria) and Umbria, February–July 2004, pp. 541–6 and pp. 547–53 respectively.

3 An extract from Schiavone's will, which survives in a notarial copy in the Archivio di Stato in Perugia, was first published by F. Canuti, *Il Perugino,* 2 vols, Siena 1931, II, p. 254, doc. 418. The text is transcribed in full for the first time as Appendix 1A below.

4 Apart from his will and the contract drawn up by his executors, Schiavone is otherwise documented only as having worked on the choir of San Domenico (see A. Rossi, 'Maestri e lavori di legname in Perugia nei secoli XV e XVI', in *Giornale di Erudizione Artistica,* 1872, I, fasc. I, p. 67).

5 In his will, Schiavone specified that his chapel was to be 'beside the column dedicated to the Magi, near which the pulpit is usually situated, and next to the tomb of the Bishop of Casciano': see Appendix 1A. A reconstructed ground plan of the church and its altars is published by Palombaro in Garibaldi and Mancini 2004 (cited in note 2), p. 544.

6 'on the wall of which column are to be painted the below mentioned images, that is Santa Maria of Loreto, Saint Jerome and Saint Francis.' See Appendix 1A.

7 For a new transcription of the contract, previously published with slight discrepancies from a notarial copy in the Archivio di Stato in Perugia by W. Bombe, *Geschichte der Peruginer Malerei,* 1912, pp. 378–9, and by Canuti 1931 (cited in note 3, p. 254, doc. 419), see Appendix 1B. (Martin Davies's exemplary transcription from the original document is in the dossier for NG 1075.)

8 Canuti (cited in note 3) I, p. 191, claimed that Perugino was paid the whole sum in that year, and therefore as good as met the deadline, but, as P. Scarpellini (*Perugino,* Milan 1984, p. 116) points out, there is no documentary proof of any such payment.

9 For the changing iconography of the Madonna di Loreto, see *L'iconografia della Vergine di Loreto nell'Arte,* exh. cat., eds F. Grimaldi and K. Sordi, Palazzo Apostolico della Santa Casa, Loreto 1995, esp. pp. 20–6. The authors illustrate many examples of the Madonna and Child beneath a tabernacle supported by angels, and further examples can be found in *La Madonna di Loreto nelle Marche. Immagini devote e liturgiche,* eds F. Grimaldi, M. Paola Mariano and K. Sordi, Camerano 1998. For an almost exactly contemporary Umbrian example of the Madonna beneath a tabernacle see Signorelli's fresco of this subject in San Crescentino, Morra, datable 1508–10 (T. Henry and L. Kanter, *Luca Signorelli,* New York 2002, pp. 220–1, cat. 87/4). It is worth noting that before the turn of the century,

the subject in pictorial form was almost exclusively confined to fresco decorations. Perugino's painting, which interestingly Schiavone originally envisaged in frescoed form, is one of the earliest surviving altarpieces of this subject, and since the prior of S. Maria dei Servi was among the carpenter's executors, this unusual departure probably reflects theological interest in the subject on the part of the Servite order.

10 See F. Grimaldi, 'L'iconografia della Vergine lauretana nell'arte: I prototipi iconografici', in Grimaldi and Sordi 1995 (cited in note 9), pp. 15–30.

11 Entry by E. Lunghi in *Dipinti, sculture e ceramiche della Galleria Nazionale dell'Umbria: Studi e restauri*, eds C. Bon Valsassina and V. Garibaldi, Florence 1994, cat. 29.

12 Davies 1961 (cited in note 1), p. 408; Tom Henry has kindly pointed out that similar three-sided, low-walled enclosures appear behind the Virgin's throne in a tondo of the *Virgin and Child enthroned with Female Saints and Angels*, usually attributed to Andrea (Aloigi) d'Assisi, in the Louvre, Paris (see Scarpellini, cited in note 8), and in a *Flagellation* attributed to Pietro di Galeotto in the oratory of St Francis, Perugia (ibid., p. 307, fig. 18c).

13 F. Grimaldi, *La historia della chiesa di Santa Maria de Loreto*, Loreto 1993, p. 314.

14 Davies 1961 (cited in note 1), p. 409, n. 3.

15 Canuti 1931 (cited in note 3), II, p. 177, doc. 224.

16 Christa Gardner von Teuffel kindly confirmed our interpretation of the document with regard to the *paramentis* for this pedestal or socle. An excellent example of fictive altar vestments of this kind is in the ante-pendium on the altar of the chapel of San Giovanni in the Collegio del Cambio in Perugia, for which Mariano di Ser Austerio received payment in 1512 (see F. Todini, *La Pittura Umbra. Dal Duecento al primo Cinquecento*, 2 vols, Milan 1989, II, p. 599, no. 1389, and P. Scarpellini ed., *Il Collegio del Cambio*, Milan 1998, pp. 158–60. We are grateful to Tom Henry for this reference.

17 Carattoli's substitute copy of the altarpiece (for which see note 31) did not include any predella scenes, although this in itself does not mean they did not previously exist, as can be demonstrated by the case of Nicola Monti's copy of Raphael's Ansidei Altarpiece of 1777 for San Fiorenzo in Perugia, still in the church to this day, which does not include the figurative scenes that formerly adorned the predella.

18 Letter, 6 May 1883, from Frederic Burton to Henry Wallis, an item among the Wallis papers sold at Bonhams, 13 March 2002, lot 975 (see Information File on Burton in the National Gallery Archive): 'I knew about the frame of our Perugino, which is said to have been designed by PP himself. It remained as a fixture in the chapel [where I saw it] and had been filled by a copy of the picture and [for *after?*] the removal of the latter by the Parma [for *Penna*] family. It was shortly after my purchase that the frame was transferred to the Pinacoteca – and it is a great pity that it was not obtainable with the picture.' Umberto Gnoli, who at the time his monograph on Perugino was published in 1923 was director of the Galleria Nazionale dell' Umbria, also reports that the frame was in the collection: '*Della Penna [...] trasportò il dipinto nel proprio palazzo lasciando in chiesa la cornice (ora nella R. Galleria)*' (U. Gnoli, *Pietro Perugino*, 1923, p. 55).

19 We are most grateful to Tiziana Biganti of the Galleria Nazionale dell'Umbria, who persisted in the search for the frame, and who is responsible for identifying it. The frame measures 192.5 × 158 cm for fitting the painting from the back, and the sight edge is 182.5 × 149 cm; these dimensions support its identification as the original frame for the *Madonna di Loreto* and prove that a predella was not part of the original commission. The frame also bears an old inscription FAMILIAE CECCONIAE (the family whose altar the picture adorned following its transfer to Santa Maria Nuova), a modern inscription S. MARIA NUOVA, and an old inventory number 279, which corresponds to the entry describing Perugino's *Pala Tezi* in the inventory of the Galleria Nazionale (*Inventario generale dei quadri della Pinacoteca Vannucci*) of 1889 of which the following is an extract: '*la cornice, dell'epoca, non appartiene al quadro, poiché si sa che fu fatta da Pietro Perugino per la tavola che dipinse per la famiglia Cecconi, posseduta poi dalla famiglia della Penna, che la conservava nella propria cappella in Santa Mari Nuova. Da detta famiglia poi venduta per £100,000 alla Galleria di Londra.*' Dottoressa Biganti has been able to establish that, following its entry into the Perugian Pinacoteca sometime between the sale of the painting to London in 1879 and Burton's recollection of 1883, the frame was fitted to the *Pala Tezi*. Matters were complicated by the fact that the frame was later substituted, apparently under Gnoli's directorship of the Gallery between 1921 and 1926, by another, more ornate one borrowed from a third Perugino altarpiece, namely the *Pala Decemviri* lost to Perugia during the Napoleonic upheavals and then in the Vatican Museums (see F. Santi, *Galleria Nazionale dell'Umbria. Dipinti, sculture e oggetti dei secoli XV–XVI*, Rome 1989, p. 103). This explains why, when Martin Davies wrote to enquire as to the whereabouts of the frame of the *Madonna di Loreto* in

1947, there was a confusion, and the then Soprintendente Bertini Calosso sent a photograph of the Decemviri frame instead. This was taken in good faith by Davies to be the frame of NG 1075 and he used it to bolster his argument that no predella pictures were ever included in the commission. Since neither the Decemviri nor the Loreto frames were designed to incorporate a predella, his argument remains substantially correct.

20 The grotesque decorations bear comparison with those found in the fictive framework of the Cambio, as well as architectural elements in other works by Perugino (see for example V. Garibaldi, *Perugino*, Milan 2004, figs 70, 71, 147, 175, 180). Nicholas Penny has kindly pointed out that the rather unusual flat ionic crowns to the demi-Corinthain capitals were also favoured by Perugino (Garibaldi, ibid, figs 171, 176 and 180), as well as by the young Raphael in his Peruginesque phase (the two artists' *Sposalizios* being excellent cases in point).

21 This was first proposed by G.B. Cavalcaselle and G. Morelli in 'Catalogo delle opere d'arte delle Marche e dell'Umbria (1861–62)', in *Le Gallerie Nazionali Italiane: notizie e documenti*, Anno II (1896), p. 287, and gained more widespread currency from the 1950s (see for example P. Scarpellini in eds Bon Valsassina and Garibaldi 1994 (cited in note 11), cat. 56).

22 Santi 1989 (cited in note 19), pp. 110–11. Both Baldassare Orsini (*Guida al forestiere per l'augusta città di Perugia* (Perugia 1784), p. 239 and Serafino Siepi (*Descrizione topologico-istorica della città di Perugia*, 2 vols, Perugia 1822, I, p. 291) recorded the predella scenes beneath a painting of Saint Sebastian and Saint Roch, attributed to Sebastiano del Piombo, in the sacristy of Santa Maria Nuova, but recalled that formerly they had served as the predella of Perugino's later *Transfiguration* altarpiece (also transferred from Santa Maria dei Servi to Santa Maria Nuova).

23 An association between the main panel and the *Annunciation* scene is argued by P. Mercurelli Salari (entry in Garibaldi and Mancini 2004, cited in note 2, p. 288). She points out the similar setting of both in a courtyard, fenced in by a low stone wall, though as mentioned in the discussion of the subject in the main text, this is not a specifically Loretan motif and is too common to guarantee a connection.

24 See Santi 1989 (cited in note 19) with previous literature; it must be said that their combined width also falls far short of the *Madonna di Loreto* (152 cm).

25 Garibaldi 2004 (cited in note 20) p. 35, lists Servite commissions in Florence, Perugia, Foligno and Città della Pieve, adding that in 1515 Perugino acquired a tomb for himself and his family in SS. Annunziata, the mother church in Florence.

26 On the probability of the *Adoration* being a Baglioni commission, see L. Teza, 'Sul tema dell'Adorazione dei Magi: Perugino, Signorelli e altri', in *Scritti in onore di Alessandro Marabottini*, Rome 1997, pp. 90–5; more generally, see P. Scarpellini in eds Bon Valsassina and Garibaldi 1994 (cited in note 11), cat. 52; Garibaldi 2004 (cited in note 20), pp. 35–7.

27 *'Nella chiesa de' Servi fece parimente due tavole: in una la trasfigurazione del Nostro Signore, e nell'altra, che é accanto alla sagrestia, la storia de' Magi; ma perché queste non sono di quella bontà che sono l'altre cose di // Piero, si tien per fermo ch'elle siano delle prime opere che facesse'* (G.Vasari, *Le Vite de' più Eccellenti Pittori Scultori e Architettori, nelle redazioni del 1550 e 1568*, eds R. Bettarini and P. Barocchi, Florence 1966–87, III, pp. 606–7). Cesare Crispolti, in his guide to Perugia of 1597, only noted one altarpiece by Perugino in the church (see *Raccolta delle cose segnalate di Cesare Crispolti. La più antica guida di Perugia (1597)*, ed. L. Teza, Città di Castello 2001, p. 107). Another local historian, Giovanni Francesco Morelli, writing in the seventeenth century, did, however, record all three altarpieces by Perugino in Santa Maria Nuova (see G.F. Morelli, *Brevi Notizie delle Pitture … di Perugia*, 1683, pp. 80–1: 'Sopra la Porta laterale di / detta Chiesa stà collocata una tavola con la Trasfigurazione del Signore, di Pietro Perugino, del quale ancora è un Quadro dell'Altar vicino à detta Porta con la Madonna, alcuni santi, come aco quello dell'Adorazione de Magi sopra questo poggiato').

28 C. Crispolti, *Perugia Augusta*, Perugia 1648, p. 125.

29 A. Mezzanotte, *Della Vita e delle Opere di Pietro Vannucci … il Perugino*, 1836, p. 53, and, more recently, O. Guerrieri, *La Chiesa di Santa Maria Nuova in Perugia*, Perugia 1962, pp. 36–7, who clarifies the fact that Carattoli's copy was at some stage removed from this altar to its current location on the second altar on the south side of the nave dedicated to the Seven Founders of the Servite Order.

30 H. Doursther, *Dictionnaire Universel des Poids et Mesures Anciens et Modernes*, Amsterdam 1965 (reprint of 1st edn, 1840), pp. 326–7, where the *scudo* is valued at '4 shillings 2 pence ha'penny'; A. Martini, *Manuale di Metrologia*, Rome 1976 (anastatic reprint of 1st edn, Turin 1883), where the value of the Roman *scudo* between 1818 and 1835 is given as 5.383 lire.

31 Carattoli's slightly reduced copy, made at the time of the picture's appropriation by the Della Penna family in 1822, is still in Santa Maria Nuova

(see S. Siepi 1822, cited in note 22, I, p. 282, and entry by A. Migliorati in eds Garibaldi and Mancini 2004, cited in note 2, p. 489), though, as mentioned in note 29, it is no longer on the first altar it inhabited after the move from Santa Maria dei Servi. It is accompanied by a later inscription: L' ANNO 1822 GIUSEPPE CARATTOLI FECE QUESTA COPIA / DALLA PALA DIPINTA DA PIETRO PERUGINO PER QUESTA / CHIESA DONDE NE FU TOLTA E PORTATA IN TERRA STRANIERA.

32 Mezzanotte 1836 (cited in note 29), p. 53: '*In tale anno piacque al sullodato patrizio di ritirarlo onde farne più diligente conservazione nella propria domestica pinacoteca, ricca di pregiatissimi lavori, dove tuttora si ammira come l'ornamento più bello della medesima.*' See also Regni 2004 (cited in note 2), p. 553, n. 116, quoting the justly more cynical Perugian historian Adamo Rossi on the altarpiece's loss to the city (Archivio di Stato, Perugia, ASCP, Amministrativo 1871–1953, b. 46, fasc.1, 1878–9,): '*la tavola donata alla chiesa de' Servi dalla pieta di un artigiano, nel marzo 1822, legalmente, il che sempre non vuol dire giustamente, passò a decorare le sale di un ambizioso signore, e quello che alla città risparmiarono le requisizioni francesi tolze l'intrigo di un frate.*'

33 'The Travel Diary of Otto Mündler', ed. and transcr. C. Togneri Dowd, *The Walpole Society*, 1985, p. 129.

34 National Gallery Archive, Board Minutes, NG 1/4, November 1856. Report from the Director on various pictures inspected by him on the Continent, read at the meeting of 10 November 1856, pp. 50–1; on the Conestabile Madonna, see also H. Chapman, T. Henry and C. Plazzotta, *Raphael from Urbino to Rome*, exh. cat., National Gallery, London 2004, cat. 32.

35 National Gallery Archive, Board Minutes (cited in note 34), p. 51.

36 A copy of Sampson's letter dated 5 November 1876 is in the dossier for NG 1076, National Gallery Library. Della Penna's entire collection of 181 paintings was for sale from 1875; see *Catalogue déscriptif des tableaux qui composent la Galerie de M.r le Baron Fabrizio Ricci della Penna à Pérouse*, Rome 1875 (the Perugino was no. 38). As is evident from Adamo Rossi's acerbic comment quoted in note 32, and articles in the local press (*Il Paese. Rivista Umbra*, Perugia, 28 December 1878, Anno III, no. 52, pp. 1–2) there was clearly considerable local outrage about Della Penna selling what had once been part of the city's patrimony; the controversy was such that the baron published an entire booklet in 1878 justifying his ownership of the painting: see F. Della Penna, *Il Quadro di Perugino nella Galleria Penna in Perugia*, Perugia 1878.

37 Sampson (see note 36) declared that 'I have not the slightest knowledge of art as a connoisseur, but am very fond of pictures …'; he was evidently unaware of the existence of any other Perugino in the National Gallery collection.

38 National Gallery Archive, Board Minutes, NG 1/5, 19 May 1879, p. 126.

39 Given the quality of the painting, the agreed price was still extremely high. Indeed this was the second highest amount spent on a single painting under Burton's directorship hitherto (surpassed only by Veronese's *Saint Helena* purchased for £3465 in 1878). These prices were soon to be far outstripped when opportunities arose to acquire two remarkable altarpieces from British aristocratic collections, Leonardo's *Virgin of the Rocks*, bought from the Earl of Suffolk for £9000 in 1880, and Raphael's *Ansidei Altarpiece* purchased from the Duke of Marlborough for the record-breaking sum of £70,000 in 1885.

40 For studies of the stipulations of Italian Renaissance contracts see H. Lerner-Lehmkul, *Zur Structur und Geschichte des florentinischen Kunstmarktes im 15. Jahrhundert*, unpublished PhD thesis, University of Wattenschied, 1936; H. Glasser, *Artists Contracts of the Early Renaissance*, PhD thesis, Columbia University, 1965 (Garland Press 1977); S. Connell, *The Employment of Sculptors and Stonemasons in Venice in the Fifteenth Century*, unpublished PhD dissertation, University of London, 1976; A. Thomas, *The Painter's Practice in Renaissance Tuscany*, Cambridge 1995; J. Shell, *Pittori in Bottega: Milano nel Rinascimento*, Turin 1995; M. O'Malley, *The Business of Art: Contracts and the Commissioning Process in Renaissance Italy*, New Haven and London 2005. See also R. Schofield, J. Shell and G. Sironi, *Giovanni Antonio Amadeo: Documents/I documenti*, Como 1989, pp. 26–32, and M. Kemp, *Behind the Picture: Art and Evidence in the Italian Renaissance*, New Haven and London 1997, pp. 32–79.

41 O'Malley 2005 (cited in note 40), pp. 32–5, 40–3.

42 For a comparison of size and price in Perugino's corpus, see M. O'Malley, 'Perugino and the Contingency of Value', in M. O'Malley and E. Welch, eds, *The Material Renaissance*, Manchester University Press, forthcoming.

43 This idea was suggested by Caroline Campbell. On relationships and social needs as central factors of pricing, see O'Malley and Welch forthcoming (cited in note 42).

44 O'Malley 2005 (cited in note 40), pp. 146–8.

45 On the relative cheapness of fresco compared to panel painting, see

Thomas 1995 (cited in note 40), pp. 281–8.

46 On the development of techniques for transferring designs, the uses of copying, and Perugino's reuse of designs, see C. Bambach, *Drawing and Painting in the Italian Renaissance Workshop*, Cambridge 1999, pp. 12–32 and 83–126.

47 R.F. Hiller von Gaertringen, 'L'uso ed il reuso dei cartoni nell'opera del Perugino: La ripetizione della formula perfetta', in *Ascensione di Cristo del Perugino*, ed. S. Casciu, Arezzo 1998, pp. 53–69, and ibid, *Raffaels Lernerfahrungen in der Werkstatt Peruginos: Kartonverwendung und Motivübernahme im Wandel*, Berlin 1999, pp. 146–91.

48 Vasari asserts that Perugino's over-reliance on this practice led to the dismantling of his reputation in his own lifetime: see Vasari (cited in note 27), III, pp. 609–10. For a recent analysis of this episode and the suggestion that Perugino's reputation was perhaps not as damaged as Vasari suggests, see J. K. Nelson, 'La disgrazia di Pietro: l'importanza della pala della Santissima Annunziata nella Vita del Perugino del Vasari', in *Pietro Vannucci, il Perugino*, L. Teza, ed., Perugia 2004, pp. 65–73.

49 Among the altarpieces for which a contract survives, drawings were produced only for the *Resurrection* (6) and the *Family of the Virgin* (7), both uncommon subjects in the painter's corpus and thus probably easier to describe by graphic rather than verbal means.

50 On the altarpieces related to the San Pietro work, see Hiller von Gaertringen 1998 and 1999 (cited in note 47). On the general price of altarpieces in the period, see O'Malley 2005 (cited in note 40), pp. 136–42.

51 In 1499 Perugino agreed to paint an altarpiece of the Resurrection for Bernardino Giovanni da Orvieto in only two months, though in that case he was provided with the prepared panel ready for painting and was therefore not responsible for the carpentry.

52 Penalty clauses appear in the contracts for the Fano and Vallombrosa altarpieces.

53 On the meaning of the *sua mano* clause, see C. Seymour, Jr, '*Fatto di sua mano*: Another look at the Fonte Gaia Drawing Fragments in London and New York', in *Festschrift Ulrich Middeldorf*, eds A. Kosegarten and P. Tigler, Berlin 1968, pp. 93–105; on the clause and the input of master painters around 1500 see M. O'Malley, 'Late Fifteenth- and Early Sixteenth-Century Painting Contracts and the Stipulated Use of the Painter's Hand', in *With and Without the Medici: Art and Patronage in Florence 1450–1530*, eds Alison Wright and Eckart Marchand, London 1998, pp. 155–78.

54 Pace Teza 1983 (cited in note 8).

55 On the cost of blues, see J. Kirby, 'The Price of Quality: Factors Influencing the Cost of Pigments during the Renaissance', in *Revaluing Renaissance Art*, eds G. Neher and R. Shepherd, Aldershot 2000, pp. 22–5, and O'Malley 2005 (cited in note 40), p. 68.

56 On the cost of reds, see Kirby 2000 (cited in note 55), p. 26.

57 D. Bomford, J. Brough and A. Roy, 'Three Panels from Perugino's Certosa di Pavia Altarpiece, *National Gallery Technical Bulletin*, 4, 1980, pp. 3–31; A. Roy, 'Perugino's Certosa di Pavia Altarpiece: New Technical Perspectives' in Brunetti, Seccaroni and Sgamellotti, eds, *The Painting Technique of Pietro Vannucci, called il Perugino*, Kermes Quaderni, 2004, pp. 13–20.

58 In addition to powdered manganese-containing glass, present in the red lakes and incorporated in the *imprimitura*, probably as a dryer, several of the pigments would have exercised a siccative effect on the oil binding medium, including azurite, lead white, lead-tin yellow and some of the earth pigments.

59 Heat pre-treatment of drying oils decreases the gelling time and overall drying time of the paint in which they are employed. Experiments carried out by Raymond White using linseed oil in various forms indicated that heat-bodying could reduce the gelling time of the binder by up to a half or by two-thirds.

60 Brunetti, Seccaroni and Sgamellotti eds 2004 (cited in note 57).

61 Analysis by EDX showed the presence of Pb, Sn (lead white and lead-tin yellow) with Si, Na, Ca, Mn (manganese-containing soda lime glass). Similar results have been obtained for early paintings by Raphael, see A. Roy, M. Spring and C. Plazzotta, 'Raphael's Early Work in the National Gallery', *National Gallery Technical Bulletin*, 25, 2004, pp. 4–35.

62 A. Mezzanotte 1836 (cited in note 29), p. 198, no. 11, recorded a study for Saint Jerome then in the Conestabile della Staffa collection in Perugia.

63 See R. Bellucci and C. Frosinini, 'The myth of cartoon re-use in Perugino's underdrawing: technical investigations', in *The Painting Technique of Pietro Vannucci called il Perugino*, Proceedings of the LabS TECH conference held at the Galleria Nazionale dell'Umbria 14–15 April 2003, eds B.G. Brunetti, C. Seccaroni and A. Sgamellotti, Florence 2004, p. 73.

64 Bellucci and Frosinini (cited in note 63), pp. 72–6.

65 The darkening of azurite (and other copper-containing pigments) in oil, through chemical interaction of pigment and medium, is a familiar phenomenon. In this case the effects are particularly severe, perhaps as a

result of the use of coarsely ground azurite and a high oil to pigment ratio.

66 For example, draperies in the *Adoration of the Shepherds*, transferred fresco, Galleria Nazionale dell'Umbria.

67 Analysis of lake pigment dyestuffs by Jo Kirby.

68 See M. Spring, 'Perugino's painting materials: analysis and context within sixteenth-century easel painting', in Brunetti, Seccaroni and Sgamellotti eds 2004 (cited in note 57), pp. 21–4; see also E. Martin and J.P. Rioux, 'Comments on the technique and the materials used by Perugino, through the study of a few paintings in French collections', in the same publication, pp. 50–3.

69 Coal black pigment was identified from its microscopical characteristics and the detection of sulphur in the EDX spectrum of particles. For other examples, see M. Spring, R. Grout and R. White,' "Black Earths": A Study of Unusual Black and Dark Grey Pigments used by Artists in the Sixteenth Century', *National Gallery Technical Bulletin*, 24, 2003, pp. 97–100.

70 Green earth was identified microscopically and by EDX (K, Si, Mg, Al, Fe).

71 Martin and Rioux 2004 (cited in note 68), p. 53.

72 Bomford, Brough and Roy 1980 (cited in note 57), pp. 6–8.

73 The main, discoloured, but soluble varnish, applied following the cleaning campaign of 1879 at the National Gallery, consisted of mastic resin with a minor addition of some heat-bodied linseed oil – at this time, this would have been a commercial 'stand oil'. Addition of this oil would plasticise or toughen the potentially brittle mastic varnish film. No other additives were found in this layer.

74 A range of samples was taken in order to establish the original paint medium of NG 1075. These included white from the sky, red paint from Saint Jerome's cloak, the blue of the Virgin's robe and the cream-coloured paint of the tunic of one of the angels. All were identified as having been formulated from heat-bodied walnut oil, though the angel's tunic appeared to be quite lean in paint medium. Some of these results, together with some provisional and tentative conclusions on the early restoration scenario, were reported in C. Higgitt and R. White, 'Analyses of Paint Media: New Studies of Italian Paintings of the Fifteenth and Sixteenth Centuries', *National Gallery Technical Bulletin*, 26, 2005, pp. 88–104.

75 Areas of greyish-brown material, most substantial in the build-up of material entrapped in the ridges and hollows of the texture of Perugino's paint, appeared as pockets of brownish, partially transparent varnish-like material when viewed under the infrared microscope, but with a somewhat more pronounced light-scattering pitted top surface; this would account for the overall greyish optical aspect presented to the unaided eye. Fourier Transform Infrared microscopy (FTIR-microscopy) led one to conclude that the material had terpenoid resin and drying oil characteristics; it was likely to be residues of an earlier tough varnish, afforded some measure of extra protection in the contours of the paint. Pyrolytic methylation with N,N,N-trimethyl-3-(trifluoromethyl)tenzenaminium hydroxide, otherwise known as 3-(trifluoromethylphenyl)trimethylammonium hydroxide (TMTFTH), and subsequent GC–MS of samples of this occluded material, yielded drimane fragments derived from diterpenoids of the *enantio*-labdane series; see J. Dunkerton and R. White, 'The Discovery and Identification of an Original Varnish on a Panel by Carlo Crivelli', *National Gallery Technical Bulletin*, 21, 2000, pp. 70–6. We may conclude that a resin, rich in polyozic acid had been employed in the formulation of these earlier varnish residues; this would limit the source to a non-coniferous origin. Thermolytic methylation of a sample with the same reagent led one to conclude that the resin had been compounded into a varnish by 'running' with heat-bodied walnut oil. On balance, this resinous material appeared to be of the type associated with that of a species of tree from within *Guibourtia* spp. (tribe Detarieae, sub-family Caesalpinioideae of the Leguminosae) and in particular *Guibourtia demeusei* (Harms) Leonard, a source of Congo copal. In summary, the material appears to be remnants of a tough Congo copal/heat-bodied walnut oil varnish. Though by the nineteenth century, fresh bled resin would have to be sought from living trees of this species deeper within the Congo interior – and this of course was not accessible until after Livingstone's expeditions in 1874 – nevertheless the buried 'semi-fossil' resin (and considerable amounts of the same (and bled) resin washed down and deposited by the rivers of the region) was available around the delta and coastal areas where maritime trading centres for commodities (and slaves) had been well established. Therefore, it is conceivable that this varnish had been applied early in the nineteenth century, rather than in the mid- or later nineteenth century (and before the painting arrived at the National Gallery). Indeed, this is even more likely to be the case, given that by the second half of the century, copal/oil varnish compositions had acquired a bad reputation, in the context of easel painting restoration, on account of their eventual lack of reversibility and their intense darkening. See *Report from the Select*

Committee on the National Gallery, together with the Proceedings of the Committee, Minutes of Evidence, Appendix and Index, ordered to be printed by the House of Commons, London, 4 August 1853, No. 500, pp. 32–3.

76 Residues of this same copal oil varnish were detected in areas from the badly deteriorated (reticulated and flaking) paint of Saint Jerome's red cloak. Although the bulk composition of this copal varnish material was similar to that mentioned earlier, there was evidence – in surface-rich scrapings of this material – of an enhanced compliment of pinifolic acid. In consideration of this, one was inclined to the opinion that some form of copaiba balsam had been applied at some stage in the past. Since, initially, this appeared to be confined to the surface of the old, tough copal varnish remnants and as NG 1075 did not feature in the list of Pettenkofer-treated paintings, our preliminary interpretation was that these residues may have been remnants of applications used solely with a view to softening and aiding the removal of the copal-oil varnish layer itself. We envisaged the use of some form of copaiba-based, alkaline cleaning nostrum – a nineteenth-century version of the form mentioned in Laurie (see A.P. Laurie, 'Preservation and Cleaning of Pictures' in *The Painter's Methods and Materials*, Dover Publications Inc., New York 1967, chapter XIX, pp. 234–5). The analysis of spots and dribbles now in the form of a brownish 'stain', which was exposed by re-paint removal, proved most taxing. Although of a passing resemblance to the blood from Saint Francis's stigmata, the anachronistic materials subsequently identified argued conclusively against this. During sampling, the upper, more exposed regions of the material had a crumbling, open texture and generally showed little or no sign of sensitivity to solvent in terms of actual dissolution, though there was a tendency to undergo eventual swelling. Under the infrared microscope, in a diamond compression cell, the material was observed to be yellowish brown for the most part, but where the layer was thickest, some areas of a more pronounced reddish-brown nature were observed. Fourier self-deconvolution-enhanced spectra of these regions gave some partially resolved bands that might be associated with certain types of flavonoid/chalcone-rich material and cinnamoyl type components. Again, in the more exposed upper region of this layer, no monomeric di- or triterpenoid resin components remained; only traces of background lipids were found and FTIR-microscopy gave no indication of the presence of proteinaceous materials, such as egg tempera, glue or casein. Curiously, methanolytic pyrolysis of an assembled collection of the

polymyrcene

HO• via •O O•

5,5-dimethyl-2(5H)-furanone

FIG. 11 Suggested mechanistic pathway for the formation of 5,5-dimethyl-2(5H)-furanone by pyrolytic fragmentation of polymeric myrcene, an essential oil component found in the liquid fractions of fresh resins produced by members of the genus *Pistacia* and particularly abundant in the balsamic resin of the species *Pistacia atlantica*.

more intense brownish-red regions of the sample, revealed some methoxychalcone-derived and aromatic pyrolytic fragments likely to have been derived from bi- and oligoflavonoid components and a coniferyl/cinnamyl-based polymer. Despite the apparent absence of any recognisable diterpenoid or triterpenoid components, it was noted that pyrolysis of this material did produce some fragments which had been liberated from a polyterpene-based material. One such pyrolytic fragment was 5,5-dimethyl-2(5H)-furanone and we have noticed this to be formed during non-methanolytic pyrolysis of the beta–resene fraction of mastic resin, but not from that of dammar and, apparently, not in the case of *Lavandula* species-sourced polyterpene and related essential oils. 5,5-dimethyl-2(5H)-furanone would appear to be specific for the aged polymyrcene content of mastic resin and we propose the following detailed scheme for its mode of formation (see FIG. 11). Definitively, no drimane or *enantio*-drimane fragments were detected, ruling out the presence of polymer from either a sandarac-based or hard copal-based varnish. Deeper within the body of this brownish accretion, where some protection had been afforded, mastic resin acids, such as moronic acid, and breakdown products were able to be identified, by GC-MS and liquid chromatography coupled to mass spectrometry (LC-MS). The latter technique, employing Atmospheric Pressure Chemical Ionisation (APCI) and Electrospray (ESI) interfaces, confirmed the presence of an aged mastic resin component, with greatly attenuated amounts of triterpenoid acids in the more exposed surface layers, once again pointing to the possible preferential sequestration of such acids by an alkaline agent. In addition, APCI–LC–MS was also able to confirm that some components within the sample of this brown accretion were identifiable with those of an artificially aged film of accroides resin from *Xanthorrhoea preissii* Endl. Other components within the sample from NG 1075 were not present in the aged accroides comparison film. However, subsequent trials on the laboratory film, involving exposure to basic agents, led to the development over time of a brown stain, probably by the formation of base-catalysed condensation products and a cluster of components in the liquid chromatogram, two of these being spectrally identical to those in the material below Saint Francis's feet. Certainly, the high proportion of polar essential oils of relatively low volatility function well as a swelling (and as a result 'softening') agent. Nevertheless, since these original findings, traces of this material have also been identified, which were associated more directly with the surface of the paint itself; notably such areas included Saint Jerome's robe and some flesh paint. With this wider pattern of application, it seems clear that it was, after all, a form of Pettenkofer treatment, primarily intended as a paint- (and residual varnish-) reviving treatment.

77 In the case of paint from the grey stone on which Saint Francis stands, heat-bodied walnut oil was established as paint vehicle. However, in some areas of this, with a rather 'scrubbed' appearance, the reduced dicarboxylic acid content and pronounced carboxylate bands tend to suggest attack by the action of strongly alkaline cleaning agents. The alternative possibility of a reduction in dicarboxylic acid content by dilution with accompanying non-drying fats from egg tempera, glue or casein was ruled out by checking the results from FTIR-microscopy.

78 Carattoli's copy (see note 31 and FIG. 3) is probably an accurate record of the appearance of Perugino's altarpiece in 1822, though it may have faded since its creation and its appearance is clearly altered by discoloured varnish and surface.

79 Raymond White and Jo Kirby, 'A Survey of Nineteenth- and Early Twentieth-Century Varnish Compositions found on a Selection of Paintings in the National Gallery Collection', *National Gallery Technical Bulletin*, 22, 2001, pp. 64–84.

80 John M. Maisch, 'Notes on the Xanthorrhoea Resins', *American Journal of Pharmacy*, 53, 1881.

81 Canuti 1931 (cited in note 3), II, pp. 208–37; see especially docs 331–2, 337 and 348, the latter, a letter from Isabella d'Este's envoy Luigi Ciocca in Florence to the Marchioness in Mantua of 29 December 1504, being particularly eloquent on the subject: 'usandoli io alcune parolle brave et minatorie de tanta sua pigritia, et poca fede, et mancho discretione, mi respose che fino a qui le stato sforsato, a servire chi lo pagava di hora in hora; … havendo visto el cartone et poi el designato de la tela mi pare una cara mercantia, et fa certe faune femine che hanno le gambe molto male proportionate et brute; et non vole esser correcto come sel fosse Iotto o altro supreme pictore.'

82 Canuti 1931 (cited in note 3), II, docs 376–8.

83 Vasari 1967–87 (cited in note 27), III, pp. 609–10. Vasari's assessment of Perugino's fall from popularity seems plausible in view of the decline in the quality of his output and his ever more provincial centres of operation; some authors have, however, suggested that this was a piece of myth-making on Vasari's part (see C. Frosinini and R. Bellucci 2004, cited in note 63, pp. 71–80, and J. Nelson, 'La disgrazia di Pietro: l'importanza della pala della Santissima Annunziata nella Vita del Perugino del Vasari', in *Pietro Vannucci il Perugino. Atti del Covegno Internazionale di studio 25–28 ottobre 2000*, ed. L. Teza, Perugia 2004, pp. 65–73.

84 Canuti 1931 (cited in note 3), II, pp. 302–13.

85 J. Shearman, *Raphael in Early Modern Sources (1483–1602)*, London and New Haven 2003, p. 93.

86 The head of the Child is close to that in the Ansidei Altarpiece, for which see D. Cooper and C. Plazzotta, 'Raphael's Ansidei altarpiece in the National Gallery', *The Burlington Magazine*, CXLIII, 2004, pp. 720–31. But it is nearer still to a drawing of a head of a child, closely related to the Ansidei Altarpiece, which emerged in a sale at Sotheby's, London, 8 July 2004, lot 23. Some nineteenth-century authors believed Raphael's hand to be present in the *Madonna di Loreto* (see for example Mezzanotte, cited in note 29, p. 55, noting the opinion of Count Leopoldo Cicognara) but this is clearly not the case!

87 See Hiller 1998 and 1999 (cited in note 47), and Bellucci and Frosinini 2004 (cited in note 63).

88 Even if Perugino did have a hand in these passages, some of the finishing touches such as the highlights in the faces appear too crude to be from his hand (see PLATE 13). The lead white paint used in these passages was of such a sticky consistency that it evidently proved difficult to manipulate. Though never subtle, the highlights have become more prominent over time due to the increased transparency of the thin paint on top of which they were applied.

89 See P. Mercurelli Salari, entry in eds Garibaldi and Mancini 2004 (cited in note 2), p. 324.

90 For echoes of the Saint Francis, see, for example, Scarpellini 1984 (cited in note 8), cats 163 (1512) and 195; for the San Severo fresco, see ibid, cat. 206.

Appendix 1 (transcriptions by Valentina Ricci Vitiani)

1A

Notarial copy of Giovanni Schiavone's will (Archivio di Stato, Perugia, Notarile, notaio Mariotto Calcina, prot. 487, cc. 162r–163v.)

Eisdem millesimo indictione pontificatu et die septimo aprilis actum in domibus habitatione infrascripti testatoris site in Porta Solis et parochia Sancti Savini fines ab (uno) strata ab (alio) Rombuccus ab (alio) Gorus nepos ser Ioannis de Agello ab (alio) heredes remedii presentibus magistro Gaudioso Baldi Priori Sancte Marie predicte fratre Luca Fini de Perusia fratre Benedicto Ioannis de Viterbio fratre Adriano Cole de Perusia fratre Bonifatio Luce de Perusia fratre Iacobo Bernardini de Passignano fratre Antonio Magii de Perusia testibus rogatis.

Cum vita hominis sit labilis et caduca et nunquam in eodem statu permaneat nil certius morte et nil incertius hora mortis ideo prudens vir magister Ioannes Mathei Giorgii Sclavionus carpentarius perusinus Porte Sancti Petri et parochia Sancti Savini Dei gratia sanus mente et intellectu quatenus corporea infirmitate gravatus et nil certius morte et nil incertius ora mortis iecirco (sic) suum ultimum et (…) condidit testamentum nuncupativum quod dicitur sine scriptis in hunc modum fieri procuravit.

In primis commandavit animam suam omnipotenti Deo totique curie celesti.

Item iudicavit et reliquit corpus suum sepelliri in ecclesia Sancte Marie Servorum in capella Annuntiate.

Item iudicavit iure legati dicte capelle florenos decem ad XL de quibus fiat unum pallium pro altari aut ematur unus calix eiusdem valoris.

Item iudicavit et reliquit iure legati amore Dei fratribus Sancte Marie Servorum pro sacristia seu fabrica ipsius ecclesie florenos quinque ad XL bolonienos pro floreno pro exequiis dicendis in dicta ecclesia per ipsos fratres Sancte Marie Servorum et pro missis Sancti Gregorii pro anima ipsius testatoris et parentum suorum defunctorum immediate post mortem ipsius testatoris que dici et celebrari apud dictam capellam.

Item iudicavit et reliquit Christoforo Leonardi de Perusia unum petium terre in pertinentiis castri Capocavalli in vocabulo manu ser Iacobi Christofori de Perusia iure institutionis et legati.

Item iudicavit et reliquit iure institutionis et legati domine Florite uxori dicti testatoris unam domum sitam in civitate Perusie Porta Sancti Petri et parochia

Sancti Savini fines ab (uno) strata ab (alio) Rombuccus ab (alio) domus boni nepotis ser Ioannis cum omnibus massaritiis in ea existentibus excepte una thobialia cum testibus alba trium bracciorum et unum sciuccatorium trium testarum pro capella facienda et construenda in dicta ecclesia ad perpetuam rei memoriam dicti testatoris apud columnam quandam esistentem vocatam de li magi apud quam solet permaneri pergulum iuxta est sepultura episcopi Cassanensis.

Item dicto iure reliquit ordinu (sic) domine alteravit (sic) eius domum sitam in dictis porta et parochia fines ab (uno) strata ab (alio) menia civitatis ab (alio) domus Thome Battista ab (alio) domus domine Diamantis Pocciotte.

Item iudicavit et reliquit dictam dominam Floritam eius uxorem dominam massariam et usufructuariam omnium suorum bonorum stabilium ipsius testatoris in vita sua tantum alterius procuratorem et quo adiuturem Christoforum eius fratrem carnalem cum hoc quod se in duat pannis lugrubribus funere dicti testatoris et de pretio (…) vestiarium cum hoc et quod ipsa domina possit pro eius necessitatibus de arboribus existentibus in possessionibus dicti testatoris minus damno sis pro igne faciendo et post eius mortem omnia eius bona stabilia denomavit pleno iure capellam infrascripta construenda ad perpetuam rei memoriam dicti testatoris cum hoc onere quod ipsa domina quolibet anno in vita sua tantum teneatur ipsa domina dare hominibus dicte Fraternitatis Annuntiate duo barilia musti in vendemnis et in qualibet estate cuiuslibet anni unam eminam grani ad mensuram comunis et de hoc esset conscentiam sua oneravit et tantum quo dictus Christoforus decessit supradictam dominam Floritam loco sui sit et esse debeat prior pro tempore exequis in Sancta Maria Servorum vel alius per ipsum deputandus.

In omnibus autem aliis suis bonis et rebus mobilibus et immobilibus exceptis supra prelegatis sacristiam et fratres Sancte Marie Servorum sibi heredes universales instituit atque fecit pleno iure cum hoc oneri quod bona stabilia hereditatis dicti testatoris non legata semper sint dotalia ipsius capelle in dicta ecclesia apud dictam columna construenda et nullo (…) tempore possint quolibet alienari neque vendi et casu quo aliquo modo in totum ut in partem alienarentur deveniant pleno iure et suis aliqua diminutione pro medietate ad hospitale Sancte Marie de Misericordia et pro alia medietate ad monasterium Sancti Petri et non possit quoquo modo derogari et per summum pontificatum et casu quo talis derogatio impetraretur tota omnia dictca bona et hereditas sit et rem intelligatur dictorum duorum locorum cum hoc esset oneri dictis fratribus Sancte Marie Servorum quod in perpetum quolibet die post mortem dicte domine Florite usufructuarie teneantur dicere seu dici et celebrari facere missam unam pro anima ipsius testatoris et parentum suorum defunctorum.

Item pro fabrica et constructione dicte capelle iudicavit et reliquit iure legati florenos triginta quos sunt in domo dicti testatoris et omnia bona que reperiuntur et sunt in eius apotheca sita in domibus ecclesia Sancte Marie Servorum quam tenet ad pensionem dictus testator excepto uno pari forzeriorum quos iure legati reliquit parrochia Sancti Savini et ipso teneatur dicere seu dici facere pro anima dicti testatoris.

In executione constructionis dicte capelle eius fidecommissarios reliquit Nicolaum Ioannis de Urbeveteri perusinum magistrum Finum Ugolini et Christophorum Leonardi predictum quibus dedit et contulit plena licentia dictas bona experientia in dicta apotheca una cum prior Sancte Marie Servorum vendendi et alienandi ipsum convertendi in fabrica et ornamentis ipsius capelle in qua columne parietis pingantur et pingi debeantur in scripte picturi videlicet picturas Sancta M. de Loreto Sanctus Ieronimus, Sanctus Franciscus.

1B

Notarial copy of the contract between Schiavone's heirs and Perugino (Archivio di Stato, Perugia, Notarile, not. Berardino di ser Angelo di Antonio, Bastardelli, 808, cc. 539v–540r)

1507 die VII Iunii, praesentibus ser Severo Petri et Johannne Bernardino Francisci de Balionibus. Reverendus Pater, Frater Nicolaus, Prior S. Mariae Servorum, et magister Gudiosus, Cristoforus Leonardi sutor Portae S. Petri, fidecommissarii et executores testamentarii magistri Johannis Schlavii olim carpentarii de Perusio defuncti, ut dixerunt costare manu ser Mariotti, locaverunt ad coptumum magistro Petro pittori magistro artis picturae praesenti et cetera ad faciendum fieri et fabricandum unam tabulam de lignamine et facta et fabrigata ad pingendum de eius manu, in qua debeat depingi Imagho Gloriose Virgini cum filio in pedibus ad similitudinem illius de Loreto cum figura Beati Hieronimi cardinalescho et S. Francisci stigmatizati cum corolibus (sic) finis ornamentis de auro et cetera. Et hoc fecerunt quia dicti locatores promiserunt pro eius labore et mercede florenos XLVII ad 40 bolonienos pro

floreno cum pledula et paramentis brochatis

quam promisit pingere et depictam restituere infra per totum mensem Septembris proxime venturi, et casu quo non restitueret solvere dictum praetium XLVII florenos reservato tamen iuxto impedimento.

Cum hoc quod debeat pro parte praetii dictarum picturarum computari quantitas lignaminis ad rationem trium solidorum pro quolibet pede.

Notes to Appendix 2 (overleaf, pp. 94–5)

1 The price of altarpiece carpentry varied widely in the period, but considering that an average cost was about 18 per cent of the expenditure for painting, woodwork and gilding combined, 18 per cent has been subtracted from those fees that covered the supply of the whole altarpiece (painting, woodwork and gilding). This offers a notional price paid for the painting of the panels alone and allows these prices to be compared with those for which Perugino was paid only for the painting. See O'Malley 2005 (cited in note 40, above), pp. 32–5; 40–3.

2 The measurement of the San Pietro altarpiece includes the main panel, lunette, predella and saints in tondos. The measurement of the Sant'Agostino altarpiece is based on the largest panel that survives for each section of the altarpiece. To calculate one side I have used the present measurements of the panels of the Adoration of the Shepherds, Pietá, Archangel Gabriel (× 2), San Girolamo and Mary Magdalene (× 2), Adoration of the Magi (× 2), Saint Monica (× 4). The total sum has been multiplied by two to obtain the approximate size of the whole painted area of the altarpiece. See the reconstruction of the altarpiece by Christa Gardner von Teuffel, 'Carpenteria e macchine d'altare. Per la storia della ricostruzione delle pale di San Pietro e di Sant'Agostino a Perugia', in *Perugino, il divin pittore*, V. Garibaldi and F.F. Mancini, eds, Milan 2004, pp. 141–53.

3 Perugino's contract for the SS. Annunziata altarpiece does not survive, but a document in the convent's books of debits and credits notes the price that he would receive and the amount that related to the work Filippino had completed on the Deposition panel. See F. Canuti, *Il Perugino*, 2 vols, Siena, 1931, II, pp. 245–7.

4 For the documents see F. Battistelli, 'Notizie e documenti sull'attività del Perugino a Fano', *Antichità viva*, 13, 1974, pp. 65–8.

5 See Canuti 1931, II, pp. 171–5.

6 Ibid, pp. 176–83.

7 See Canuti 1931, pp. 184–6.

8 See C. Gardner von Teuffel, 'The Contract for Perugino's 'Assumption of the Virgin' at Vallombrosa', *Burlington Magazine*, 137, 1995 pp. 307–12.

9 See Canuti 1931, II, pp. 187–8.

10 Ibid, pp. 197–8.

11 Ibid, p. 237.

12 Ibid, pp. 239–41.

13 Ibid, pp. 270–8.

14 Ibid, pp. 208–37; for the contract, see pp. 212–13.

15 The altarpiece was begun by Filippino Lippi in 1503 and he completed approximately half of the Deposition side before he died and the work was taken over by Perugino.

16 See Canuti 1931, II, pp. 241–51.

17 Ibid, pp. 254–6.

18 Ibid, pp. 259–60.

19 Ibid, pp. 257–9.

20 Ibid, p. 269.

Appendix 2
Chronological table of works by Perugino with surviving contracts giving documented prices.
Altarpieces with two subjects are double-sided. The 'adjusted price' is the notional price of the painted part(s) only, excluding the cost of the woodwork.[1] The size includes the main panel and lunette or top panel but excludes the predella panels, except for the San Pietro and Sant'Agostino altarpieces, because for some altarpieces it is unclear whether or not a predella was included and for others it is unclear which sets of surviving panels constitute the correct predella for the altarpiece.[2]

No.	Subject	Site	Contract Date[3]	Woodwork	Delivery Deadline
1	Madonna and Child with Saints	S. Maria Nuova, Fano	1488[4]	supplied	? ?
2	Madonna and Child with Saints	Palazzo Comunale, Perugia	1483 1495[5]	supplied	4 months 6 months
3	Ascension	S. Pietro, Perugia	1495[6]	supplied	30 months
4	Madonna della Consolazione	Oratory of the confraternity of S. Maria Novella, Perugia	1496[7]	?	?
5	Assumption	Badia, Vallombrosa	1497 1498[8]	supplied	5 months 10 months
6	Resurrection	S. Francesco al Prato, Perugia	1499[9]	supplied	2 months
7	Family of the Virgin	S. Maria degli Angeli, Perugia	1500[10]	supplied	?
8	Crucifixion and Coronation	S. Francesco al Monte, Perugia	1502[11]	supplied	7 months
9	Crucifixion	S. Agostino, Siena	1502[12]	supplied	12 months
10	Baptism and Nativity	S. Agostino, Perugia	1502[13]	supplied	?
11	Combat of Love and Chastity	Gonzaga Palace, Mantua	1503[14]	canvas	6 months
12	Deposition and Assumption (1.5 sides)[15]	SS. Annunziata, Florence	1505[16]	supplied	?
13	Madonna di Loreto	S. Maria dei Servi, Perugia	1507[17]	Painter to supply	Approx. 4 months
14	Madonna and Child with Saints	S. Gervasio, Città della Pieve	1507[18]	Painter to supply	12 months
15	Assumption	S. Maria, Corciano	1512[19]	Painter to supply	Approx. 7 months
16	Transfiguration	S. Maria dei Servi, Perugia	1517[20]	Painter to supply	5 months

Delivery Date	Price (florins)	Adjusted Price	Size m²	Head No.	Client
1497	300	300	9.38	13	Durante di Giovanni Vianuzzi
Not recorded	100	100	3.96	6	Perugian Comune: Decemviri
1499 (approx. 56 months)	500	500	12.70	16	Benedictines
1499	60	60	2.37	2	Confraternity and Comune
1500 (32 months)	300	180	11.32	6	Vallombrosans
Not recorded	50	50	3.84	4	Bernardino Giovanni da Orvieto
Not recorded	65	65	7.66	9	Angelo di Tommaso Conti
Not recorded	120	120	8.64	18	Franciscans
1506 (46 months)	200	200	11.56	9	Cristofano Chigi
1523	500	500	24.68	18	Augustinians
1505 (28 months)	100	100	3.05	8 to 14	Isabella d' Este
1507 (27 months)	200	200	15.6	24	Servites
Not recorded	47	38	2.49	4	Giovanni di Matteo Schiavone
1514?	130	107	5.28	6	Canons of San Gervaso
Not recorded	100	82	3.84	13	Church and Comune
Not recorded	100	82	5.36	6	Adriana Signorelli

Working with Perugino: The Technique of an Annunciation attributed to Giannicola di Paolo

CATHERINE HIGGITT, MARIKA SPRING, ANTHONY REEVE AND LUKE SYSON

IN 1881, the National Gallery purchased four panels from the collection of Marchese Perolo Monaldi in Perugia: three elements from an altarpiece, then attributed to Fiorenzo di Lorenzo and now thought to have been executed in the late 1470s by another leading Perugian painter of the same generation, Bartolomeo Caporali (NG 1103.1–3),[1] and a cut-down *Annunciation* given simply to the 'School of Perugino' (PLATE 1). It is not clear what exactly prompted the purchase of the *Annunciation*. Though charming in its way, the picture is not of notably high quality, and Martin Davies mustered only enough interest in his 1951 catalogue to note that the painting, by then 'ascribed to' Giannicola di Paolo, derived 'perhaps from the upper part of an altarpiece in compartments', adding laconically: 'The attribution to Giannicola di Paolo does not appear to have been rejected; if the picture is by him, as seems likely enough, it would be a fairly early work, still strongly under Perugino's influence.'[2]

Vasari listed Giannicola di Paolo, formerly erroneously called Giannicola Manni — his surname was actually Smicca — among the 'many masters of that style' that Perugino 'made'.[3] Towards the end of Vasari's catalogue of Perugino's *discepoli*, which is headed, of course, by Raphael (the only one of Perugino's pupils, according to Vasari, to outdo his master), we find the Perugian Giannicola 'who painted, in San Francesco, a panel of Christ in the Garden, the *Ognissanti* [All Saints] *Altarpiece* for the Baglioni chapel in the Church of San Domenico, and the stories of Saint John the Baptist in fresco in the chapel of the Cambio'.

The word *discepoli* has usually been translated simply as 'pupils'; the painters to whom the term is applied are thus assumed to have been trained by Perugino in either his Florentine or his Perugian workshop. As a result Giannicola, like the more famous Raphael, has historically been treated as an artist whose style and technique were formed by

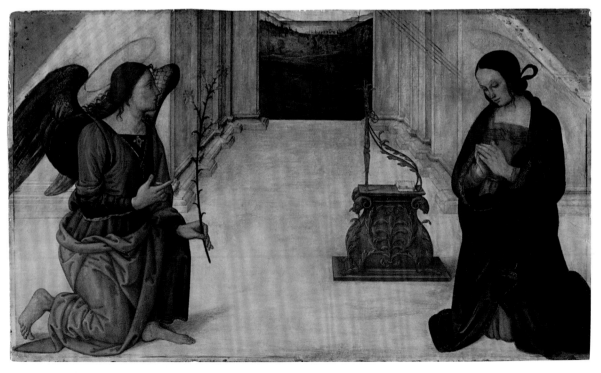

PLATE 1 Giannicola di Paolo, *Annunciation* (NG 1104), mid-1490s. Panel, 61 × 105.4 cm.

Perugino. Raphael's schooling by Perugino in Perugia in the late 1490s remains axiomatic in some quarters, but Tom Henry and Carol Plazzotta, among others, have recently taken a more sceptical view.[4] It has therefore become all the more important to re-examine the functioning of Perugino's *botteghe* in both Florence and Perugia (and the relationship between the two), his alternative methods of collaboration with junior painters and, in particular, his possible use of assistants whose initial formation may not have been Perugino's responsibility, and who had in fact received their first training from another master. These last might belong to a different category of *discepoli*. The recent conservation treatment of Giannicola's National Gallery *Annunciation*[5] has provided the opportunity to consider this question through technical examination of a painting by an artist who was demonstrably close stylistically to Perugino, and by comparison with the working methods of Perugino himself.

Technical examination

Examination of the poplar panel on which the *Annunciation* is painted, and of its X-radiograph, makes it clear that its shape has been altered. The panel consists of two planks with the grain running horizontally, with asymmetrical triangular additions at both top corners (FIG. 1).[6] The grain of the left addition runs tangentially to that of the main part of the panel, while that of the right addition is parallel. In the X-radiograph of the main panel, pieces of canvas over the knots and joins can be seen beneath the thickly applied gesso ground layer. The ground on the additions is also thickly applied, with that on the left-hand addition again running in a different direction to the main work. Unfortunately, technical examination of the materials used in the additions does not help with the dating, but the direction of the gesso brush-strokes shows that the additions were not always part of the panel.[7] Also visible in the X-radiograph are two haloes with punched decoration above and closer to the centre of the panel than the heads of Gabriel and the Virgin (FIG. 1). Their position suggests that they were made for an earlier version of the composition.[8]

The original shape and architectural setting of the *Annunciation* might distantly derive from the gable of Piero della Francesca's Sant'Antonio altarpiece,[9] although the evidence of cutting and additions (as well as the composition itself) suggests a somewhat simpler shape. The architectural perspective indicates that a low viewing point was intended, so a position high up in an altarpiece, or conceivably over a door, seems likely. There are some clues in the painting itself to the possible original size and format: the rays of

FIG. 1 Giannicola di Paolo, *Annunciation* (NG 1104). Detail of the X-radiograph showing the triangular addition at the top corner and the punched decoration of the halo from an earlier version of the composition.

golden light extending towards the Virgin would have been expected to incorporate a dove or a representation of God the father, and in the landscape seen through a gap in the architecture in the middle of the panel there are the thin wispy trunks of two trees that are missing their leafy crowns, suggesting that the top of the panel has been cut. The current central axis of the panel falls slightly to the left of the central point of perspective in the middle of the architectural doorway, suggesting that the panel has also been cut on the right-hand side. The Virgin is missing part of her cloak at the right-hand side and both the thick gesso and the paint itself run to the very edge of the panel, all of which suggests that this side of the panel has indeed been trimmed. The missing treetops, as well as the paint extending to the right edge, show that the change in panel format was made after the painting was completed, and so does not relate to the haloes from an earlier composition seen in the X-radiograph. The panel may have been cut and the corners added to give the picture a new format after removal from its original location, or because worm erosion or other physical damage may have made it necessary to remove some of the wood.

The original width of the panel can be estimated by assuming the architectural composition to have been symmetrical and the left-hand side to be original; this would add about 6 cm to the existing size (61 × 105.4 cm), making an overall width of about 111 cm. Determining the shape of the top of the panel is less straightforward. If it is assumed that the diagonal slope of the right-hand corner is original, and this slope is transposed to the left-hand edge (which would trace a line more or less along that of the current join) then, by extending these two diagonals, a number of possible formats with a gabled top or a

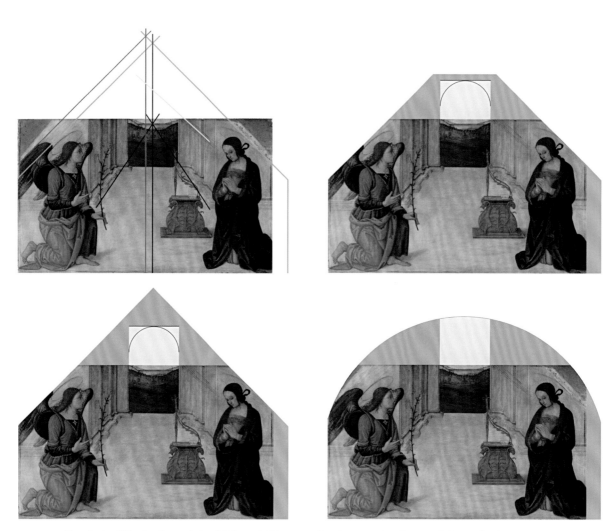

FIGS 2–5 Giannicola di Paolo, *Annunciation* (NG 1104). Diagrams showing postulated original shapes for the panel.

pointed pinnacle can be envisaged (FIGS 2–4). Such a format would mean that the figures would have been rather cramped. It is also conceivable, though perhaps less likely, that the panel originally had an arched top, giving the protagonists and landscape more space (FIG. 5); in that case, the corners would have been cut straight for convenience during the attachment of the triangular corner additions, and thus all evidence for an arched shape would have been lost when the format was changed.[10]

Pounced dots indicating transfer from a cartoon are visible with the naked eye around the contours of the lectern (FIG. 6). The underdrawing for the figures of the Virgin and Angel Gabriel revealed in the infrared reflectogram follows simple contours, and these also appear to have been transferred from a cartoon by pouncing; some *spolveri* are visible in the right wrist of the angel and around the feet. The drawing for the figure of the Virgin is less easily visible by infrared reflectography, but it appears to be similar in character to that for the angel, and some dots from pouncing can be seen around the hands.

The incisions that were ruled for the architecture, both those relating to that which was painted and some extra lines, perhaps perspective lines or ones pertaining to an earlier compositional idea, show more clearly in the infrared reflectogram. An incised horizon line crosses the window and runs through the tops of the hills. Very few changes were made to the composition at the underdrawing stage, except for slight adjustments in the position of the left hand of the angel, where the thumb and forefinger have been moved.

Before the recent technical examination, it had been thought that the binding medium of the *Annunciation* was oil, perhaps because of a supposed date of around 1500, the influence of Perugino, and the rough impasto-like quality of the background paint (where the brushstrokes have a marked texture not usually seen with egg tempera). Crucially for the argument presented below, new analytical work has, however, revealed that the work is actually painted in egg tempera. The pigments are all standard for the turn of the sixteenth century.[11] The angel's purple

FIG. 6 Giannicola di Paolo, *Annunciation* (NG 1104). Infrared reflectogram detail showing pouncing in the lectern.

robe is painted with a mixture of red lake, ultramarine and white on an underpaint of azurite, red lake and white. The multi-coloured wings have a red underpaint containing vermilion and red lake. The purplish paint strokes at the surface of the wings consist of mixtures of red lake, azurite, lead white and ultramarine. The wings have been decorated with semicircular highlights of silver leaf applied on an unpigmented mordant.[12] The silver is barely visible since it has degraded to black silver sulphide and is only detectable by elemental analysis. Kermes red lake mixed with lead white was used for the Virgin's dress,[13] and coarsely ground azurite for her cloak, which is poorly covering so that the underlying gesso is visible in the thinner parts of the brushstrokes. Malachite was used for the green lining of her cloak, which now appears brown because of discoloration of the binding medium; it was also used for the landscape.

The green hilly landscape has been given a sense of depth by varying the density of small green dots of paint, a technique seen in a number of other paintings associated with Perugino in the later fifteenth century, particularly in fresco.[14] The use of malachite reflects the choice of binding medium since generally at this period in Italy verdigris was used as the main green pigment when the binding medium was oil.[15] The gold decoration on the Virgin's cloak and robe and on the angel's robe, and the rays directed towards the Virgin, are mordant gilded.[16] The orange-brown paint of the lectern consists of vermilion, yellow earth and manganese black. Rather few occurrences of manganese black have been reported in sixteenth-century paintings, although it has recently been found in some other paintings in the National Gallery[17] and, interestingly, in two paintings attributed to Perugino in the Galleria Nazionale dell'Umbria (Perugia), the *Penitent Saint Jerome* on canvas (certainly after 1512, perhaps as late as 1520) and the roughly contemporary *Beato Giacomo della Marca*.[18] The flesh paint in the National Gallery *Annunciation* has a greenish hue due to the green underpaint beneath the pink surface paint, a traditional and perhaps slightly old-fashioned technique by the mid-1490s, the proposed date of the painting, but again consistent with the use of egg tempera as a binding medium.[19]

The attribution to Giannicola

Giannicola is first documented in 1484 as the witness to a notarial deed (he was therefore of age), and first mentioned as a painter in 1493, contracted to work for the Perugian *comune*.[20] He is therefore thought to have been born in Perugia in the early 1460s, and he died, after a long, successful and well-documented career, in August 1544. He waited until 1500 before he registered his name in the *matricula* of the painters' guild, perhaps in order to take on his first *garzone*; one Francesco is recorded in the same year – painting with Giannicola in the area of the high altar of San Pietro in Perugia.[21] Like Perugino's workshop after January 1502, Giannicola's workshop was on the Piazza del Sopramuro, although they rented their spaces from different organisations.[22]

Only fragments of Giannicola's documented works from the 1490s survive; these include the figures of Christ, Saint John and Saint Peter and some of their architectural setting from a *Last Supper*, one of the frescoes commissioned by the *comune* for the Refectory of the Palazzo dei Priori, for which Giannicola received a very detailed contract in September 1493 (the month and year that are inscribed within the fresco itself) and which were assessed in April the following year (PLATE 2).[23] Recently restored, their style suggests that the attribution to Giannicola of other works usually dated to the beginning of his career should be queried.[24] His *Last Supper* was unmistakably a copy of the *Cenacolo del Fuligno* at Sant'Onofrio in Florence, executed according to Perugino's designs by one or more members of his Florentine workshop.[25] The date of this Florentine fresco is controversial, though it is probable that it was executed in the late 1480s, or perhaps a little after. It has not yet been established if the same cartoons were used for both, but it is equally or perhaps more probable

PLATE 2 Giannicola di Paolo, Fragments of a fresco of *The Last Supper*, 1493. Refectory of the Palazzo dei Priori.

FIG. 7 Giannicola di Paolo, *Ognissanti Altarpiece*, 1506. Panel, 211 × 225 cm. Perugia, Galleria Nazionale dell'Umbria, inv. 323.

that Giannicola had access to Perugino's *modelli* which he copied to make his own drawings; some of the group of drawings related to the *Cenacolo del Fuligno* may be Giannicola's.[26] He therefore is likely to have established a close association with Perugino by the winter of 1493/4, and it seems at least possible that he knew Perugino in his Florentine *bottega* prior to 1493.

The earliest of Giannicola's important altarpiece commissions to survive is the *Ognissanti Altarpiece*, mentioned by Vasari (FIG. 7). This was assigned to him in November 1506, and cost Margherita della Corgna, the wife of Baglione di Montevibiano, fifty florins; in January 1508, it was placed in the Baglioni family chapel, in the church of San Domenico Vecchio in Perugia.[27] Here the basic composition, although none of the individual figures, is heavily reliant upon the *Ascension* main panel of Perugino's San Pietro high altarpiece, now in Lyon – which is hardly surprising given Giannicola's own contribution to the decoration in the same part of the church as the altarpiece.[28] As we have already seen, Vasari mentions Giannicola's works in the chapel of the Collegio del Cambio, which can be dated to 1513–18 (vault) and 1526–8 (walls), and by this stage in his career it is plain that he had broadened his range of sources, inspired by the work of contemporary Tuscans such as Andrea del Sarto.[29] Other later, less Peruginesque works that are

securely, or traditionally, attributed to Giannicola include an Annunciation panel in Washington of about 1510–15, the altarpiece of around 1510–15 in the Duomo of Città della Pieve, and the *Quattro Santi Coronati Altarpiece* of 1512, painted for the Cappella dei Lombardi, now in the Louvre.[30]

The style of his first two documented early works supports the attribution of the London *Annunciation* to Giannicola.[31] The physiognomy of Gabriel in the *Annunciation* is close to that of other young male figures, in particular the sleeping Saint John in the *Last Supper*; they have the same stylised contours, straight noses, individuated curling tresses and simplified arched eyebrows. Despite the well-defined perspectival setting of the *Annunciation*, the figures remain notably flat, an imperfect three-dimensionality shared by Giannicola's two earliest documented works and resulting from the use of contour lines and the limited use of middle tones; the darks and lights are not well unified, especially when the artist has attempted shot colours.[32] The Virgin Annunciate in the National Gallery panel and many of the figures in the *Ognissanti Altarpiece* have heads with big round foreheads and rather uncomfortable relationships between their mouths and noses. They also have the same brownish lines between their lips. The artist uses a greyish contour between their fingers in both works, sometimes strengthened to make a contour with a blacker tone. The fingernails are always very small and set some distance from the ends of the fingers, and the thumb ends have an oddly bulging appearance (PLATE 3), although this last is a character-

istic that appears in other Peruginesque works less certainly associated with Giannicola.

In this work, as in all of these early works, Giannicola's dependence on models by Perugino is obvious. The pose of the Virgin in the London panel is seemingly derived from the Nativity scene in the Albani Torlonia polyptych, almost always (though not necessarily correctly) attributed to Perugino (PLATE 4),[33] with an inscription dating the picture to 1491,[34] or from a drawing for it. She is not a traditional Annunciate, kneeling with her arms crossed or standing with her arms raised, but a Madonna adoring the Child, albeit minus the Child. The fact that she lacks the monumentality of the adoring Virgins in very similar poses dating from the later 1490s, such as the Virgin in the frescoed *Nativity* in the Sala dell'Udienza in the Collegio del Cambio (*c*.1499–1500), suggests that Giannicola had access to the earlier model, but not yet the later, and therefore that his National Gallery *Annunciation* should be dated to the mid-decade, a date stylistically compatible with the Palazzo dei Priori fresco fragments. The type and pose of Gabriel are copied from the *Annunciation* altarpiece painted by Perugino in 1488–9 for the Chapel of the Annunciation in the Church of Santa Maria Nuova in Fano, with only the tilt of the head and the position of his wings altered (PLATE 5).[35]

PLATE 4 Perugino or workshop, detail of the Albani Torlonia Altarpiece, 1491. Panel, 140 × 160 cm. Rome, Museo di Villa Albani.

Although the billowing swathe of drapery at the shoulder is encountered quite regularly in Perugino's paintings, the angel's double sleeve (with an upper sleeve cut at the elbow in one colour and a lower sleeve in another colour, split to reveal a white undershirt beneath), imitated by Giannicola, is seen only in the Fano *Annunciation*, confirming this picture as Giannicola's source. Since the colours are not the same, Giannicola is once more likely to have studied Perugino's drawings rather than the painting itself. The scaling-up of 'model-book' drawings on paper to the desired size before transferring the design onto the panel might explain the use of cartoons for the National Gallery *Annunciation*. This combination of models taken from different sources helps to explain the lack of emotional contact between the figures in Giannicola's own work.

Pupils and workshop

Despite this reuse of figures from Perugino's paintings, it remains to be asked whether or not Giannicola actually spent any time in Perugino's workshop, and if so, where and in what capacity. A number of artists were working in a Peruginesque style in Umbria in the late fifteenth and early sixteenth centuries, but their precise relationships to one another and to Perugino himself vary. Collaboration with Perugino did not necessarily imply entering his employ.

Perugino renewed his contacts with Perugia in March 1495 when the contract for the *Pala dei Decemviri* (now in the Vatican) for the chapel of the Palazzo dei Priori was revived[36] and when he received the commission to execute the high altarpiece of the church of San Pietro, which turned out

PLATE 3 Giannicola di Paolo, *Annunciation* (NG 1104). Detail of angel's thumb.

PLATE 5 Perugino, *Annunciation* (Fano Altarpiece), *c*.1489. Panel, 212 × 172 cm. Fano, Church of Santa Maria Nuova.

to be one of the most expensive altarpieces painted in the last part of the Quattrocento.[37] The frescoes for the Sala dell'Udienza in the Collegio del Cambio were commissioned in January 1496 and signed and dated in 1500. It has therefore frequently been supposed that Perugino set up the Perugia branch of his workshop in about 1495, forming a team largely to undertake these two latter enormous projects. In the next two years, however, he is known to have remained highly peripatetic, spending only short periods of time in the city. He was more firmly established in Perugia from February 1499, passing most of his time there for the next two years and deluged by a veritable flood of commissions for churches in Perugia. Only in 1502, for the first time, do we have records of a physical location, in Piazza di Sopramuro, for Perugino's shop in Perugia.[38] Thus its precise configuration and the date of its establishment remain issues of speculation.[39]

Perugino had certainly established a permanent site for his *bottega* in Florence much earlier – from 1487 at the latest (he may have had other premises

there before this).[40] The elusive Rocco Zoppo (Giovanmaria da Balforte), seemingly an assistant of long-standing but whose works remain stubbornly unidentified, and Bacchiacca's equally mysterious brother, Baccio di Ubertino Verde, are both listed among Perugino's *discepoli* by Vasari and are both documented in his *bottega* (supporting Vasari's assertion that Bacchiacca himself was also a pupil or assistant).[41] This Florentine *bottega*, made up of a mixture of pupils and young pre-trained assistants, may have been run rather like Verrocchio's Florentine shop, in which Perugino worked after his initial training in Perugia.[42] Vasari, as we have seen, mentioned other *discepoli* whose careers were focused partly or entirely in Perugia; apart from Giannicola, he listed Pintoricchio, Eusebio da San Giorgio, Domenico di Paris and his brother Orazio. Eusebio is documented as one of the witnesses to the 1495 contract for the San Pietro altarpiece.[43] Lo Spagna, documented in Florence and subsequently in Perugia, was, according to Vasari, driven out of Perugia because of the hostility of native Perugian painters.[44] Andrea Aloigi d'Assisi, called

l'Ingegno ('the Talent'), is described as collaborating with Perugino (and the young Raphael) on the frescoes in the Collegio del Cambio although there is no documentary support for this. Giovanni Battista Caporali appears after Giannicola in Vasari's list and he was to collaborate with Giannicola from the 1510s onwards. Significantly in this context, Caporali and Perugino were on dining terms in Rome and are sometimes thought to have worked together; however, we might reasonably assume that Caporali was first tutored in painting by his father, Bartolomeo.[45] A painter known as 'Il Montevarchi' and stated by Vasari to have painted pictures in his (presumably) native town and in San Giovanni Valdarno[46] is confirmed as having worked in Perugia. This must be Roberto da Montevarchi, described as one of Perugino's *garzoni*, who received payments on his behalf from the Collegio in 1502, 1503 and 1504, moneys assumed to relate to the painting of the Sala dell'Udienza.[47]

The connections to Perugino of many of the painters in Vasari's list are therefore independently proven. More recently scholars have added to the catalogue of Perugino's 'pupils' on the basis of further documentation. Giovanni di Francesco Ciambella, called 'Il Fantasia', was the other witness of the 1495 San Pietro contract.[48] In May 1499, Ciambella is mentioned again in connection with payment for canvas for a *gonfalone* for the Confraternity of San Francesco commissioned from Perugino – here called 'suo charzone', and had therefore entered his employ by then if not before.[49] The first mention of *garzoni* in Perugia was almost exactly a year earlier in May 1498, when fifty ducats were paid to Perugino by the monks of San Pietro in relation to their high altarpiece 'per le spese facte a lui et suoi garzoni'.[50] Like Roberto da Montevarchi, Ciambella acted as courier for a payment by the Collegio in 1502.[51] In 1494 one 'Ruberto di Giovanni', probably the painter later usually called Berto di Giovanni, seems to have delivered five florins to Bartolomeo Caporali on Perugino's behalf for a painting (which interestingly had been subcontracted to yet another painter, Sante di Apollonio, who was by this time dead) to be placed above Perugino's not-yet-executed *Decemviri Altarpiece*.[52] Ludovico d'Angelo Mattioli was one of the witnesses to the final payment for the San Pietro altarpiece in 1500.[53] Given that Perugino himself does not seem to have had permanent premises for his activities in Perugia until the beginning of the sixteenth century, it is interesting to note that in 1496 Berto di Giovanni, Ludovico d'Angelo and Eusebio da San Giorgio joined with two other painters

(Sinibaldo Ibi and Lattanzio di Giovanni) in a 'società' sited nearby to where Perugino was to work from 1502, to undertake commissions together.[54] It is often assumed that this 'società' was formed to challenge Perugino's artistic and commercial hegemony but, more recently, it has been argued that it functioned with his blessing – exploiting his inventions by permission.[55] Several of the artists involved are documented as collaborating in other partnerships on particular projects in the first decades of the Cinquecento.

Documented works of the early sixteenth century, which can be treated as touchstones for the styles of Berto and Eusebio, link these two painters (in particular) to the 1500 *Tezi Altarpiece* painted for the Perugian church of Sant'Agostino (now Galleria Nazionale dell'Umbria), giving weight to the theory that they (and the 'società' to which they belonged) may have been responsible for executing this commission. This has another version of the *Cenacolo del Fuligno* for its predella (now Berlin).[56] The Virgin and Child in the *Tezi Altarpiece* are faithful copies of the central figures in the *Madonna della Consolazione*, an altarpiece commissioned from Perugino in 1496 (paid for in 1498) by the Disciplinati of Santa Maria Novella for their chapel.[57] This latter picture has most recently been catalogued as fully autograph.[58] There is evidence that in other circumstances Perugino sought to control the unauthorised use of his inventions.[59] Thus a repetition of a Perugino-designed Madonna by members of the Società, just like Giannicola's own derivations, is likely to have been approved by Perugino himself, perhaps as part of ongoing arrangements whereby those painters who collaborated with him at moments when his own workload became too great could benefit indirectly from their association with him.

It cannot be assumed, however, that even the majority of these painters received a first training at Perugino's hands (and the association of some, it should be pointed out, may have been somewhat tangential). For example, Berto di Giovanni and Ludovico d'Angelo are first documented in 1488 when Perugino was still in Florence.[60] Ludovico signed and dated a painting of *Christ as Redeemer with Saints Jerome, Francis, Martha and Anthony Abbot* made for San Simone (now in the collection of the Duomo, Perugia) in 1489 and he must therefore have been independently active by the early 1490s.[61] Eusebio is thought to have been born in about 1465; he too was independently active by 1493 – he was paid in that year by San Pietro for a painting of Saint Benedict and for applying gesso to a tabernacle.[62] Ciambella

PLATE 6 Collaborator of Perugino (Giannicola di Paolo?), *Luna*, 1496–1500. Fresco. Perugia, Palazzo dei Priori, Collegio del Cambio, detail of roundel from the vault of the Sala dell'Udienza.

PLATE 7 Collaborator of Perugino, *Venus*, 1496–1500. Fresco. Perugia, Palazzo dei Priori, Collegio del Cambio, detail of roundel from the vault of the Sala dell'Udienza.

too, for all that he was later called a *garzone*, in 1491 could also be found working autonomously in Monteluce.[63] It seems that at this period many Perugian painters worked as independent masters, maintaining small permanent workshops and joining together with partners and assistants as required, sometimes on a quite temporary basis, for particular commissions, or subcontracting certain aspects of their commissions. It is likely that this is exactly how Perugino and the group of younger painters working around him in Perugia operated.

These facts suggest a possible pattern of development for Perugino's methods of collaboration in Perugia after the beginning of his renewed activity there in 1495. He may first (on projects such as the San Pietro altarpiece) have worked with local artists already established there in temporary arrangements of the type outlined above. As he became more settled, and as the number of commissions expanded, he took on his own assistants on a more permanent basis: Ciambella, who probably already had a physical base in Perugia, and (perhaps later) Roberto da Montevarchi. Finally, he set up his workshop in Piazza del Sopramuro, the ideal location to enable the continuation of his working partnerships with other painters. The chronology of his career suggests that Giannicola, possibly after a spell in Perugino's Florentine workshop, could have been one of the established local artists in Perugia who worked in temporary partnerships with Perugino, although the only document that would support this proposal refers

to Giannicola's work in the same part of San Pietro as Perugino's altarpiece. This lack of documented direct contact with Perugino puts Giannicola into the same category as l'Ingegno. Giannicola's putative involvement in Perugino's known projects must thus be judged mainly on the basis of connoisseurship. Various suggestions have been made, but none has achieved wide acceptance.[64] Both the San Pietro altarpiece and the frescoes for the Sala dell'Udienza, however, have long been accepted as highly collaborative works.[65] Raphael's involvement in the Cambio frescoes has also, following Vasari's lead, often been alleged.[66] Although we know that Ciambella and il Montevarchi were involved latterly (or at least that they were in the workshop during the period payments were being made), we have no way of knowing exactly who Perugino's first collaborators were or what they may have contributed because the accounts from the first two years of the Cambio project are lost. However, it has long been accepted that the roundel images of the moon and planets on the *alla grottesca* ceiling were delegated to at least two painters, and since it can probably be assumed that the ceiling was started first, their contribution would date to shortly after the work was commissioned in 1496.[67] How the work was divided between the different hands is a matter of considerable dispute among connoisseurs. But, if none of them was Raphael's, it seems possible that one of Perugino's collaborators was Giannicola.[68] Giannicola's flattened anatomies and distinctive physiognomies make their appearance,

PLATE 8 Giannicola di Paolo, *Annunciation* (NG 1104). Detail of the lectern.

especially, in the image of *Luna* (whose profile is so like Gabriel's in the London *Annunciation*) and her handmaidens depicted on the Sala dell'Udienza ceiling (PLATE 6). The similarities between the head of the red-booted nymph on the centre left and the Virgin in the National Gallery *Annunciation* are especially striking. Certainly Giannicola knew these ceiling frescoes well; the Virgin's lectern in the London painting is clearly derived from the throne-chariot of Venus in another of the Cambio ceiling roundels (PLATES 7 and 8).

Egg tempera and oil techniques

Even if Giannicola did contribute to the Cambio ceiling, he is unlikely to have been acting as a pupil-assistant (already rendered improbable by the fact that he was working independently in 1493, three years before the Cambio project was begun) or to have been first trained by Perugino. This is borne out by the technique of the London *Annunciation* where an egg-tempera binding medium is used. There

remains much analytical work to be done, but the available evidence suggests that Perugino himself seems to have painted in oils on panel from the very beginning of his career.[69] Indeed, Perugino was evidently famed within his lifetime for his mastery of the oil medium. His canvas of the *Combat of Love and Chastity*, delivered to Isabella d'Este, Marchioness of Mantua, for her *studiolo* in June 1505 after what was seemingly a painful artistic struggle, may well be the only securely autograph work the artist ever painted in egg tempera. In this case, tempera was almost certainly used because it was understood, perhaps mistakenly, to be a term of the commission and intended to complement existing works by Andrea Mantegna (though the choice of support may also have been a factor). In the event Isabella, who claimed she had always wanted an oil painting, in the technique for which Perugino had become celebrated, deplored the choice of the tempera medium.[70]

It should, however, be pointed out that there remains a much-disputed group of works of generally high quality considered or known to be works in tempera. These paintings are sometimes attributed to Perugino, either working alone or dividing the execution with a collaborator (according to different theories), and sometimes to one or other of his pupils or assistants, albeit again working under Perugino's direct supervision; this group should certainly include, for instance, the 1491 Albani Torlonia polyptych mentioned above.[71] Judgements as to the autograph status of these works have usually been formed largely on stylistic grounds, and medium analysis has only rarely entered the argument. The problem is compounded because there are currently few analytical studies of the binding medium of those works from the last three decades of the fifteenth century that are reliably dated, attributed and documented.

Nevertheless, for paintings in which the binding medium has not been analysed, it is sometimes possible to infer indirectly that the painting is in oil because of the presence of finely ground colourless manganese-containing glass as a siccative in the red lake glazes.[72] The manganese in the glass can be detected by X-ray fluorescence spectroscopy, a non-invasive technique that does not require a paint sample, allowing 47 works by Perugino to be examined. Manganese, and therefore siccative glass, was found in areas of red lake in all except four of the works dated after 1493 and thus it appears that the majority of the works have an oil binding medium.[73] The four exceptions are all, revealingly, ascribed only somewhat dubiously to Perugino rather than considered securely autograph. The absence of the siccative

PLATE 9 Workshop of Pietro Perugino, *The Virgin and Child between Saints Jerome and Augustine*, 1505–10.
Canvas transferred from panel, 217 × 185 cm. Bordeaux, Musée des Beaux Arts (inv. Bx E 22).

glass in these paintings would suggest that these paintings are in egg tempera, as will be discussed below.[74]

Although Giannicola certainly worked in an oil medium later in his career, his technique in his early years when he was working in tempera (at the point when he painted the National Gallery *Annunciation*) seems to have been untouched by his collaboration with Perugino.[75] If therefore Giannicola was working by Perugino's side, as the attribution of the roundel of *Luna* in the Cambio, the San Pietro association, and his inclusion in Vasari's list all imply, this is further evidence that he was employed as an assistant rather than as a pupil, using a technique in which he had been trained elsewhere. The haloes from the earlier design visible in the X-radiograph of the London *Annunciation* resemble those in works by Bartolomeo Caporali (active 1467–91) and Benedetto Bonfigli (*c*.1420–1496).[76] The punched gold leaf is certainly more old-fashioned than the delicate shell-gold haloes common in paintings by Perugino of the 1490s and early 1500s.[77] It is not possible to determine if the earlier design had progressed beyond the gilding and punching stage before it was abandoned, or indeed if the first design was Giannicola's, working in a different, non-Peruginesque mode, or that of another Perugian artist, such as Caporali himself. However, this finding might suggest that Giannicola was initially

trained in the Caporali workshop, a hypothesis that becomes perhaps more plausible because of his later professional connection with Bartolomeo's son, Giovanni Battista. Giovanni Battista and Giannicola worked together in 1512 when they painted the Perugian town clock, in 1516 on the commission for the Chapel of Sant'Ivo in the Cathedral, and in 1521 on the fresco decoration of the Chapel of the Annunciation in San Pietro, Perugia.[78] Even if it was not Giannicola himself who started the first abandoned version of the *Annunciation*, the fact that he inherited the project suggests a connection with a longer-established *bottega* in Perugia.[79] It therefore becomes likely that both the *Annunciation* and the 1506 *Ognissanti Altarpiece* were executed in tempera because, although Giannicola had almost certainly worked in collaboration with Perugino, he had not in fact been trained by him.

Since Perugino himself was working exclusively in oil in the period when Giannicola's *Annunciation* was painted, it is important to reconsider other late works in egg tempera associated with the workshop. With the exception of the *Combat of Love and Chastity*, produced, as we have seen, under particular circumstances, these late works are all paintings where the precise attribution is uncertain, or in which a number of artists seem to have been involved. The very large Sant'Agostino polyptych, for example, still unfinished at Perugino's death in 1523, is agreed to have been a highly collaborative piece. Thus it is revealing that, although most panels are in oil, two small panels from the top of the reverse were painted in egg tempera.[80] The *Daniel* and *David* roundels are probably the work of two different assistants. *The Virgin and Child with Saints Jerome and Augustine*, now in the Musée des Beaux Arts, Bordeaux, dated 1505–10, is also in egg tempera, and has green underpaint in the flesh; this too is almost certainly the work of an assistant (PLATE 9).[81]

Conclusion

Further consideration of the results of technical examinations of paintings by Perugino, those ascribed to his workshop, and those by known or supposed associates remains necessary. This study should be treated as merely a prolegomenon; nonetheless, since Perugino seems from the outset to have employed an oil medium, it appears that where egg tempera is found in Peruginesque paintings, this can be used as a factor to support connoisseurial judgements that the works were not executed by Perugino's own hand. Indeed, this fundamental difference in technique suggests that, although some may have been painted in Perugino's workshop, such works are likely to have

been undertaken by assistants initially trained elsewhere rather than by his own pupils. From this observation, we gain more insight into Perugino's methods of collaboration in Perugia. It has become clear that not all of the *discepoli* of Perugino listed by Vasari were in fact Perugino's pupils and that, like Giannicola di Paolo, they may have used his designs but not necessarily adopted his technique. Other divergences of technique might profitably be reassessed to arrive at a greater understanding of how the painters in Vasari's list (Raphael included) may have worked with Perugino.

Acknowledgements

We would like to thank Michael Bury, Carol Plazzotta, Francis Russell and Sheri Francis Shaneyfelt for their helpful comments concerning the attributional problems attached to paintings currently given (though usually not consistently) to Giannicola, Perugino, Raphael and other painters working in Perugia at the period, and about their working methods. We also acknowledge the assistance of Rachel Billinge for infrared reflectography, and Bruno Brunetti (University of Perugia) for providing a sample of Umbrian propolis, a material initially thought to be present in the mordant.

Notes

1 *The Virgin and Child with Saints, Angels and a Donor* (NG 1103). See M. Davies, *The Earlier Italian Schools, National Gallery Catalogues*, London 1961, pp. 181–2.

2 Davies 1951 (cited in note 1), p. 228.

3 G. Vasari (ed. G. Milanesi), *Le vite de' più eccellenti pittori, scultori ed architettori*, Florence 1878, III, pp. 590–8: 'Fece Pietro molti maestri di quella maniera, et uno fra gl'altri che fu veramente eccellentissimo, il quale datosi tutto agl'onorati studî della pittura, passò di gran lunga il maestro; e questo fu il miracoloso Raffaello Sanzio da Urbino, il quale molti anni lavorò con Pietro in compagnia di Giovanni de' Santi suo padre. Fu anco *discepolo* [our italics] di costui il Pinturicchio pittor perugino, il quale ... tenne sempre la maniera di Pietro. Fu similmente suo *discepolo* Rocco Zoppo pittor fiorentino ... Lavorò il medesimo Rocco molti quadri di Madonne e fece molti ritratti, de' quali non fa bisogno ragionare; dirò bene che ritrasse in Roma, nella cappella di Sisto, Girolamo Riario e Francesco Piero cardinale di San Sisto. Fu anco *discepolo* di Pietro il Montevarchi, che in San Giovanni di Valdarno dipinse molte opere, e particolarmente nella Madonna l'istorie del miracolo del latte; lasciò ancora molte opere in Montevarchi sua patria. Imparò parimente da Pietro e stette assai tempo seco Gerino da Pistoia ...; e così anco Baccio Ubertino fiorentino, il quale fu diligentissimo così nel colorito come nel disegno, onde molto se ne servì Pietro ... Di questo Baccio fu fratello, e similmente *discepolo* di Pietro, Francesco che fu per sopranome detto il Bacchiacca, il quale fu diligentissimo maestro di figure piccole ... Fu ancora *discepolo* di Pietro Giovanni Spagnuolo, detto per sopranome lo Spagna, il quale colorì meglio che nessun altro di coloro che lasciò Pietro dopo la sua morte. Il quale Giovanni dopo Pietro si sarebbe fermo in Perugia, se l'invidia dei pittori di quella città, troppo nimici de' forestieri, non l'avessino perseguitato di sorte che gli fu forza ritirarsi in Spoleto ... Ma fra i detti *discepoli* di Pietro miglior maestro di tutti fu Andrea Luigi d'Ascesi, chiamato l'Ingegno, il quale nella sua prima giovanezza concorse con Raffaello da Urbino sotto la disciplina di esso Pietro, il quale l'adoperò sempre nelle più importanti pitture che facesse, come fu nell'Udienza del Cambio di Perugia dove sono di sua mano figure bellissime, in quelle che Andrea tal saggio di sé, che si aspettava che dovesse di gran lunga lavorò in Ascesi e finalmente a Roma nella cappella di papa Sisto; nelle quali tutte opere diede trappassare il suo maestro ... Furono medesimamente *discepoli* di Pietro, e perugini anch'eglino, Eusebio S. Giorgio che dipinse in S. Agostino la tavola de' Magi, Domenico di Paris che fece molte opere in Perugia et attorno per le castella, seguitato da Orazio suo fratello; parimente Giannicola, che in S. Francesco dipinse in una tavola Cristo nell'orto, e la tavola d'Ognisanti in S. Domenico alla cappella de' Baglioni, e nella cappella del Cambio istorie di S. Giovanni Battista in fresco. Benedetto Caporali, altrimenti Bitti, fu anch'egli *discepolo* di Pietro, e di sua mano sono in Perugia sua patria molte pitture ...' Carol Plazzotta points out (oral communication) that the phrase 'il quale [Raphael] molti anni lavorò con Pietro in compagnia di Giovanni de' Santi suo padre' could be significant. It may be that Vasari is here implying a distinction between those who were taught by Perugino, such as Gerino da Pistoia, and those, like Raphael, whom he states 'worked with' the Umbrian master. The fact that he does not spell this out suggests that he was familiar with the system whereby some young artists were taken on by a master as apprentices, whereas others came into a famous workshop to work as more skilled assistants while continuing their training. A. Di Lorenzo, 'Documents in the Florentine Archives' in K. Christiansen, ed., *From Filippo Lippi to Piero della Francesca: Fra Carnevale and the Making of a Renaissance Master*, exh. cat., Metropolitan Museum of Art, New York 2004, pp. 290–8, has demonstrated that such a system operated in the workshop of Fra Filippo Lippi in the 1440s where artists pre-trained in the Marches were employed for brief periods.

4 T. Henry and C. Plazzotta, 'Raphael: From Urbino to Rome' in H. Chapman, T. Henry and C. Plazzotta, *Raphael: From Urbino to Rome*, London 2004, p. 16. The authors point out that Raphael is not mentioned as one of Perugino's pupils in any documents and that his earliest independent paintings are not in fact his most Peruginesque in style. Therefore, although they believe that he had a close association with Perugino slightly later in his career, they argue that it is unlikely that Raphael was trained in Perugino's workshop in the 1490s.

5 The picture was cleaned and restored by Anthony Reeve in 2004.

6 The triangular addition on the left side is 27 × 25 cm, while that on the right is 19 × 18.5 cm. The panel has been thinned to c.5–7 mm and has suffered worm damage in the past, as can be seen by filled holes on the back and open exit holes on the front, which are most prominent in the Virgin's robe. The character of the wood grain (as seen in the X-radio-

graph) is similar on both additions, but different from that of the main part of the panel.

7 The additions have a gesso ground, and were painted in egg tempera, which suggests that they are early in date. Identification of the pigments used does not allow the paint to be dated, however. The paint of the angel's wing on the addition is brownish in colour (translucent yellow pigment and black). The translucent yellow pigment may be a red lake that has faded and which has proved to be less durable than that used on the main part of the panel, since the paint no longer matches the wing on the main part.

8 Since punching of the decoration is carried out after gilding, one would expect to find gold leaf beneath the paint in the areas where the haloes are visible in the X-radiograph. Traces of gold were found in samples from these areas, but so little that it seems likely that the gold was scraped off when it was decided that the composition would be changed. This is also suggested by the fact that no trace of the haloes is visible in the infrared reflectogram.

9 Galleria Nazionale dell'Umbria, Perugia.

10 An arched format was certainly not unusual for fresco and panel paintings, both in works by Giannicola and by his contemporaries in Umbria. Several examples are illustrated in G. Carli, *Pittura in Umbria tra il 1480 e il 1540. Premesse e sviluppi nei tempi di Perugino e Raffaello*, Milan 1983, p. 75 (Perugino), p. 115 (Dono Doni), p. 118 (Tiberio d'Assisi and Eusebio da San Giorgio), p. 132 (Gian Battista Caporali), pp. 137 and 178 (Tiberio d'Assisi). For examples by Giannicola di Paolo see p. 101 (1515), p. 130 (undated), p. 153 (attributed). When the panel width was reduced (by cutting on the right side), it would have been necessary to make an addition to the upper left corner to balance the composition and it seems likely that this was when the corner additions were added. Painted lines on these additions suggest that at least two gabled formats have been adopted at various stages.

11 The results of medium analysis are published in C. Higgitt and R. White, 'Analyses of Paint Media: New Studies of Italian Paintings of the Fifteenth and Sixteenth Centuries', *National Gallery Technical Bulletin*, 26, 2005, pp. 88–104. The pigments were analysed by optical microscopy, energy dispersive X-ray analysis (EDX) in the scanning electron microscope (SEM) and Fourier Transform Infrared (FTIR) microscopy.

12 This rather unusual unpigmented mordant does not appear to contain any of the organic materials normally associated with mordants that are commonly mentioned in documentary sources (oils, proteins or polysaccharides). However, analysis of the mordant by FTIR microscopy and GC-MS gave a very close match to authentic samples of gum ammoniac or ammoniacum, a gum resin exuded from the stems of *Dorema ammoniacum* D.Don (Umbelliferae, now Apiaceae), native to Iran and India. Details of the analytical results and further research will be the subject of a future publication. Gum ammoniac has a complex composition, containing approximately 1–7% volatile oil, 50–70% resin and 18–26% gum. The resin contains a 3-alkyl substituted 4,7-dihydroxycoumarin, ammoresinol, probably present as a salicylic acid ester. R.D.H. Murray, J. Méndez and S.A. Brown, *The Natural Coumarins, Occurrence, Chemistry and Biochemistry*, Norwich 1982, pp. 45–51, 56–69, 97–111 and 444; A. Tschirch and E. Stock, *Die Harze*, 3rd edn, Berlin 1933–6, pp. 201–10; *The Merck Index*, 12th CD-ROM edn, ed. S. Budavari, M. O'Neil, A. Smith, P. Heckelman and J. Obenchain, London and Boca Raton, Chapman and Hall/CRC, 2000. Gum ammoniac is mentioned in various early sources (as *arminiacho* or *armoniaco*) including a fifteenth-century Sienese manuscript, see A.P. Torresi, *Tecnica Artistica a Siena. Alcuni trattati e ricettari del Rinascimento nella Biblioteca degli Intronati*, Ferrara 1993, pp. 48–9 (referring to Siena, Biblioteca degli Intronati, MS L.XI.41 f. 40r.). The sources describe its use (sometimes mixed with gums, bole, egg white, garlic, urine or vinegar) for applying gold to a number of substrates including parchment or paper, see I. Bonaduce, 'A Multi-Analytical Approach for the Investigation of Materials and Techniques in the Art of Gilding', PhD thesis 2003–5, University of Pisa 2006. This is the first time that the use of gum ammoniac as a mordant component in easel paintings has been reported. A very similar mordant has been identified in panels by the Sienese artist known as the Master of the Story of Griselda (*c.*1492) see J. Dunkerton, C. Christensen and L. Syson in this *Bulletin*, pp. 4–71 and in a number of other fifteenth-century Sienese and North Italian works.

13 See J. Kirby, M. Spring and C. Higgitt, 'The Technology of Red Lake Pigment Manufacture: Study of the Dyestuff Substrate', *National Gallery Technical Bulletin*, 26, 2005, pp. 71–87.

14 The modelling of green areas in the landscapes with spots of green paint, both in the middle ground and in the background (including distant hills; this does not stand for grass) appears to be particularly common in fresco; it can be seen for example in the Perugino frescoes in the Collegio del

Cambio in Perugia and in Perugino's *Adoration of the Kings* of 1504 in the Oratorio di Santa Maria dei Bianchi in Città della Pieve. However, Perugino also used this method in his panel paintings, for example the *Madonna in Glory with Saints* (*c.*1500), in the Pinacoteca Nazionale, Bologna (No. 579), and the *Transfiguration* of 1517 in the Galleria Nazional dell'Umbria. It can also be seen on paintings by other painters, such as *Alexander the Great* by the Master of the Story of Griselda, in the Barber Institute, Birmingham; see the article in this *Bulletin*, pp. 4–71.

15 Higgitt and White 2005 (cited in note 11).

16 The gold leaf is applied onto the same translucent yellow unpigmented mordant observed beneath the silver decoration on the angel's wings. See note 12.

17 M. Spring, R. Grout and R. White, 'Black Earths: A Study of Unusual Black and Dark Grey Pigments used by Artists in the Sixteenth Century', *National Gallery Technical Bulletin*, 24, 2003, pp. 96–114.

18 C. Seccaroni, 'Some rarely documented pigments. Hypotesis [sic] and working observations on analyses made on three temperas by Correggio', *Kermes*, 34, January–April 1999, pp. 41–59. For a discussion of the date of the *Penitent Saint Jerome* see T. Mozzati in V. Garibaldi and F.F. Mancini eds, *Perugino, il divin pittore*, exh. cat., Galleria Nazionale dell'Umbria, Perugia, Milan 2004, pp. 316–17, cat. I.59.

19 A pale green layer of lead white and a little green earth was seen in a cross-section of a paint sample from the Virgin's flesh. For general discussion of the painting techniques of the period, see J. Dunkerton and A. Roy, 'The Materials of a Group of Late Fifteenth-century Florentine Panel Paintings', *National Gallery Technical Bulletin*, 17, 1996, pp. 20–31. In tempera works, areas of flesh appear dark in infrared photographs because the green earth-containing underpaint absorbs infrared radiation.

20 For Giannicola's biography see F. Canuti, 'La patria del pittore Giannicola con notizie e documenti sulla vita e sulle opere', *Bollettino della Regia Deputazione di Storia Patria per l'Umbria*, XII, 1916, pp. 279–337; U. Gnoli, 'Giannicola di Paolo', *Bollettino d'arte*, XXII, 1919, pp. 33–43; P. Mercurelli Salari, 'Giannicola di Paolo', *Dizionario biografico degli italiani*, LIV, Rome 2000, pp. 474–7; S.F. Shaneyfelt, *The Perugian Painter Giannicola di Paolo: Documented and Secure Works*, Ph.D. dis., Indiana University at Bloomington, 2000. We also look forward to the publication of Sheri Shaneyfelt's forthcoming lecture 'New documents for the Perugino School: a reappraisal of Giannicola di Paolo's early career', presented at the Southeastern College Art Conference (SECAC), 26–30 October 2005, University of Arkansas, Little Rock, Arkansas.

21 F. Canuti, *Il Perugino*, Siena 1931, II, pp. 181–2, docs 233, 235. Interestingly, one further connection between the two painters can be traced: a contract of 1520 between Giannicola and canons of Santa Maria di Spello for paintings that were then executed by Perugino (Canuti 1931, II, pp. 279–80, doc. 482).

22 Canuti 1916 (cited in note 20), p. 310, publishes a rental agreement of 1509, but the document implies that Giannicola may already have been working there before that date.

23 F.F. Mancini, 'La residenza dei priori: uso e decorazione degli spazi interni dal XIV al XVIII secolo' in Mancini, ed., *Il Palazzo dei Priori di Perugia*, Perugia 1997, pp. 279–325, esp. pp. 290–1; V. Garibaldi, 'Novità su Giannicola di Paolo: i ritrovati affreschi dell'antico refettorio del Palazzo dei Priori a Perugia' in P. Mercurelli Salari, ed., *Pietro Vannucci e i pittori perugini del primo Cinquecento*, Perugia 2005, pp. 111–24; and V. Garibaldi, 'Da Perugino a Giannicola di Paolo: il Cenacolo di Perugia' in R.C. Proto Pisani, ed., *Perugino a Firenze. Qualità e fortuna d'uno stile*, exh. cat., Cenacolo di Fuligno, Florence 2005, pp. 45–9.

24 For a complete list, see Mercurelli Salari 2000 (cited in note 20), p. 474. A detached *Crucifixion* fresco in the Galleria Nazionale dell'Umbria remains particularly problematic. Canuti, followed by Gnoli and others, connected it with payments in 1501 from the Confraternity of San Domenico for a Crucifixion for its oratory. See Canuti 1916 (cited in note 20), pp. 292 and 301, note 30; A. Alberti in Carli 1983 (cited in note 10), p. 193. Tiranti, however, re-examining the documents in 1985, suggested a later dating and an alternative attribution to the still somewhat ill-defined Pompeo Cocchi. See A. Tiranti, 'Novità per Pompeo Cocchi' in *Esercizi. Arte, musica e spettacolo*, 8, 1985, pp. 20–9. This suggestion was rejected by S. Blasio in G. Baronti, S. Blasio, A. Melelli, C. Papa and M. Squadroni, eds, *Perugino e il paesaggio*, Palazzo della Corgna, Città della Pieve (Perugia), Milan 2004, pp. 52–3, cat. 5, who accepts the attribution to Giannicola. The design of the corpus is clearly based on a Perugino model – such as the Crucifixion fresco in Santa Maria Maddalena de' Pazzi, Florence. Even if Tiranti's revised attribution cannot be proved with certainty, comparison with the fresco fragments in the Palazzo dei Priori suggests that his doubts about the attribution to Giannicola may be well founded.

25 See S. Padovani, 'Il Cenacolo di Sant'Onofrio detto "del Fuligno"' in L.

Teza, ed., *Pietro Vannucci, il Perugino. Atti del convegno internazionale di studio (Città della Pieve, 25–28 ottobre 2000)*, Perugia 2004, pp. 49–64; S. Padovani, 'Il Cenacolo del Perugino' in Proto Pisani ed. 2005 (cited in note 23), pp. 29–44, in which she unconvincingly argues for an early date and fully autograph status. More usually it has been recognised that the execution was delegated to one or more of Perugino's Florentine associates. The names Rocco Zoppo and Roberto da Montevarchi have been suggested (see F. Todini, *La pittura umbra dal Duecento al primo Cinquecento*, I, Milan 1989, pp. 306–7), but neither of these figures is sufficiently well defined for this proposal to be more than hypothetical; in particular, there is no evidence that Roberto worked with Perugino prior to *c*.1500. Until recently, it has also sometimes been cautiously proposed that Giannicola himself was one of the executors. See S. Ferino Pagden, *Disegni umbri del Rinascimento da Perugino a Raffaello*, exh. cat., Uffizi, Florence 1982, p. 47. This theory is disproved by the recent restoration and analysis of his Palazzo dei Priori copy, which is stylistically divergent.

26 See L. Aquino in Proto Pisani ed. 2005 (cited in note 23), pp. 152–63, cats 30–5: divided between the Uffizi (Florence), the Kupferstichkabinett (Berlin), the British Museum (London) and the Fitzwilliam Museum (Cambridge). That some of these (Uffizi nos 1725E, 1724E) are copies after drawings rather than the finished fresco is indicated by the fact that the legs of the apostles can be seen under the table, obscured in the fresco by the table-cloth.

27 The chapel was acquired in 1494. S. Blasio 2004 (cited in note 24), pp. 54–5, cat. 6.

28 The San Pietro altarpiece is discussed in C. Gardner von Teuffel, 'Carpenteria e machine d'altare. Per la storia della ricostruzione delle pale di San Pietro e di Sant'Agostino a Perugia' in Garibaldi and Mancini ed. 2004 (cited in note 18), pp. 141–53.

29 See F.F. Mancini, 'Giannicola di Paolo e la Cappella di San Giovanni al Cambio' in P. Mercurelli Salari ed. 2005 (cited in note 23), pp. 103–10.

30 The Louvre and Città della Pieve altarpieces are illustrated in Carli 1983 (cited in note 10), pp. 108 and 146 respectively.

31 This painting was first attributed to Giannicola di Paolo by Berenson (B. Berenson, *Central Italian Painters of the Renaissance*, New York 1909, p. 193) and Crowe and Cavalcaselle in 1909 and 1914 (J.A. Crowe and G.B. Cavalcaselle, *A History of Painting in Italy: Umbria, Florence and Siena from the Second to the Sixteenth Century*, III, *The Sienese, Umbrian and North Italian Schools*, London 1909, pp. 326–7, and V, *Umbrian and Sienese Masters of the Fifteenth Century*, London 1914, pp. 458–9) and this attribution has been followed in the subsequent literature. See Shaneyfelt 2000 (cited in note 20), 'Catalogue C: Works of Possible Attribution', pp. 519–20, which gives the wide date range of *c*.1485–1510; however, as the author explains, she had not had the chance to see the picture in person.

32 This effect may have become exaggerated by some fading of pigments. Nonetheless, it is more marked than in other paintings by Perugino or his *discepoli*.

33 This polyptych, in the Albani Torlonia collection in Rome, has most recently been catalogued as a work in egg tempera by V. Garibaldi in V. Garibaldi and F.F. Mancini ed. 2004 (cited in note 18), pp. 232–3, cat. I.31. Certainly the brushstrokes have the hatched appearance of tempera (see, however, the caveat in note 69 below). Interestingly, for the argument related to pictures in tempera attributed to Perugino presented below, the attribution has been questioned by L. Teza (cited by Garibaldi), who believes it to have been painted by l'Ingegno, and by F. Russell, 'Review: *Perugino, il divin pittore*', *Apollo*, CLIX, June 2004, pp. 94–5.

34 The inscription states PETRUS/ .DE PERUSIA/ PINXIT/ .M.CCCC.VIIII.PRIMO. Perugino did not use this unusual dating format elsewhere, perhaps reinforcing the idea that the 'signature' may have been added by a member of his shop.

35 The Fano *Annunciation* is catalogued as a work in oil by P. Scarpellini, *Perugino*, Milan 1984, p. 84, cat. 46; V. Garibaldi, *Perugino. Catalogo completo*, Florence 1999, pp. 109–10, cat. 23. There is a fragmentary inscription on this *Annunciation* which seems to read 1489. There are also more superficial similarities with the *Annunciation* scene from the predella of the main altarpiece in the Church of Santa Maria Nuova in Fano of *c*.1497, often credibly thought to be a work by one of Perugino's pupils or assistants (Scarpellini 1984, pp. 92–3, cat. 73; F. Marcelli in Garibaldi and Mancini ed. 2004 (cited in note 18), pp. 314–15, cat. I.58a–58e), and the *Annunciation* in the Ranieri collection which has been attributed to Perugino, although both date and authorship of this picture are rightly debated, see Scarpellini 1984, pp. 99–100, 233, cat. 101; F.F. Mancini in Garibaldi and Mancini eds 2004 (cited in note 18), pp. 236–7, cat. I.33. These latter indicate only how Perugino's inventions were developed by his associates, and should not be treated as sources for Giannicola.

36 F. Canuti 1931 (cited in note 21), II, p. 175, doc. 220.

37 M. O'Malley, *The Business of Art: Contracts and the Commissioning Process in Renaissance Italy*, New Haven and London 2005, p. 133. The panels from the altarpiece are now dispersed, the main panel and lunette in Lyon, the narrative predella panels in Rouen, two prophet roundels in Nantes, and small panels of saints in Perugia and the Vatican (Scarpellini 1984 (cited in note 35), pp. 93–5, cats 74–88).

38 Canuti 1931 (cited in note 21), II, pp. 302–4, docs 541–7. Payments continue into 1509.

39 The issue of Perugino's workshops has most recently been examined by F.F. Mancini, 'Considerazioni sulla bottega umbra del Perugino' in L. Teza ed. 2004 (cited in note 25), pp. 329–34; E. Lunghi, 'Perugino e i suoi imitatori' in P. Mercurelli Salari ed. 2005 (cited in note 23), pp. 27–46; L. Teza, 'Un dipinto in società: Perugino, Berto di Giovanni e la bottega del 1496', in ibid., pp. 47–61; F. Todini, 'Il Perugino, le sue botteghe e i suoi seguaci' in Proto Pisani ed. 2005 (cited in note 23), pp. 51–68.

40 A. Victor Coonin, 'New documents concerning Perugino's workshop in Florence', *Burlington Magazine*, CXLI, 1999, pp. 100–4.

41 Ibid.

42 A. Butterfield, *The sculptures of Andrea del Verrocchio*, New Haven and London 1997, pp. 185–98.

43 See Canuti 1931 (cited in note 21), II, pp. 176–7, doc. 224, on which basis it has been suggested that Eusebio was perhaps responsible for the predella figures of Saints Ercolano and Costanzo. See F. Russell, 'Perugino and the early experience of Raphael' in J. Beck, ed., *Raphael Before Rome. Studies in the History of Art, National Gallery of Art, Washington*, 17, 1986, pp. 189–201, esp. p. 192. Equally (but less convincingly) it has been suggested that these saints were painted by Giannicola. See Scarpellini 1984 (cited in note 35), p. 94, cats 81–2; they do not in fact seem to have been executed by the same hand. For Eusebio, see also C. Fratini, 'Eusebio di Iacopo', *Dizionario biografico degli italiani*, XLIII, 1993, pp. 524–7, esp. p. 524.

44 Coonin 1999 (cited in note 40), p. 101; F. Gualdi Sabatini, *Giovanni di Pietro detto Lo Spagna*, Spoleto 1984, p. 366, doc. 2 (1504).

45 Vasari (see note 3) actually lists 'Benedetto Caporali' but he certainly intended Giovanni Battista Caporali, *c*.1476–1554 (also sometimes called Gianbattista or Giambattista), son of Bartolomeo Caporali (active 1467–91). See also note 81 below.

46 Todini 1989 (cited in note 25), p. 306.

47 Canuti 1931 (cited in note 21), II, pp. 191–2, docs 260–1.

48 Canuti 1931 (cited in note 21), II, pp. 176–7, doc. 224.

49 Canuti 1931 (cited in note 21), II, p. 188, doc. 252

50 Canuti 1931 (cited in note 21), II, p. 180, doc. 232 (19 May?).

51 Canuti 1931 (cited in note 21), II, p. 191, doc. 260.

52 Canuti 1931 (cited in note 21), II, pp. 174–5, doc. 219. 'Ruberto' however is not designated a painter.

53 Canuti 1931 (cited in note 21), II, p. 181, doc. 234.

54 An opinion influentially formulated by F.F. Mancini, 'Un episodio di normale "routine": l'affresco cinquecentesco dell'Oratorio di Sant' Agostino a Perugia', *Commentari d'arte*, I, no.1, 1995, pp. 29–48.

55 Lunghi 2005 (cited in note 39).

56 V. Garibaldi in Garibaldi and Mancini eds 2004 (cited in note 18), pp. 270–3, cat. I.47; Mancini in Teza ed. 2004 (cited in note 25); Teza in Mercurelli Salari ed. 2005 (cited in note 39). Todini 1989 (cited in note 25), I, p. 78, attributed the whole altarpiece to Giannicola. Others have thought that Giannicola may have been responsible for the predella alone. See Padovani in Teza ed. 2004 (cited in note 25), p. 52. This last suggestion deserves further consideration that might be assisted by technical examination.

57 Canuti 1931 (cited in note 21), II, p. 184, doc. 242.

58 Scarpellini 1984 (cited in note 35), p. 95, cat. 90; P. Mercurelli Salari in Garibaldi and Mancini eds 2004 (cited in note 18), pp. 266–7, cat. I.45.

59 Lunghi in Mercurelli Salari ed. 2005 (cited in note 39), p. 27. Lorenzo Ghiberti similarly sought to control the use of his drawings by others. See A. Thomas, *The Painter's Practice in Renaissance Florence*, Cambridge 1995, p. 157.

60 They are referred to in a notarial deed, and were therefore of age. For Berto, see F. Gualdi, 'Berto di Giovanni', *Dizionario biografico degli italiani*, IX, 1967, pp. 555–7.

61 U. Gnoli, *Pittori e miniatori nell' Umbria*, Spoleto 1923, p. 186.

62 Gnoli 1923 (cited in note 61), p. 103.

63 Gnoli 1923 (cited in note 61), p. 154.

64 It has been suggested unconvincingly that the *Virgin and Child with Saints* (Baltimore Museum of Art) and the *Flagellation* (Washington, National Gallery of Art, Kress Collection) are works by Perugino possibly in collaboration with Giannicola, see Scarpellini 1984 (cited in note 35), pp. 111–12, cats 136, 139; Garibaldi 1999 (cited in note 35), pp. 158–9, cats A11, A13.

65 V. Garibaldi, *Perugino*, Milan 2004, pp. 150–1, 171: 'La volta, che rappresenta la prima importante antologia della grottesca nella pittura italiana rinascimentale, è sostanzialmente estranea al gusto di Perugino e al suo modo figurativo e il pittore interviene quasi esclusivamente a livello progettuale. Richiesta dalla commitenza sull'onda della moda imperante in quegli anni, impegnò in un tema a lui non congeniale. L'estraneità culturale è confermata dalla scelta da affidare gran parte dell'esecuzione ai suoi aiutanti. Sono infatti rintracciabili tre diversi linguaggi figurative, che avolte si sovrappongono e si intersecono. Non è possibile dare un nome all'autore dei segni zodiacali. Vasari ricorda l'Ingegno, ma quelle poche, incerte notizie che abbiamo di lui non permettono di confermare la sua presenza. Neppure trovano riscontro diretto gli altri nomi che sono stati fatti, da Eusebio da San Giorgio, al Fantasia, a Roberto da Montevarchi, a Giannicola di Paolo, attivo di lì a poco nell'attigua capella di San Giovanni.'

66 Raphael has also sometimes been thought, with even less evidence, to have contributed to the predella of the San Pietro altarpiece. See Scarpellini 1984 (cited in note 35), p. 94, cats 79–80; Garibaldi 2004 (cited in note 65), p. 158.

67 Canuti 1931 (cited in note 21), pp. 189–90, doc. 256.

68 C. Acidini, 'Gli ornate delle tarsie perugine dal repertorio antiquario alla grottesca', *Annali della Fondazione di Studi di Storia dell'Arte R. Longhi*, I, 1984, pp. 55–69, esp. p. 68, note 14.

69 Statements in the literature about binding media are often based simply on the character of the brushstrokes. This, however, is not always a good criterion, as some painters at this time applied oil paint in the hatched brushstrokes typical of tempera. In addition, painters sometimes used a combination of oil and egg in the same painting and also some of the pigments and additives in the paint can interfere with interpretation of the instrumental analyses, see Higgitt and White 2005 (cited in note 11). The problem is compounded by a lack of unanimity among art historians as to the extent of Perugino's autograph oeuvre, and not just at the beginning of his working life. For the moment, inevitably, some judgements on medium use are based on the way in which they are currently catalogued and on their surface appearance. However, the authors of this article accept the attribution to Perugino of the following early works convincingly catalogued as having been painted using an oil medium: *The Birth of the Virgin* (Liverpool, Walker Art Gallery), the *Miracle of the Madonna della neve* (Polesden Lacey, from the same predella), the *Miracle of Bishop Andrea*, the *Miracle of the Hanged Youths* and the *Imago pietatis* (all from the same predella devoted to the miracles of Saint Jerome and all now in the Louvre) and, most importantly, the *Adoration of the Magi* of c.1475, from Santa Maria dei Servi (now Galleria Nazionale dell'Umbria). See Scarpellini 1984 (cited in note 35), pp. 71, 74–5, cats 8–10, 25; A. Bellandi and P. Mercurelli Salari and Mancini eds 2004 (cited in note 18), pp. 176–83 and pp. 194–5, cats I.5–8, I.12.

70 S. Delbourgo, J.P. Rioux, E. Martin, 'L'analyse des peintures du *studiolo* d'Isabelle d'Este', *Laboratoire de recherche des musées de France, Annales*, 1975, pp. 21–8. For the exchange of letters see Canuti 1931 (cited in note 21), II, pp. 236–7, docs 376, 378. Isabella d'Este to Perugino, 30 June 1505: '… et rincrescene che quello Lorenzo Mantovano vi dissuadesse da colorirlo ad olio: perochè noi lo desideravamo sapendo che l'era più vostra professione et di maggior vaghezza …' Perugino to Isabella, 10 August 1505: 'Io ricevuta una vostra Rx.sa S. E. per quella inteso il quadro essere giunto a salvamento, di che ho preso piacere assai, ed émi da altro chanto doluto che da principio io non abbia saputo il modo del cholorire preso da M. Andrea Mantegna, perchè m'era più facile colorirla a olio che a tempera di cholla, e sarebbe riuscita più dilicata avando più dilicato il piano di sotto.'

71 For the Albani Torlonia polyptych see note 33 above. Other works that fall into this category include: the *Virgin and Child with the Infant Saint John the Baptist* in the National Gallery (NG 181), the *Virgin and Child with Saints Jerome and Peter* (Chantilly, Musée Condé), the tondo with the *Virgin and Child enthroned with Saints Rose and Catherine of Alexandria and Angels* (Paris, Louvre). See Scarpellini 1984 (cited in note 35), pp. 80, 87, cats 37, 39, 55. The first of these is currently labelled as a work by an associate of Perugino, at least partly on stylistic grounds, though it was catalogued by Davies as autograph (Davies 1951, cited in note 1, pp. 401–2). It was certainly painted in egg tempera and has green earth underpaint for the flesh and malachite in the landscape. See A. Roy, 'Perugino's Certosa di Pavia Altarpiece: new technical perspectives', *Postprints of the workshop on the painting technique of Pietro Vannucci, called Il Perugino, Quaderni di Kermes*, 2004, pp. 9–20. For a recent argument regarding this group, see L. Teza, 'Osservazioni sulla decorazione del Collegio del Cambio' in Garibaldi and Mancini eds 2004 (cited in note 18), pp. 115–27.

72 Recent examinations of many works in oil by Perugino, Raphael and other fifteenth- and sixteenth- century painters have revealed the addition of colourless manganese-containing crushed glass to red lake glazes. In works by Perugino where glass has not been found in red lake glazes (and where the medium has been examined) aqueous media have been found. See A. Roy, M. Spring and C. Plazzotta, 'Raphael's Early Work in the National Gallery: Paintings before Rome', *National Gallery Technical Bulletin*, 25, 2004, pp. 4–35; M. Spring, 'Perugino's painting materials: analysis and context within sixteenth-century easel painting', pp. 21–8, and C. Seccaroni, P. Moioli, I. Borgia, B.G. Brunetti and A. Sgamellotti, 'Four anomalous pigments in Perugino's palette: statistics, context and hypotheses', pp. 29–41, both in *Quaderni di Kermes* 2004 (cited in note 71).

73 In this period some painters used oil with transparent pigments such as red lake and verdigris, and egg tempera for opaque areas such as flesh. Perugino did not generally add powdered glass to flesh paint as it contains lead white, and therefore dries well. The presence of glass detected by XRF therefore only provides an indication of the binding medium of the red lake paint, and not of the whole painting.

74 Seccaroni et al. 2004 (cited in note 72). Other than works in fresco or on canvas, the paintings which did not contain powdered glass were the *Madonna della Cucina* (c.1520), the reverse of the *Monteripido Altarpiece* (c.1503–4), *David* and *Daniel* (reverse of the Sant'Agostino polyptych, after 1510?). The *Virgin and Child with Saints Jerome and Augustine* in the Musée des Beaux Arts, Bordeaux (probably 1505–10), is catalogued as a work by Perugino and collaborator and here the medium has been shown to be egg tempera by GC–MS. See E. Martin and J.P. Rioux, 'Comments on the technique and the materials used by Perugino, through the study of a few paintings in French collections', *Quaderni di Kermes* 2004 (cited in note 71), pp. 43–56. The absence of glass in the red lake paint of the London *Annunciation* by Giannicola is not surprising since the binding medium is egg tempera and therefore does not require a siccative.

75 The *Ognissanti Altarpiece* by Giannicola di Paolo was most recently catalogued as a work in oil (Blasio 2004, cited in note 24). However, Santi describes it as a work in egg tempera (F. Santi, *Galleria Nazionale dell'Umbria, Dipinti, sculture e oggetti dei secoli XV–XVI*, 1st edn Rome 1985, reprinted 1989). This is also the opinion of the current authors and of the restorers who worked on the painting during the recent conservation treatment (written communication Sheri Shaneyfelt), although there may be some glazes in oil. The Washington *Annunciation* of c.1510–15, however, appears to be painted mainly if not exclusively in oil.

76 In the X-radiograph of Giannicola's *Annunciation*, scored radiating lines can be seen in the haloes, and a punched decoration of five-lobed flowers around the circumference. This is very similar to the decoration on the haloes in Benedetto Bonfigli's *Madonna and Child with Four Angels* in the Galleria Nazionale dell'Umbria (inv. no. 78). Caporali's *Virgin and Child with Saints Francis and Bernardino* (NG 1103) probably dates to 1475–80 and is catalogued as egg tempera and oil on wood, but has not been analysed.

77 Only Perugino's earliest paintings have punched gold leaf haloes. See the panels now in the Louvre (the *Pietà* and *The Miracle of the Hanged Youths*, c.1470–3) and *Saints Anthony of Padua and Sebastian* (Nantes, Musée des Beaux Arts, c.1476–8).

78 Canuti 1916 (cited in note 20), pp. 319, note 99, and 326, note 135.

79 As Michael Bury points out (written communication), the reuse of panels begun for one purpose and either never completed or not paid for is likely to have been common practice, since properly prepared and seasoned panels would have been quite expensive. It is also likely that if the work had been started by one master but interrupted by his death, it would be passed to one of his pupils.

80 L. Bordoni, G. Martellotti, M. Minno, R. Saccuman and C. Seccaroni, 'Si conclude l'anno del Perugino. Il politttico di Sant'Agostino. Ragionamenti e ipotesi ricostruttive', *Quaderni di Kermes*, 56, 2004, pp. 41–54; Seccaroni et al. 2004 (cited in note 72).

81 Martin and Rioux 2004 (cited in note 74). It has been catalogued by Scarpellini 1984 (cited in note 35), pp. 111-12, cat. 137, as a work by Giovanni Battista Caporali and Perugino, followed by Garibaldi 1999 (cited in note 35), p. 159, cat. A12. However, this attribution has no documentary foundation and should be treated as highly dubious, though there can be no doubt that it is not an autograph work.

Gilding and Illusion in the
Paintings of Bernardino Fungai

DAVID BOMFORD, ASHOK ROY AND LUKE SYSON

IN 1932, Bernard Berenson classified Bernardino Fungai (1460–1516) as 'Umbro-Sienese'.[1] Gaetano Milanesi had earlier argued that the painter's early works adhere to the stylistic tradition of the Sienese Quattrocento, while 'in his later works, he demonstrates that he has become detached from it [nelle sue più tarde opere … mostra di essersene alquanto discostato]'.[2] He thus identified a shift from one style to another – or at least a blending of the two – one in which skilled and varied techniques of painting and, especially, gilding were key to the works' aesthetic appeal, and another, which remained highly decorative, but which contained a new naturalistic imperative, predicated on the example of Umbrian painters, in particular Pintoricchio and Perugino, perhaps even before works by the former could be seen in Siena.[3] This 'Umbrian' manner depended increasingly on the use of oil paint, for which Perugino was celebrated throughout Italy. Here was a merged style that enshrined the growing importance of cultural, diplomatic and economic connections between Siena and papal Rome (including, of course, the Umbrian papal states) in the wake of the Piccolomini papacy of Pius II.

Fungai's career and chronology await a thorough reconsideration. Born in September 1460 into a family from Fungaia, near Siena, he has been thought, by some, to be a pupil of Giovanni di Paolo.[4] However, his first documented activity, already at the age of 21, was as a 'gharzone' to Benvenuto di Giovanni on 28 June 1482 – seemingly working with Benvenuto on the grisaille painting of prophets in the drum of the cupola of the Siena Duomo; his individual hand cannot be identified.[5] Fungai's early Madonnas are to some degree indebted to Benvenuto's, and that the two artists were pupil and master is entirely possible. After that date, the documentary record is patchy. Fungai was apparently resident in Siena in July 1491, May 1494 and March 1495 when his children by his first marriage were baptised. In December 1494, he painted ceremonial banners with the arms of the Charles VIII, king of France, and his queen; payments were made for both

gold and lapis.[6] In March 1499, he could be found buying land in the contrada of Poggio de' Malavolti, the area that is also associated with Giovanni di Paolo (dal Poggio), which perhaps reinforces the suggestion of a link between the two painters.[7] In the same year he gilded the organ case in Siena cathedral.[8]

The sole secure touchstone for Fungai's style is the altarpiece from San Nicola al Carmine of 1512 (now in the Pinacoteca Nazionale, Siena),[9] which he signed and dated only four years before his death. It shows the Virgin and Child enthroned with angels, with Saints Sebastian, Jerome, Nicholas of Bari and Anthony of Padua. Fungai's entire oeuvre has been reconstructed on the basis of stylistic affinities between this and what are frequently earlier works; none of his major pictures is now seriously disputed. The *Stigmatisation of Saint Catherine of Siena* altarpiece for the Sienese Oratory of the Confraternity of Santa Caterina in Fontebranda is, for example, universally agreed to be his, and has been dated on the basis of documents (although these do not actually mention the name of the painter). The project for the altarpiece – and an accompanying *gonfalone* (standard) – was proposed in 1493, with the work underway by February 1495 and completed by November 1497 when the altarpiece was still called 'nuova'.[10] The high altarpiece of Santa Maria dei Servi, also in Siena, is first mentioned in the April 1498 will of Battista Guerrini of Sinalunga, who was to leave the money to pay for it.[11] It was finished by 10 August 1501, when Fungai is stated as being owed 180 florins out of the total of 325.[12] His career seems to have taken off in this period – c.1495–1501 – perhaps held back until then by the existence of several well-established workshops run by his seniors, an older generation of artists, several of whom died around 1500.[13] In the 1480s and early 1490s, he had evidently been content to be subcontracted for work commissioned from others. He contributed figures and the landscape to a story of Orpheus and Eurydice, now in a private collection in Florence, one of a pair of mythological scenes, whose principal artist seems to have been the anonymous 'Maestro di Stratonice',[14] a painter close

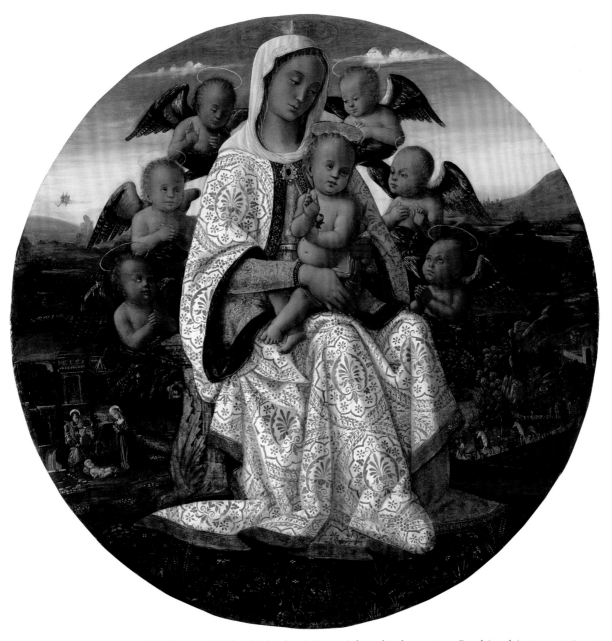

PLATE I Bernardino Fungai, *The Virgin and Child with Cherubim* (NG 1331), here dated *c.* 1506–10. Panel (tondo), 119.4 × 118.1 cm.

in style to Matteo di Giovanni. And, probably in the mid-1490s, he executed the right side of the central Nativity panel of the Tancredi altarpiece in San Domenico, working under Francesco di Giorgio.[15] Indeed, Alessandro Angelini has convincingly argued that Fungai may have been one of a group of Sienese painters assisting Pintoricchio in his decoration of the Borgia apartments at the Vatican, work that was well underway by December 1493.[16] This putative early contact might explain why Pintoricchio was stylistically so important for Fungai.

As Carolyn Wilson has written: 'Fungai's abundant use of gold is noteworthy in sumptuous damasks and in painted areas incised to reveal gilding … he may have had a reputation for his adept handling of expen-

sive materials.'[17] This technique is exemplified in his tondo *The Virgin and Child with Cherubim* (NG 1331), painted on panel (PLATE I),[18] and remarkable for a particular aspect of its gilding technique. The Virgin and Child are seated on a golden throne with, behind them, scenes from the narrative of the the Nativity in a brilliantly sketchy (but controlled) landscape background – the procession of the Magi on the right, the Annunciation to the Shepherds on the far left (in the middle ground), and in front on the left the Adoration of the Child.[19] In this last scene, the Virgin is dressed – according to the traditional iconography – in a red dress and dark blue mantle, her 'worldly' dress. In the primary image, however, she somewhat unusually wears a white and gold cloak. In standard Marian

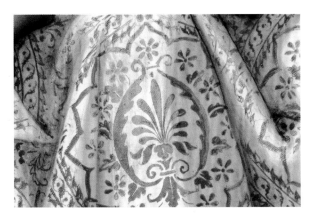

PLATE 2 *The Virgin and Child with Cherubim* (NG 1331). Detail of the Virgin's *sgraffito* drapery.

PLATE 3A *The Virgin and Child with Cherubim* (NG 1331). Paint cross-section of a *sgraffito* area of the Virgin's white and gold drapery, showing a layer of white paint over gold leaf. An orange-brown layer of bole is present beneath the gold, and gesso below that. Original magnification 220×; actual magnification 170×.

PLATE 3B *The Virgin and Child with Cherubim* (NG 1331). Paint cross-section of the orange-brown design on a greyish area of the Virgin's drapery, executed purely in paint. The upper layer represents the design over a pale grey paint; gesso lies directly beneath. Original magnification 220×; actual magnification 170×.

imagery, the throne refers to her role, after her Assumption, as the Queen of Heaven. And in Siena the image of the Virgin Assunta was of extraordinary significance; this white and gold costume is the traditional garb of the Virgin Mary at the moment of her Assumption – the most important feast day for the city.[20] So Fungai's tondo not only presents the Virgin as both the Bride of Christ and the Queen of Heaven at the same time, but turns her into a particularly Sienese protectress.

In painting this startlingly prominent white cloak with its gold pattern and red hem, Fungai employed a type of illusionism that seems to be unique to his works, and that draws special attention to this part of the picture. The cloak is rendered with the traditional technique of *sgraffito* (PLATE 2). Described in Cennino Cennini's *Il Libro dell'Arte*, this method for depicting rich cloth-of-gold fabrics followed a well-established sequence.[21] On a gessoed panel, preparatory red-toned bole and gold leaf were applied across the marked-out area of the drapery; the main colour layer of the fabric (white paint in the present example) was applied on top of the gilding. The paint layer was then scraped away with a fine wooden implement before the paint was completely hard in order to expose the pre-determined gold pattern. Finally, the exposed areas of gold leaf were tooled and incised to give them detail that sparkled and shone as they caught the light. Repeating patterns for *sgraffito* designs were commonly made using stencils or pounced cartoons. The palmate pattern favoured by Fungai seems to have been similarly reproduced in this manner for his draperies.

In the *Virgin and Child with Cherubim*, Fungai employed a novel variation to the normal *sgraffito* method.[22] First he scrupulously divided the white drapery into its lit and shadowed parts, and the areas that were intended to be lit were gilded. The gold leaf was then covered with white paint, and the shadows painted in a warm grey tone directly onto the gesso (PLATES 3A and B). While still soft, the paint was scraped away to reveal the gold pattern in the white, lit areas; in the grey, shadowed areas, the pattern was simply painted in a dull orange-brown colour (PLATE 4). On close examination, the transition between the two techniques is striking. As the repeating palmate design passes from light into shadow, gold gives way to orange-brown paint. In some places, a single lobe begins as exposed gold and is completed in paint (PLATE 5). On a smaller scale, the red hem of the robe, too, is differentiated between a transparent red over gold in the lights and a darker red with a painted pattern in the shadows.

The reason for this unusual adaptation of traditional *sgraffito* becomes clear when the surface of the painting is viewed with light striking it at an angle – as possibly was the case in its original setting. When light is reflected from the surface, the areas with bright gold patterning appear to leap forward, while the areas with orange-brown paint recede (PLATES 6A

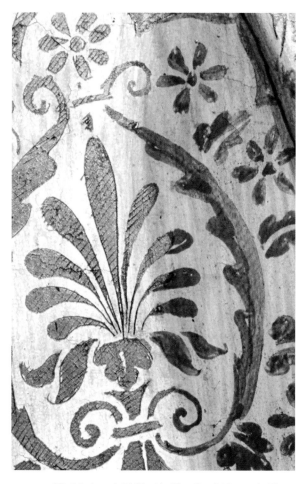

PLATE 4 *The Virgin and Child with Cherubim* (NG 1331). Close detail of the palmate pattern on the Virgin's drapery.

PLATE 5 *The Virgin and Child with Cherubim* (NG 1331). Macro detail of a single lobe of the palmate pattern on the Virgin's drapery.

and B). The resulting illusion of three-dimensional drapery is highly effective – and this was undoubtedly Fungai's intention. It is significant that one of the few panels by Fungai to remain *in situ*, the *Coronation of the Virgin with Saints Sigismund, John the Baptist, Jerome and Roch* (FIG. 1) in the church of Santa Maria di Fontegiusta, Siena, which has a related type of illusionistic gilding (although not identical; see below) is illuminated obliquely through a nearby window early in the morning and through three windows in the opposite wall later in the day (in the absence of any documentary evidence, however, we cannot be absolutely sure that this was its original location).[23]

The use of the *sgraffito* technique for depicting sumptuous draperies was common in Sienese painting during the fifteenth century. In early examples, the design was purely flat, without any variation to suggest folds in the material: transparent darker shadows were simply painted over the regular pattern. Towards the mid-century, particularly in the works of Giovanni di Paolo, a more sophisticated approach becomes evident, in which design correctly follows form. A notable example of this more naturalistic rendering of drapery is Giovanni di Paolo's 1475 'Staggia Altarpiece' (Siena, Pinacoteca Nazionale) in which the Virgin wears a robe of grey and white, exquisitely decorated with gold *sgraffito*: here, the pattern stops at the sharp edges of folds, and resumes naturalistically in a different position and at a different angle where it emerges from the fold (PLATE 7). This precedent is worth considering in the light of the uncertainty surrounding Fungai's training.

However, nowhere else in Sienese painting of the period do we find the complexity of Fungai's illusionism. Some Sienese painters – Matteo di Giovanni and Francesco di Giorgio, for example – used a related technique for gold-patterned draperies, in which the design was superimposed on the colour layers with mordant gilding in the lights and duller yellow-brown paint or uncovered mordant in the shadows.[24] This indeed was the technique employed by Fungai himself in his Fontegiusta altarpiece, where the pattern on the Virgin's white robe is painted out in brown mordant, which is similarly left dark and exposed in the shadows and only covered with gold in the lights, and it occurs also on Christ's darkened azurite cloak. The intention was again to render the highlights more prominent than the shadows, but it was much less effective than Fungai's unique form of adapted *sgraffito,* described above for the National Gallery tondo,[25] a technique that he repeated, with some variation, in a number of altarpieces still to be seen in Siena. It seems possible to propose some sort of chronology for these

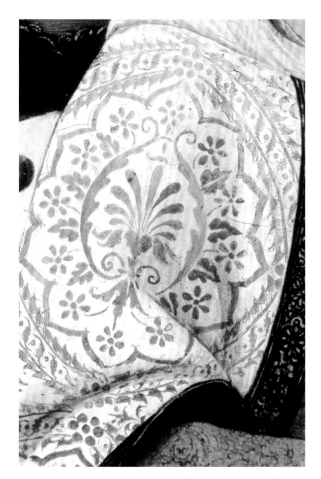 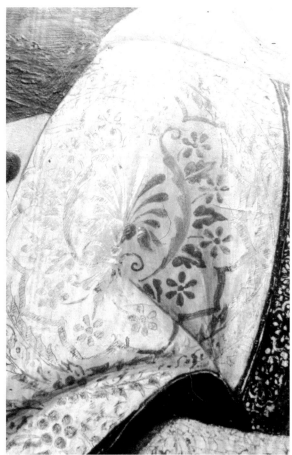

PLATES 6 A AND B *The Virgin and Child with Cherubim* (NG 1331). Detail of the Virgin's drapery in both normal and raking light.

works, based on the development of his technique in general and his illusionism in particular.

Fungai was painting at the time when the egg-tempera medium was giving way to oil in Italy, and he makes this transition in the years around 1500–4. Analysis has shown that the National Gallery tondo is executed principally in a medium of walnut oil, although there is evidence, particularly from the condition of the flesh paints, that Fungai may not have been wholly used to the character of the oil medium at this point in his career.[26] In an early work, *The Assumption of the Virgin* (Siena, Pinacoteca Nazionale), painted largely in the clearly visible hatched strokes that are typical of egg tempera, the Virgin's robe has the familiar white and gold *sgraffito*, but it is relatively simply constructed.[27] The palmate pattern follows the form in the deepest folds but not in the shallower indentations. More importantly, the *sgraffito* is wholly of the conventional kind and there is no transition into a painted pattern in the shadows. Interestingly, the layer of gilding below the robe here extends across a much larger area than just the drapery itself. Fungai water-gilded the panel in a great oval around the Virgin, using it for the rays of gold

scratched through the blue of the sky and for the gilded draperies of the musical angels at the left and right sides.

Fungai's 1512 panel *The Virgin and Child Enthroned* from the Carmine (Siena, Pinacoteca Nazionale), was almost certainly painted in oil (FIG. 2). The passage in this work most relevant to the present discussion is the white cloth-of-honour hanging beneath the Virgin's throne, where we see the familiar repeated motif of the white-over-gold palmate pattern. In this case, however, the fabric is represented as flat, without shadows, and the *sgraffito* is straightforward, and not variegated. As in the other examples of the technique, the exposed gold leaf is hatched with incised lines running diagonally from right to left. Although now rather worn, the patterning on the Virgin's blue robe consists of mordant gilding with the brown mordant left ungilded in the shadows, as in the Fontegiusta panel. Thickly applied mordant gilding is used for the simpler linear haloes of the cherubim in the London tondo, and more delicate work in mordant gilding highlights the cherubim's wings, the edging of the Virgin's veil and the upper part of her cloak.

The largest and most complex of Fungai's Sienese

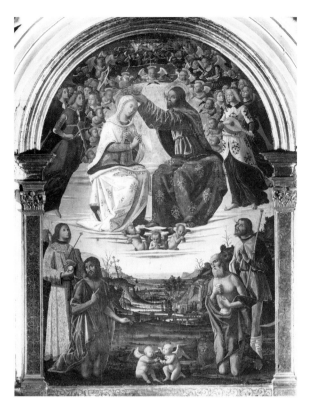

FIG. 1 Bernardino Fungai, *The Coronation of the Virgin with Saints Sigismund, John the Baptist, Jerome and Roch*, 1506–10. Panel. Siena, Santa Maria di Fontegiusta.

altarpieces is the *Coronation of the Virgin*, painted for the high altar of Santa Maria dei Servi (PLATE 8), where the main panel remains *in situ*. In this work, the Virgin's white robe is identical in technique to the London tondo – the palmate pattern set out with conventional *sgraffito* in the lit areas and with orange-brown paint over grey in the shadows. Some areas of the pattern are divided between light and shadow exactly as in the London panel. The exposed gold is also tooled in the same diagonal manner and direction.[28] As elsewhere in Fungai's work, a variety of other gilding techniques are employed in the *Coronation*, including the use of draperies patterned with brown mordant touched with gold leaf on the highlighted areas and left ungilded in the shadows, Christ's ultramarine drapery being a case in point.

The close resemblance of the key *sgraffito* passages in the Santa Maria dei Servi *Coronation* and the London tondo and the general handling of figure shape, flesh tones and so on, suggest that the two paintings may be relatively close in conception and date; the *Coronation* has traditionally been dated to around 1498–1501. Nevertheless, Pèleo Bacci draws attention to similarities between the white cloths-of-gold in the *Coronation* and the *Virgin and Child Enthroned* of 1512 from the Carmine (and, by implica-

PLATE 7 Giovanni di Paolo, the centre panel from *The Assumption of the Virgin and Saints Bernard, John the Baptist, George and Gregory the Great* ('La Pala di Staggia'), 1475. Panel, approx. 199 × 210 cm overall. Siena, Pinacoteca Nazionale.

FIG. 2 Bernardino Fungai *The Virgin and Child Enthroned with Saints*, Carmine Altarpiece, signed and dated 1512. Panel, 315 × 208 cm. Siena, Pinacoteca Nazionale.

tion, the National Gallery tondo), showing that Fungai continued to employ much this technique throughout the latter part of his career.[29] The London tondo has a further connection with the Carmine panel: the throne and the Christ Child in each appear to have been based on the same drawing (reversed for the Carmine painting). A date for the London panel of *c.*1501–12 would therefore seem the safest conclusion. However, one aspect of the three works changes quite considerably in these eleven years – their landscapes – a feature that may make a more precise dating possible. The Servi *Coronation* retains a piecemeal landscape constructed with each individual element carefully and crisply isolated within it, notably the fern-like fronds standing for trees, sometimes with little regard for relative scale and often set against what resembles a sequence of theatre flats. This bright, cool style of landscape, inspired to no small degree by Pintoricchio, had been standard for Fungai in the 1490s. It can be observed, for example, in his Saint Clement predella panels, now divided between York and Strasbourg, probably originally part of the

Servi altarpiece, and also in his several bedchamber pictures of the life of Scipio Africanus, usually (though not universally) dated to the mid to late 1490s.[30] However, in the London tondo Fungai has thoroughly realised the possibilities afforded by the use of an oil medium to paint with greater freedom (even scratching into the surface when still wet to indicate the paths in the background), blending the paint to achieve a more convincing aerial perspective. The colour has consequently become more unified, giving a lovely autumnal mood to the work. Fungai was possibly inspired to experiment by the landscape in Perugino's *Crucifixion* altarpiece in Sant' Agostino, installed by 1506.[31] By the time of the Carmine altarpiece, however, this sketchiness has become almost exaggerated, moving away once again from a naturalistic approach. Bruce Cole has pointed out that Fungai's oil paint had by then attained a fluidity that anticipates the technique of Domenico Beccafumi.[32] The controlled animation and persuasive naturalism of the landscape in the tondo are in fact stylistically closest to the Fontegiusta altarpiece. It would therefore seem reasonable to place the London tondo and the Fontegiusta *Coronation* between the Santa Maria dei Servi *Coronation* and the Carmine altarpiece and therefore to date both these two first works to *c.*1506–10.

Fungai's inventive and novel treatment of draperies that combine *sgraffito* with equivalent painted passages for areas of shadow is not the the only decorative effect achieved with gold to be seen in his panels: all the works discussed here also involve other gilding techniques. Both water-gilding, treated differently from the *sgraffito* method, and mordant gilding were used extensively for draperies and in other features, not only for their particular decorative effect, but also for their impact when used in conjunction with the *sgraffito* designs. In the National Gallery tondo, for example, the Virgin's dress consists of a flat area of water-gilding, laid on over a red-brown bole at the same time as those areas to be developed in *sgraffito*. This gold leaf was next densely stippled with a simple metal punch and finally decorated with a finely drawn arabesque pattern in a red lake glaze paint, with the shadows of the gold fabric modelled in brownish glazes on the sleeve and bodice.[33] Interestingly, the passages representing the red and gold dress where it passes into shadow at the Virgin's feet, and to the right of the Christ Child, are constructed from flat yellow-brown paints over which the red lake arabesque design is continued. The upper part of the dress, with its exposed tooled gold leaf, and the sections in shadow, where only paint is employed, therefore echo

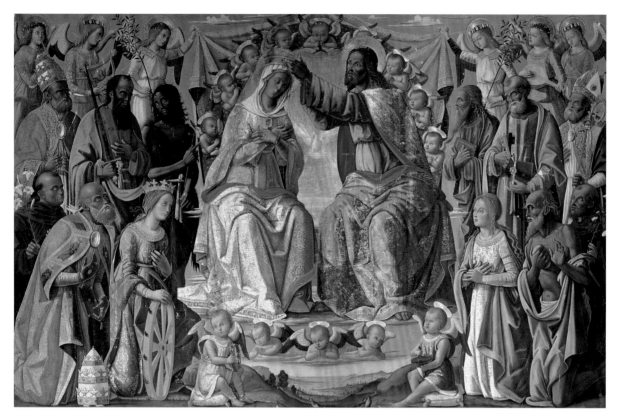

PLATE 8 Bernardino Fungai, *The Coronation of the Virgin*, 1498–1501. Panel. Siena, Santa Maria dei Servi.

the concept of the *sgraffito* and paint conjunction of the white and gold mantle (PLATE 9). Closely comparable techniques are found on others of Fungai's works. In the Fontegiusta altarpiece, for example, the Virgin's underdress, parts of the costume of Saint Sigismund to the left and the sleeves of several of the angels in heaven are created using red lake arabesque designs over water-gilding in just the same way as the Virgin's dress in the London tondo. In addition, the hem of Sigismund's drapery continues the gold and red lake pattern onto a band of orange-brown paint with a red lake design, in the same way as shadow areas of the Virgin's dress do in the London picture. In the gilded parts of the latter's drapery, the gold leaf underlies only the highlighted folds of fabric. Equivalent techniques in translucent red, gold and orange-brown for cloth-of-gold draperies occur in both the *Coronation of the Virgin* in Santa Maria dei Servi and the Carmine *Virgin and Child Enthroned* in which the technique is used for Saint Nicholas of Bari's robe.

Water-gilding is used in other contexts. It is employed, for example, for the haloes of the Virgin and the Christ Child in the London tondo, which are depicted as solid golden ovals. Here the gold leaf is heavily inscribed with radial lines, and triangular radiating sectors of the haloes are marked out with translucent red glazes.[34] In the Fontegiusta panel, deep

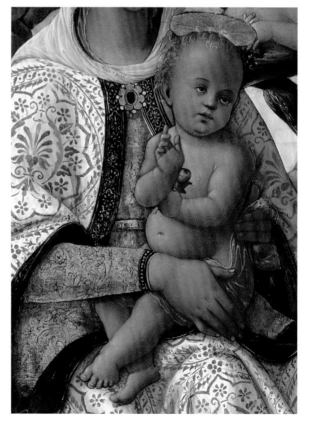

PLATE 9 *The Virgin and Child with Cherubim* (NG 1331). Detail showing the upper part of the Virgin's inner dress with gilding and red lake design to the left and a painted section, without gilding, in the shadow area.

incisions in the gold leaf radiate from the centre of the sun inscribed as concentric circular lines made with compasses; and the effulgence emanating from the Holy Ghost, represented as an oval patch of water-gilding, is similarly incised, the rays in this case continuing into the surrounding paint of the sky as lines of mordant gilding on a thickly applied adhesive.

Fungai's allegiance to the Sienese taste for beautifully patterned cloth-of-gold textiles, and his use of a great variety of techniques to exploit the reflective capacity of gold leaf, are perhaps seen to best advantage and in most elaborated form in his Servi high altarpiece, but the London tondo is almost its equal. Fungai's unique contribution to advancing the expression of decorative richness was his construction of draperies wrought in *sgraffito* work, combined with painted passages that create both an unusual three-dimensional quality and a shimmering effect when the light strikes the surface at an angle (it must also have been especially impressive in candlelight). The costume of the Virgin in the National Gallery painting is a particularly attractive and well-preserved example of Fungai's use of this very specific and apparently personal gilding technique. It is a technique that celebrates the traditional craft virtues associated with Sienese painting, while imbuing them with a greater naturalism, and is entirely in keeping with his self-consciously more modern, 'Umbrian' style.

Notes

1 Bernard Berenson, *Italian Pictures of the Renaissance*, Oxford 1932, p. 211.
2 Gaetano Milanesi, *Sulla storia dell' arte Toscana. Scritti varj*, Siena 1873, pp. 54–5.
3 The final payments for Perugino's Crucifixion altarpiece in Sant' Agostino, a Chigi commission, were made in 1506. See Pietro Scarpellini, *Perugino*, Milan 1984, pp. 112–13, cat. 141. Pintoricchio moved to Siena in 1503/4, to decorate the Piccolomini Library, remaining there until his death in 1513. See Pietro Scarpellini and Maria Rita Silvestrelli, *Pintoricchio*, Milan 2003, pp. 233–81, esp. p. 234.
4 For example, Berenson, 1932 (cited in note 1), p. 211.
5 Pèleo Bacci, *Bernardino Fungai: pittore senese (1460–1516)*, Siena 1947, pp. 12–13.
6 Bacci 1947 (cited in note 5) pp. 15–16, 35–6.
7 Bacci 1947 (cited in note 5) pp. 37–8.
8 Bacci 1947 (cited in note 5) p. 38.
9 OPUS BERNARDINI FONGARII DE SENIS 1512. See Piero Torriti, *La Pinacoteca Nazionale di Siena. I dipinti*, Genoa 1990, pp. 331–2, cat. 431.
10 Bacci 1947 (cited in note 5), pp. 51–4.
11 Bacci 1947 (cited in note 5), pp. 89–90.
12 Bacci 1947 (cited in note 5), p. 94: 'Anno Domini MCCCCCI, indictione IV, die vero 10 mensis augusti. Cum sit quod Bernardinus Nicolai de Fongariis fuerit et sit creditor Fratrum Capituli et Conventus sancte Marie Servorum de Senis in florenos centum octuaginta … pro residuo florenorum 325 sibi debitorum, ex causa sui salarii et mercedis seu manifacture tabule altaris maioris dicte Ecclesie constructe et picte per eundem Bernardinum omnibus ipsius Bernardini sumptibus et expensis.'
13 Pietro Orioli died (at an early age) in 1496, Matteo di Giovanni in 1495, Neroccio de' Landi in 1500, Francesco di Giorgio in 1501/2 and Pietro di Domenico in 1502, leaving the field clear for a younger generation.
14 Aldo Galli in L. Bellosi, ed., *Francesco di Giorgio e il Rinascimento a Siena, 1450–1500*, exh. cat., Chiesa di Sant' Agostino, Siena (Milan 1993), p. 280, cat. 50b; Gigetta Dalli Regoli, 'I pittori nella Lucca di Matteo Civitali. Da Michele Ciampanti a Michele Angelo di Pietro' in AA.VV., *Matteo Civitali e il suo tempo. Pittori, scultori e orafi a Lucca nel tardo Quattrocento*, exh. cat., Museo Nazionale di Villa Guinigi, Lucca (Milan 2004), pp. 95–141, esp. p. 109. It remains uncertain whether this anonymous master is the same painter as Michele Ciampanti from Lucca. Fungai's involvement with these panels makes it unlikely that they can be dated as early as c.1470 –5. In perhaps 1487 Fungai painted an *Assumption of the Virgin* still *in situ* in the convent of San Girolamo, Siena, to complete an ensemble usually (though not necessarily correctly) thought to have been started by the Ghirlandaio-esque painter Fra Giuliano da Firenze. See Marcella Parisi in L. Bellosi, ed., 1993, p. 521.
15 Alessandro Angelini in L. Bellosi, ed. (cited in note 14), pp. 478–80, cat. 107b, who argues that Fungai may have completed the picture started by Lodovico Scotti, the latter working from cartoons by Francesco di Giorgio. It may in fact be the case that the two painters worked simultaneously on the picture under Francesco di Giorgio's direction, Fungai returning to work again on the main panel when he came to execute the predella, which stylistically resembles those panels thought to have belonged with the 1498–1501 Servi altarpiece. For these latter see Laurence B. Kanter, *Painting in Renaissance Siena, 1420–1500*, exh. cat., Metropolitan Museum of Art, New York 1988, pp. 353–8, cat. 76a–d.
16 Alessandro Angelini, 'Pinturicchio e i pittori senesi. Dalla Roma dei Borgia alla Siena di Pandolfo Petrucci' in M. Caciorgna, R. Guerrini and M. Lorenzoni, ed., *Studi interdisciplinari sul Pavimento del Duomo d Siena: iconografia, stile, indagini scientifiche. Atti del Convegno internazionale di studi (Siena, Chiesa della SS. Annunziata, 27 e 28 settembre 2002)*, Siena 2005, pp. 83–99, esp. pp. 94–5. Scarpellini and Silvestrelli 2003 (cited in note 3), p. 286, doc. 57.
17 Carolyn C. Wilson, 'Fungai, Bernardino' in J. Turner, ed., *The Dictionary of Art*, XI, London 1996, p. 842.
18 Martin Davies, *The Earlier Italian Schools, National Gallery Catalogues*, rev. edn, London 1961, pp. 206–7. The picture was cleaned and restored by David Bomford in 2004.
19 This little scene seems to derive from a standard composition used by Fungai and his workshop for autonomous panels, most notably in the *Nativity with Saints Francis and Jerome* in San Secondiano, Chiusi. See also the *Nativity* in the Wadsworth Atheneum, Hartford (1962.445) – a work of the late 1490s – and the *Nativity* sold by Sotheby's in the Earl of Haddington Sale, 8 December 1971, lot 35, perhaps closer in date to the London tondo. See Jean K. Cadogan in Cadogan, ed., *Wadsworth Atheneum Paintings II. Italy and Spain. Fourteenth through Nineteenth Centuries*, Hartford 1991, pp. 146–7.

20 Diana Norman, *Siena and the Virgin: Art and Politics in a Late Medieval City State*, New Haven and London 1999, pp. 3 and 209.

21 Cennino Cennini's recommendations for the execution of *sgraffito* draperies are given in F. Brunello, ed., *Il Libro dell'Arte di Cennino Cennini*, 2nd edn, Vicenza 1982, CXLI and CXLII, pp. 143–5; see also David Bomford et al., *Art in the Making: Italian Painting before 1400*, exh. cat., National Gallery, London 1989, pp. 130–4.

22 First noted by J. Plesters, 'Gold in European Easel Paintings', *The Whiley Monitor*, December 1963, p. 8.

23 This picture is not to be confused, as it was in the past, with Girolamo di Benvenuto's 1515 vault painting above the high altar of Santa Maria di Fontegiusta, which was an *Assumption*. See Gaetano Milanesi, *Documenti per la storia dell'arte senese*, III, Siena 1856, p. 70, no. 31.

24 For example, Matteo di Giovanni's triptych of the *Virgin and Child Enthroned with Angels, Saints Jerome and John the Baptist* and Francesco di Giorgio's *Adoration of the Shepherds* (as we have seen, a collaboration with Fungai, who contributed to the main panel and painted the predella; see note 15) both in San Domenico, Siena. Interestingly, in Matteo di Giovanni's altarpiece of the *Assumption of the Virgin* in the National Gallery (NG 1155) the pattern on the hem of Saint Thomas's drapery is also created with mordant gilding, in which the highlights are gilded and the shadows in the folds are left as the ungilded dark brown mordant. It would be misleading to propose that this technique for representing cloth-of-gold brocades is confined to the work of Sienese painters; a similar technique occurs, for example, in Benozzo Gozzoli's National Gallery altarpiece of 1461–2, *The Virgin and Child Enthroned among Angels and Saints* (NG 283), in the depiction of Saint Zenobius's cope.

25 Although the bulk of the gold pattern on both the Virgin's drapery and that of Christ in the Fungai altarpiece in the Fontegiusta church is created from gilded and ungilded mordant applied over the body colour of the drapery, uniquely, two small patches in each drapery which directly adjoin the water-gilded heavenly sky are treated with the *sgraffito* technique.

26 Examination of samples of the tondo by FTIR and GC–MS has indicated the general use of walnut oil as binding medium, probably heat-bodied in some areas (upper layer of flesh paint, deep green of tree, blue of sky) and non-heat-bodied elsewhere, for example green of grass and landscape paint beneath cherub's flesh. The medium of the Virgin's white robe, treated in *sgraffito*, has been identified as essentially egg tempera. The drying faults evident in the flesh paints of the cherubim arise from the overlap of these upper layers with the surrounding landscape; no reserve had been left for the cherubim. We are most grateful to Catherine Higgitt for her work on these samples.

27 Torriti 1990 (cited in note 9), pp. 242–3, cat. 324 (in which, however, it is catalogued as a 'tired' late work). The exquisite gold-ground *Virgin and Child with a Goldfinch* in the Hermitage, St Petersberg, is also in tempera and probably dates to the mid-1490s. See Tatyana K. Kustodieva, *The Hermitage: Catalogue of Western European Painting. Italian Painting, Thirteenth to Sixteenth Centuries*, Florence 1994, p. 176, cat. 91.

28 The authors were able to examine the Servi altarpiece at close quarters in the church. In addition to the general appearance of the *sgraffito* parts of the Virgin's cloak, it was evident that in places the exposed water-gilding had been worn away revealing the bole beneath. This observation confirmed the nature of the technique involved.

29 Bacci 1947 (cited in note 5), p. 91.

30 Kustodieva 1994 (cited in note 27), p. 175, cat. 90; Marilena Caciorgna, *Il naufragio felice. Studi di filologia e storia della tradizione classica nella cultura letteraria e figurativa senese*, Sarzana 2004, pp. 152–5, 168–84. These works, like others from this period in Fungai's career, are frequently catalogued as having been executed using both oil and egg-tempera paints.

31 The works seems significantly less indebted to Pintoricchio, whose land-scape comes closest in his 1513 signed and dated canvas of the *Road to Calvary* (Stresa, Borromeo Collection), a work which must surely have been executed after the National Gallery tondo. See Scarpellini and Silvestrelli 2003 (cited in note 3), p. 280.

32 Bruce Cole, *Sienese Painting in the Age of the Renaissance*, Bloomington 1985, pp. 142–4.

33 The red lake glaze has been identified by Jo Kirby using HPLC as containing both madder and kermes dyestuffs; it is not known, however, whether these pigments were mixed or used in separate layers.

34 The red glazes used to decorate the incised haloes are now scarcely visible on the picture, having become seriously worn; however, they are very evident under magnification.